Hope in

Hard Times

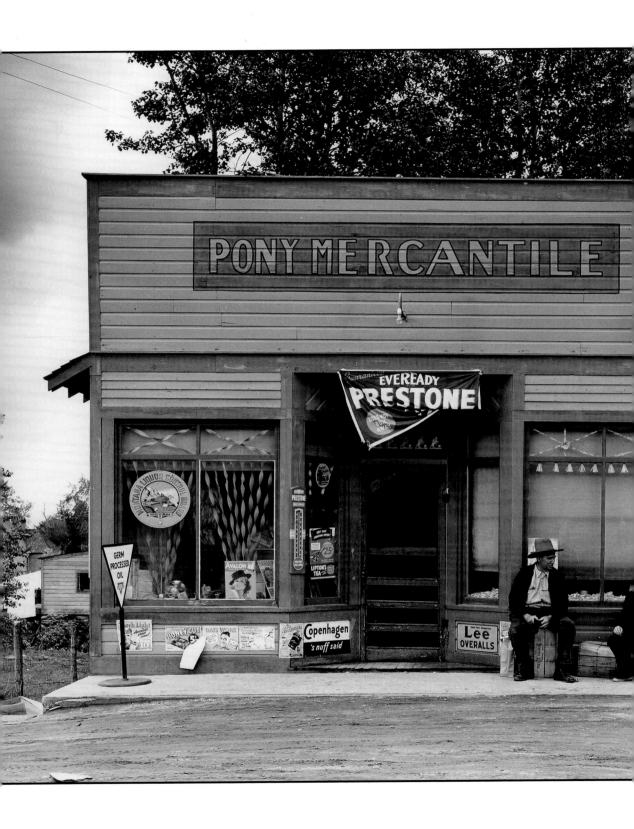

MARY MURPHY

Hope in

Hard Times

New Deal Photographs
of Montana, 1936–1942

Montana Historical Society Press

Helena, Montana

Front cover photo: Russell Lee • Bess Harshbarger, nine years old, Sheridan County, November 1937.
Photo on page ii and iii: Arthur Rothstein • The General Store, Pony, June 1939.
LC-USF34-027267-D

Book design, cover, and composition by Diane Gleba Hall
Typeset in Adobe Garamond
Printed in Canada by Friesens

MONTANA CULTURAL TRUST *Partial funding for this project was provided by Montana's Cultural Trust*

12 13 14 15 16 17 18 19 20 11 10 9 8 7 6 5 4

ISBN-10 0-917298-81-0
ISBN-13 978-0-917298-81-3

Library of Congress Cataloging-in-Publication Data
Murphy, Mary, 1953–
 Hope in hard times: New Deal photographs of Montana, 1936–1942 /
 Mary Murphy.
 p. cm.

Includes bibliographical references and index.

ISBN 0-917298-80-2 (alk. paper)—ISBN 0-917298-81-0 (pbk. : alk. paper)

 1. Montana—History—20th century—Pictorial works.
 2. Montana—Social conditions—20th century—Pictorial works.
 3. New Deal, 1933–1939—Montana—Pictorial works.
 I. Title.

 F732.M87 2003
 978.6'032'0222—dc21

 2002155767

With deepest respect for those who
navigated the Great Depression

Funding for publication of this book was provided in part by the Montana Cultural Trust and the Schnitzler Foundation, as a memorial to Helen Schnitzler Hornby.

Contents

ix Acknowledgments

3 Photographing History

20 Part I.
HARD TIMES

90 Part II.
ON THE ROAD

Arthur Rothstein 118
Marion Post Wolcott 140
Russell Lee 160
John Vachon 180

206 Afterword

211 Notes

225 Bibliography

237 Index

Acknowledgments

THIS BOOK was born on an afternoon Melissa McEuen and I spent in the Phillips Collection visiting a retrospective exhibit of Dorothea Lange's photographs. We were both participants in the National Endowment for the Humanities Summer Institute, "The Thirties: American Literature, Art and Culture in Interdisciplinary Perspective," organized by Joy and John Kasson at the University of North Carolina, Chapel Hill, and we had driven up to Washington, D.C., one weekend to see the Lange exhibit. I have loved the Farm Security Administration photographs ever since they first came to my attention in graduate school; Melissa was working on her book, *Seeing America: Women Photographers between the Wars*. Our conversation that afternoon as we wandered through rooms filled with Lange's luminous photographs, each of us playing off the other's knowledge, was one of the most satisfying I can recall. It was hard not to be inspired, and I determined to do some kind of book on Montana's FSA photographs, only a handful of which had been published previously.

Since that day, many people have helped bring this book to fruition. Doug Howard, another participant in the Summer Institute, invited me to St. John Fisher College, where I tried out some early ideas with his students. Betsy Jameson invited me to the University of Calgary, where

the graduate students were as insightful as they were delightful. Sue Armitage included me in a wonderful group of women scholars who met to discuss the state of gender history in the Pacific Northwest. The work begun there led to an invigorating panel at the Fifth Women's West Conference in Pullman, Washington, and the publication of my essay "Picture/Story: Representing Gender in Montana Farm Security Administration Photographs" in *Frontiers, A Journal of Women Studies* 22, no. 3 (2001). Audiences across Montana, who have come to the presentation I give for the Montana Committee for the Humanities Speakers Bureau, have shared their stories of the state during the Great Depression and helped me see and identify things I had missed in the photographs. I am grateful for the many layers of help I have received from the National Endowment for the Humanities. An especially memorable research trip took me to Sheridan County, Montana, where many people went out of their way to assist me. My thanks to Magnus Aasheim, Conrad Olson, and Minnie Harshbarger for their hospitality and knowledge of local history.

Beverly Brannan, curator of photography at the Library of Congress, has been an enthusiastic supporter of this book and a clearinghouse of knowledge about the FSA photographers and other scholars working on FSA projects. I am particularly in her debt for putting me in touch with John Peterson, Arthur Rothstein's biographer, who generously read part of this manuscript. My thanks as well to the staff of the Prints and Photographs Reading Room at the Library of Congress, who were always helpful. Also in Washington, D.C., Judy Throm, Beth Joffrion, and Diana Johnson at the Archives of American Art made working there one of the highlights of this project. My time in Washington would have been far less fruitful without the hospitality and conversations of Carrie Johnson.

In Texas my thanks go to the staffs of the Harry Ransom Humanities Research Center and the Center for American History at the University of Texas at Austin and to the staff of Special Collections, Albert B. Alkek Library at Southwest Texas State University, San Marcos. Tish Burnham shared her home and her expertise in art history with me. Maggie Murphy, as she did for my previous book, gave me generous logistical and sisterly support.

The first draft of this book was written at Ucross, a paradise in Wyoming for writers and artists. My thanks to the Ucross Foundation for

the residency that allowed me to work with a view of Clear Creek. At Ucross I was privileged to have for company Bruce Jacobs and Renate Gokl. Bruce, with his poet's ear, was a responsive sounding board for ideas; Renate, with her sleek sense of design and love of the western landscape, helped me see the photographs in a different light. Renate drove us on many field trips, including a journey to the Quarter Circle U Ranch, where owner Kay Lohoff graciously showed us around and shared memorabilia from the dude ranch operation.

Librarians and archivists in Montana were crucial to the book. Jan Zauha, Kim Allen Scott, and Jodee Kawasaki at the Renne Library at Montana State University, Bozeman, never failed to find what I needed and always provided help with cheerful generosity. Ellen Crain at the Butte–Silver Bow Public Archives, Kevin Kooistra-Manning and Kathy Mosdal O'Brien at the Western Heritage Center, Billings, and Jodi Allison-Bunnell at the K. Ross Toole Archives, University of Montana, Missoula, were unfailingly helpful, and I especially appreciate their quick replies to last minute requests.

I would have to list the entire staff of the Montana Historical Society to give credit to everyone there who had a hand in this book and in the photograph exhibit that precedes it. Let me particularly thank Martha Kohl, Kirby Lambert, Dave Walter, Sue Near, Brian Shovers, Jodie Foley, Ellie Arguimbau, Angie Murray, Todd Saarinen, Julie Keenan, Annie Hanshew, Molly Holz, Roberta Jones-Wallace, Molly Miller, and Chere Jiusto.

Several students at Montana State University also provided able research assistance. Trinette Ross, Jeremy Johnston, Amy McKinney, and Rusty Hawkins saved me a great deal of time because of their careful work. Tim LeCain and Dale Martin, Sr., also lent their expertise when I was trying to identify elements in the photographs.

My very great thanks to Ann Vachon for permission to use her father's letters, to Pablo Delano for permission to use his father's cartoons, and to Ann Mundy for permission to look at the rough footage of her film on Russell Lee.

This project also received generous support in the form of a Research and Creativity Grant from the College of Letters and Science and a Scholarship and Creativity Grant for the Advancement of the Arts,

Humanities, and Social Sciences from the Office of Vice President for Research and Creativity, both at Montana State University, Bozeman, as well as a grant from the Montana Cultural Trust and funding from the Schnitzler Corporation and the Schnitzler Foundation, as a memorial to Helen Schnitzler Hornby.

Tom Wessel read part of the manuscript and gave this historian, who feels more comfortable with urban matters, the benefit of his expertise in agricultural history. To Dale Martin, who read all of it, more than once, my most heartfelt thanks. This book is much improved because of his knowledge of Montana history. He, along with dear friends Michelle Maskiell, Billy Smith, Susan Kollin, and Anastatia Sims, gave me unwavering support.

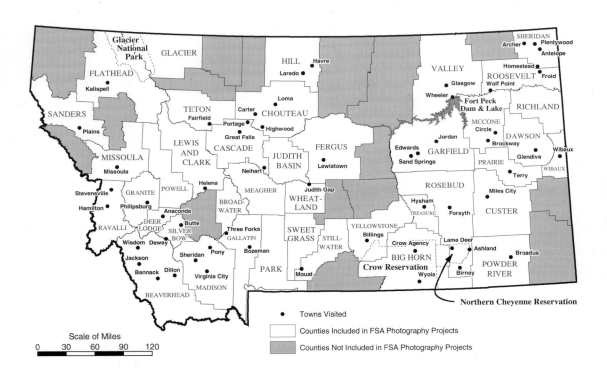

Scale of Miles

0 30 60 90 120

- Towns Visited

Counties Included in FSA Photography Projects

Counties Not Included in FSA Photography Projects

The FSA photographers traveled to all reaches of Montana and made photographs in the majority of counties. Towns shown on the map are those in which the photographers took pictures.

Montana State Library, Natural Resource Information System

Hope in

Hard Times

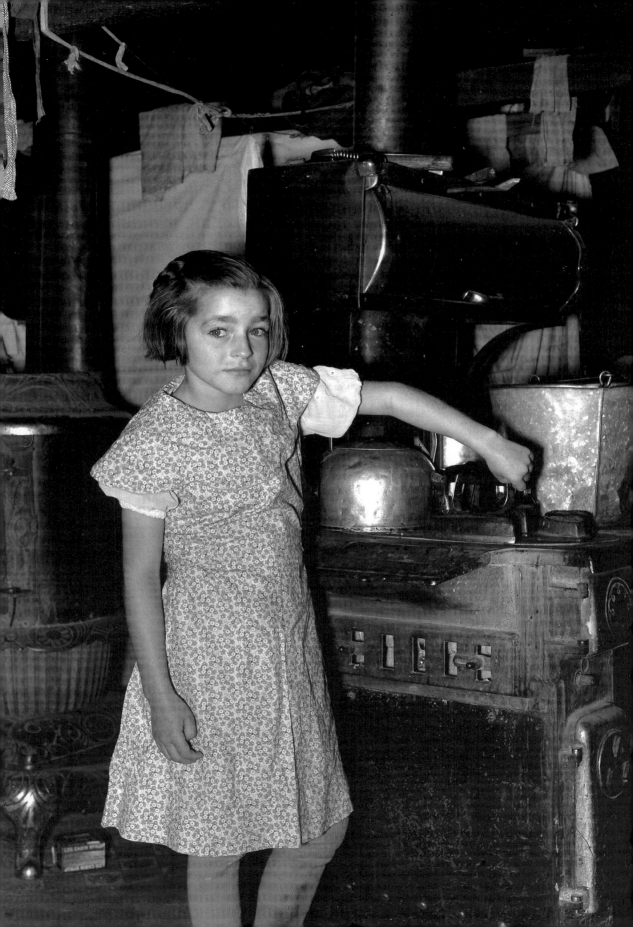

I'm taking pictures of the history of today.

— RUSSELL LEE

Photographing History

BESS HARSHBARGER did not have many dresses. Russell Lee's photograph of the nine-year-old girl shows her standing at the stove, heating sadirons on a November day in 1937. Her hair is neatly braided off her face; she wears a flower-sprigged dress with eyelet sleeves and stained stockings. The house surrounding her is dark and cramped; she is framed by draped-cloth room dividers and by various household goods clustered on the floor, sitting precariously on top of the stove, hanging from nails. There seems to be little maneuvering room for this young girl, child of the Great Depression. Yet she looks out at us with a clear, steady gaze, undefeated by hard times.

Russell Lee had crossed the border from North Dakota into Sheridan County, Montana, on assignment to photograph the drought on the northern plains. He had heard that conditions in Montana were even worse than in North Dakota, and while he did not have time to do extensive fieldwork in Montana that year, he decided to spend a few days in the far northeastern corner of the state. On one of those days, he met the Harshbarger family. Lee made several powerful photographs during his sojourn in Sheridan County, but his series of pictures of the Harshbarger family is particularly eloquent and a good example of the early work of the photographic project of the Farm Security Administration's (FSA) Historical Section.

(facing page)
**Russell Lee •
Bess Harshbarger,
nine years old, Sheridan
County, November 1937**
LC-USF34-030925-D

3

The Harshbargers were somewhat unusual among county residents; they were members of a small congregation of Mennonites, and they had an exceptionally large family. Whether it was this combination that brought them to Lee's attention we will never know, but they suited his purpose.[1] Lee was engaged in a mission to convey to the American public the straits of the country's rural citizenry. Depression had wracked America since 1929, but the Great Plains had also been ravaged by drought. Erick Olson, whose parents homesteaded in the Fort Peck area in 1910, recounted the 1930s on a scale of dryness: "Oh god, it was terrible dry.

Russell Lee • John and Mayree Harshbarger and their family, Sheridan County, November 1937. The Harshbarger home had been built to house chickens, but after it was completed, Mrs. Harshbarger decided that it would be warmer than their homestead cabin, so the family moved into this twenty-four-by-twenty-four-foot, one-room building.

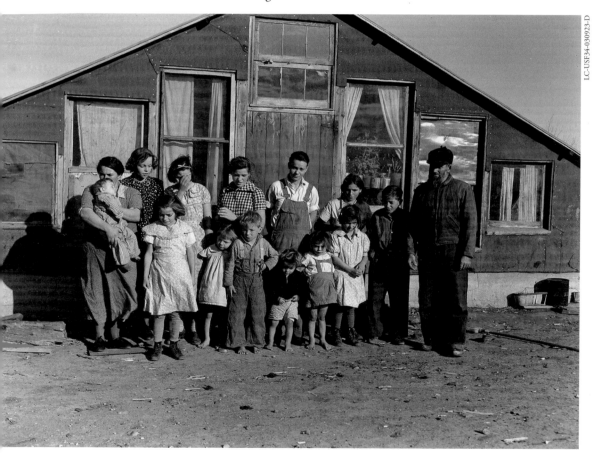

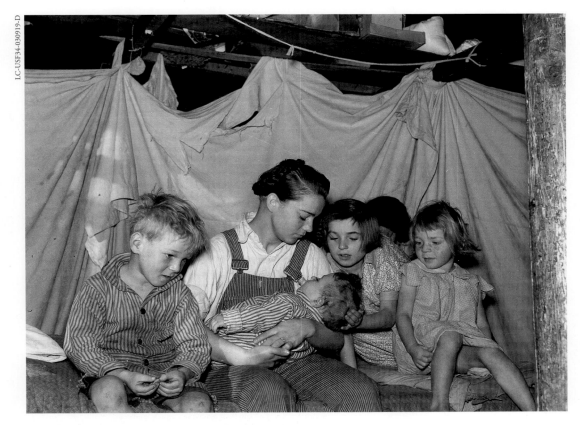

Russell Lee • Harshbarger children, Sheridan County, November 1937. Lee's photograph of Minnie Harshbarger cradling her little brother, surrounded by four other siblings and set against the backdrop of the canvas used to divide space in their one-room house, is reminiscent of Dorothea Lange's *Migrant Mother*, a photograph of a migrant woman and her children in their canvas tent. One scholar of the FSA noted the "Madonna of the Fields" motif that runs through the file.

Our first dry year was 1929 and it was real dry. Well, then we had '30, and that was another dry year, '31 was another, '32 was a real good year, but the price of wheat was, well, in Hinsdale it was fifteen cents a bushel . . . and '33 was dry, '34 was terribly dry, '35 was dry, oh boy it was dry, '36 was real dry. And that's when I went to the [Fort Peck] dam."[2] Dryness begat dust. Vast dust storms propelled mushrooming clouds of desiccated topsoil into the air and across the miles. It piled up against fences, sifted through the tiniest cracks in doorways and windowsills, invaded the respiratory tracts of millions of plains dwellers. Voracious insects—grasshoppers and Mormon crickets—compounded the distress. Searching

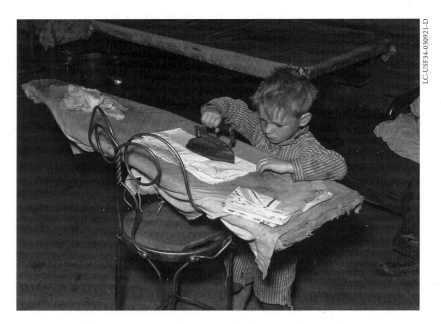

Russell Lee • Jim Harshbarger, five years old, Sheridan County, November 1937. FSA photographers frequently focused on rural children in an effort to drum up public support for New Deal relief programs. A decade of hard times and high unemployment caused Americans to fear what effect inadequate diet, erratic schooling, and a future of joblessness might have on the country's youth.

for food like other animals, they swept across what green they could find, leaving nothing harvestable in their wake.

Russell Lee was working in the northern plains in autumn 1937, making portraits of people and land in need of assistance. The Harshbargers were some of those people. Lee photographed John and Mayree Harshbarger's family in front of their house on their farm outside Antelope, Montana. There are thirteen children in the picture, nine girls and four boys. Yet the Harshbarger family was even larger. At the time Lee took this photograph, Mayree Harshbarger had borne eighteen children; a set of twin boys had died shortly after birth, another child was stillborn, and the two oldest children had already left home. She would have two more children after 1937.[3]

In their quest to document American farm families' trials in the 1930s, Russell Lee and his FSA colleagues made thousands of photographs of people living like the Harshbargers. But the physical conditions they recorded in the photographs were only part of the story. As their boss, Roy

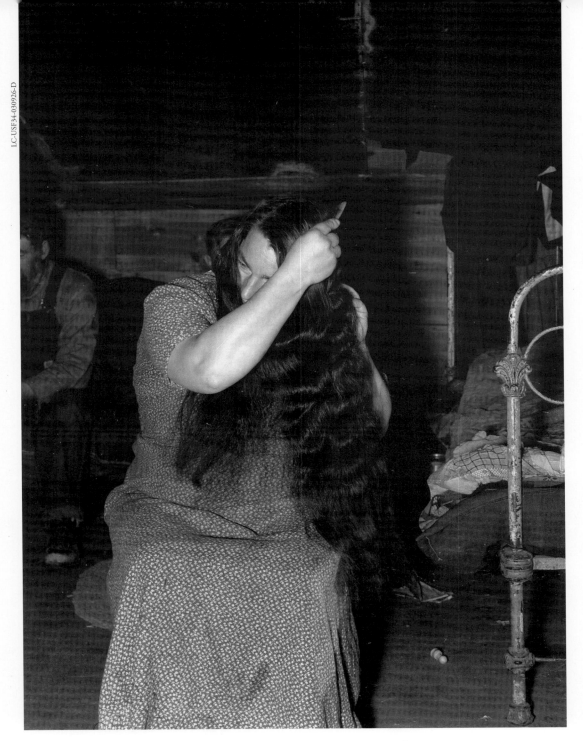

Russell Lee • Mayree Harshbarger, Sheridan County, November 1937. Russell Lee captured an intimate moment in Mayree Harshbarger's day. Minnie Harshbarger fondly remembered that she and her siblings used to comb her mother's hair: "I'll never forget that, combing that nice long hair. She'd sit there on the chair and sleep and we'd comb her hair, so you know she was tired."

Stryker, director of the FSA's Historical Section, asserted: "You could look at the people and see fear and sadness and desperation. But you saw something else, too. A determination that not even the Depression could kill. The photographers saw it—documented it."[4]

Roy Stryker was the driving force of the Historical Section, and his western roots would mark the FSA photography project. Born in Great Bend, Kansas, in 1893 and raised in Montrose, Colorado, he began studies at the Colorado School of Mines in order to become a mining engineer but found he did not like it. Leaving college in 1913, he and his older brother Mitch took up ranching, and Stryker spent several summers running cattle and stringing fence in the Uncompahgre Valley near Ouray and winters working in the hard-rock mines at Ophir.[5] With the United States' entry into World War I, he enlisted in the infantry, and, at some point during his nine months in France, decided that he would resume college once the war ended. Returning to western Colorado in 1919, he re-enrolled in the School of Mines and tried to envision a future not bound to "the price of hay and the price of beef."[6] Marriage to schoolteacher Alice Frasier became part of that future, and the newlyweds moved to New York City in 1921. Stryker enrolled at Columbia University, soon meeting the man who would profoundly shape his future, economics professor Rexford Guy Tugwell. After finishing his undergraduate work, Stryker began a master's degree in economics and worked as a teaching assistant. He extended the walls of his classroom to the city at large, introducing students to American economic life through visits to union halls, banks, museums, and slaughterhouses. A writer later commented on his teaching career, "Fresh from the rangelands of the West, he found himself trying to impart some feeling of America to students from largely urban backgrounds, whose

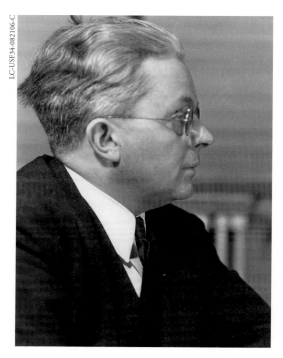

John Collier, Jr. • Portrait of Roy Stryker, Washington, D.C., January 1942. Orchestrating the project from his Washington, D.C., office, Roy Stryker sent the FSA photographers into the field with detailed shooting scripts. His visions of the West particularly influenced the photographers' perceptions of the region.

ideas about the country west of the Hudson were almost as vague as a fifteenth century Londoner's ideas about Cathay."[7] Stryker would never completely abandon the role of teacher.

Stryker also accepted an invitation from Tugwell to locate illustrations for a textbook he was writing with Thomas Munro, *American Economic Life*, and to share the text's authorship. Stryker worked closely with documentarian Lewis Hine and the then relatively little-known photographer Margaret Bourke-White, both of whom provided many of the photographs for the book. In that work Stryker discovered the power of photographs and the great pleasure he gleaned from working with them.

In the meantime, Tugwell had become a close advisor to Franklin Delano Roosevelt, first when FDR was governor of New York and then candidate for president. Rural economics was Tugwell's area of expertise, and it was he who brought to Roosevelt's attention the ideas of Milburn L. Wilson. Wilson, Montana's first agricultural extension agent and later head of the agricultural economics program at Montana State College, designed the Domestic Allotment Plan, in which a tax on agricultural processors would create a fund to pay farmers to let acreage lie fallow, thereby cutting supply and raising crop prices. The plan became the core of the New Deal's Agricultural Adjustment Act, passed in 1933. When Roosevelt became president, Tugwell became assistant secretary of agriculture; Wilson was appointed head of the Wheat Section of the Agricultural Adjustment Administration (AAA).[8] In 1935 Tugwell assumed responsibility for the Resettlement Administration (RA), an independent agency created by executive order, charged with rectifying some of the ills of rural poverty not addressed by the Agricultural Adjustment Administration and some unintentionally caused by it. Foreseeing the need to convince the American public of the advisability and feasibility of some of the agency's projects, Tugwell established an Information Division and brought Stryker to Washington, D.C., to head its Historical Section. In 1937 the new Farm Security Administration absorbed the Resettlement Administration under the umbrella of the United States Department of Agriculture and the Historical Section along with it. The photographs made under Roy Stryker's aegis in both the RA and the FSA have become known simply as the FSA photographs.[9]

Tugwell's first instructions to Stryker were vague. He told him to

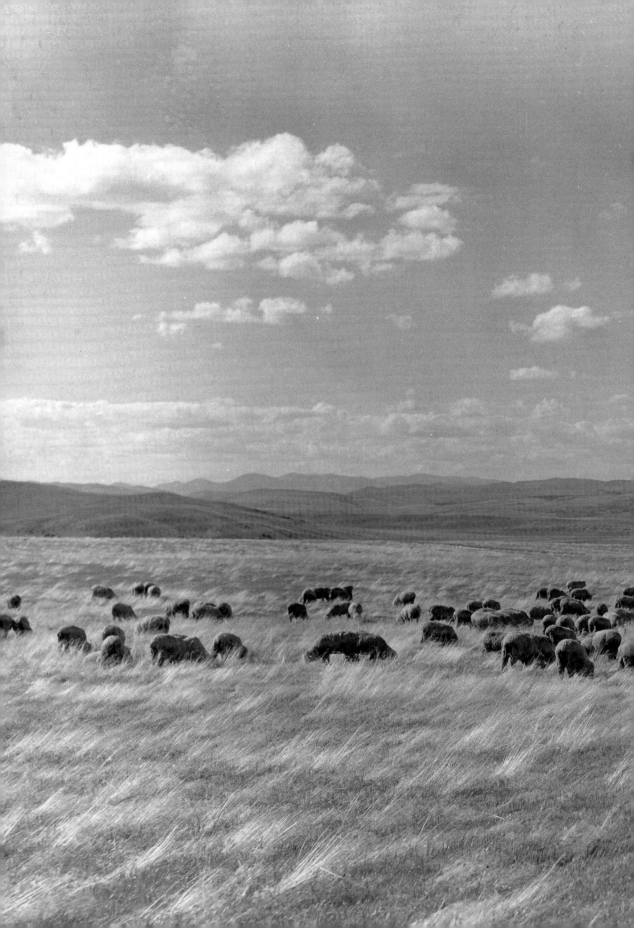

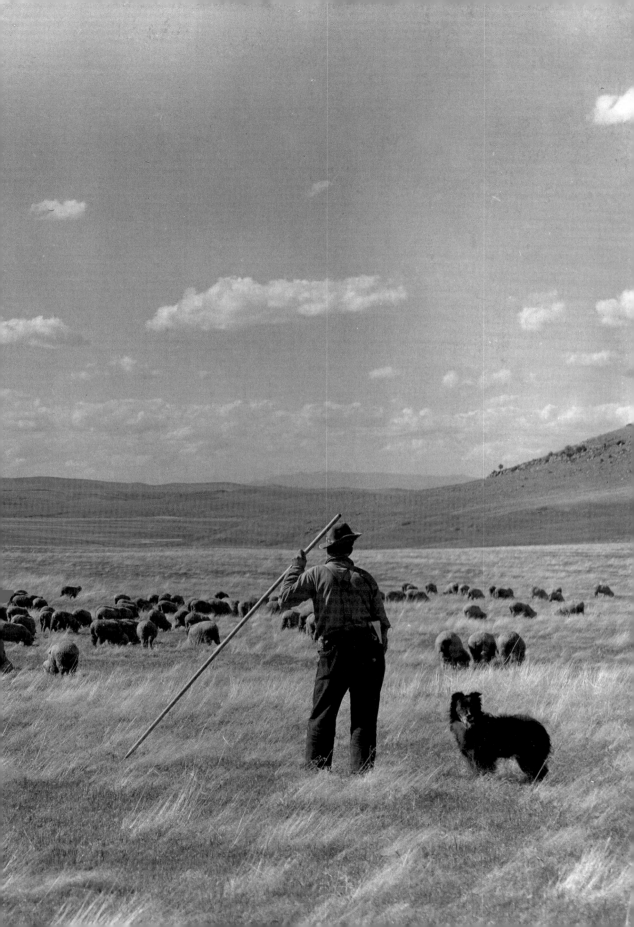

"show the city people what it's like to live on a farm," and Stryker made the most of that liberal charge.[10] Hiring a few photographers, he sent them out to document the conditions of rural Americans. From the beginning the purpose of the Historical Section was propagandistic, to garner favor for New Deal agricultural policies. Stryker wanted as many people as possible to see the FSA photos, and he aggressively pursued their distribution. By 1940 nearly two hundred magazines and newspapers had reprinted agency photos. Some publications, such as the *Survey Graphic*, had a reformist agenda, but FSA pictures also appeared in the *Saturday Evening Post, Collier's, Time, Life, Look, Newsweek,* and *McCall's*.[11] Montanans might not have seen many photographs of their own state, but they may well have been familiar with other FSA photographs because rural readers widely subscribed to picture magazines, such as *Life* and *Look*, which debuted in the late 1930s.[12] Stryker also successfully placed FSA photographs in major photo exhibitions of the decade.[13]

Quite simply the photographs were intended to document the dire condition of much of America's agricultural land and people and to drum up support for New Deal programs designed to reform agricultural practices and assist farm families. In 1938 Stryker described the work in these terms: "Our photographic unit shows the cause—the black blizzards, the dust-covered farms, the floods, the worked-out land—as well as the result in human terms. We picture sharecroppers, dust-bowl farmers, people driven from their homes by the earth's rebellion against misuse."[14] Stryker encapsulated New Dealers' belief that human error as well as nature was to blame for agriculture's dismal state and that human energy could repair it. He recollected that in FDR's Washington, "there was an exhilaration . . . a feeling that things were being mended, that great wrongs were being corrected, that there were no problems so big they wouldn't yield to the application of good sense and hard work."[15] For eight years, until he resigned from government service to begin amassing a photographic file for Standard Oil of New Jersey, Roy Stryker fought off threats to his program, massaged his budget, unraveled red tape, and, from his office in Washington, D.C., directed the paths of a talented cadre of mostly young, relatively inexperienced photographers. Edwin Rosskam, who joined the Historical Section in 1939, gave the best description of its ambitious aims: "We had a long look. A long look at the whole

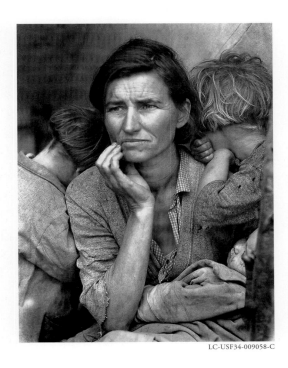

Dorothea Lange • Destitute pea pickers in California. Mother of seven children. Age thirty-two. Nipomo, California, February 1936. Lange's *Migrant Mother* is one of the most frequently published photographs of the twentieth century and became emblematic of the FSA photography project.

LC-USF34-009058-C

vast, complicated rural U.S. landscape with all that was built on it and all those who built and wrecked and worked in it and bore kids and dragged them up and played games and paraded and picnicked and suffered and died and were buried in it. That was our assignment."[16]

Stryker invariably described the project as a documentary record of America, but it was always a selective record, and the agenda of the Historical Section shifted over the course of its life. While still at Columbia, Stryker had confessed to Tugwell that he wanted to produce a pictorial history of agriculture in the United States. The loosely defined parameters of the Historical Section's brief allowed him to engage in that task on an unimagined scale. He instructed photographers to document as many stages as possible in the production of cotton, corn, cranberries, wheat, tobacco, cattle, sheep, sugar beets, sugarcane, and any other crops they saw. Between 1935 and 1937 the project's focus was rural poverty, the effects of drought, erosion, insect infestation, migration, and hard times. A major brouhaha erupted over Arthur Rothstein's 1936 photograph of a bleached steer skull on a parched, cracked alkali flat of the South Dakota badlands. When it was printed in a North Dakota newspaper, a tremendous outcry resulted. Dakotans claimed that one could see this scene any year in Dakota, even in years of good rainfall; they claimed that Rothstein had manipulated the skull and faked the image to portray Dakota and by proximity, Dakotans, in a bad light.[17] Dependent on continued political support for the project's existence, Stryker began redirecting the photographers to include more benign photographs in the collection. A conversation with the sociologist Robert Lynd ignited a new passion, to photograph the passing life of small-town America, the crossroads of

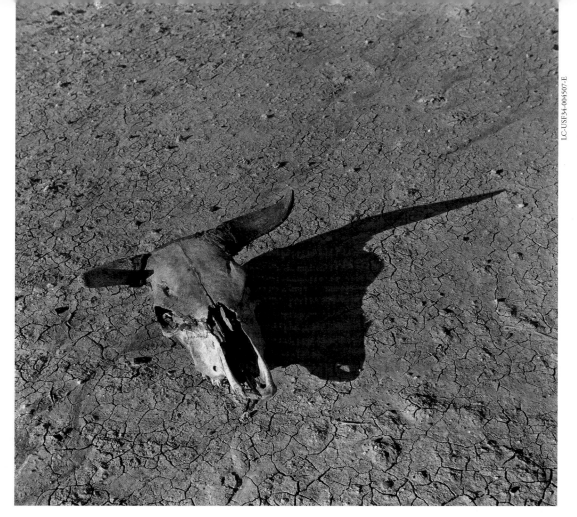

Arthur Rothstein • Bleached skull, South Dakota, May 1936. This photo and Rothstein's caption, "bleached skull of a steer on the dry sun-baked earth of the South Dakota Badlands," caused an uproar when it was published because Dakotans believed it was a false and exaggerated portrait of lifeless, dried-out plains.

rural society.[18] FSA photographers did not abandon recording hard times or the faces of American farms. They continued to photograph the labors of plowing, planting, and harvesting, but they also pictured the signs, storefronts, beer halls, schools, and churches of villages, towns, and cities across the country.

Stryker was always seeking to add to the file. As he and the photographers learned more about the country, they came up with new ideas of scenes and stories they should cover. By embracing small-town America, Stryker offered a counterweight to the photos of eroded landscapes and pathetic living conditions of southern sharecroppers and Dust Bowl

migrants. Too, by 1937 the New Deal had been in place for several years, and the project now had to accomplish two things: demonstrate that the New Deal was working, that conditions were better than in 1931 and 1932, but that more still needed to be done. As Stryker wrote to Russell Lee in 1939, "We particularly need more things on the cheery side . . . where are the elm-shaded streets?"[19] And so in 1937 FSA photographers journeyed with a new purpose. The last turn in the project came with America's entry into World War II. The Office of War Information (OWI) assimilated the Historical Section in 1942, and the portrait of America Stryker now sought was dramatically different from that of the mid-1930s: fresh, green, plentiful, a country that needed to be enshrined, protected, and defended, not reformed. The new mission of documenting war preparedness also pushed the photographers to the cities to photograph factories and industrial workers.

In the eight years of the Historical Section's existence, FSA photographers made some 77,000 images, and thousands more were collected from other sources. The prints and negatives are now housed in the Library of Congress, as the FSA-OWI collection, constituting a body of 107,000 images in the public domain.[20] They form the most powerful visual representation of America in the later years of the Great Depression and the early years of World War II. Not all of the pictures in the FSA file are great, many are repetitive (you could probably do an entire book on fruit and vegetable canning in the forty-eight states). Some are not even very good. But every jam-packed file drawer holds dozens of cardboard-mounted prints that make you stop and marvel. Some of the FSA photos have been reprinted so often that they have become part of the nation's memory of the Great Depression: Dorothea Lange's *Migrant Mother*; Arthur Rothstein's skull or his photo of father and sons running for shelter in an Oklahoma dust storm; Walker Evan's cemetery marker looming over a Bethlehem, Pennsylvania, neighborhood; Marion Post Wolcott's stooped child carrying a pail of kerosene down the gravel track of a West Virginia coal town. It is one truth of the FSA file that in it are images that seem in a single frame to capture the meaning of the Depression for America. They were powerful when they were first printed and published and have gained power since. Yet none of these photos were intended to stand alone—either as art photos, denuded of their context

Arthur Rothstein • Portrait of Marion Post Wolcott, Montgomery County, Maryland, January 1940. Marion Post Wolcott with her Rolleiflex and Speed Graphic cameras, on assignment.

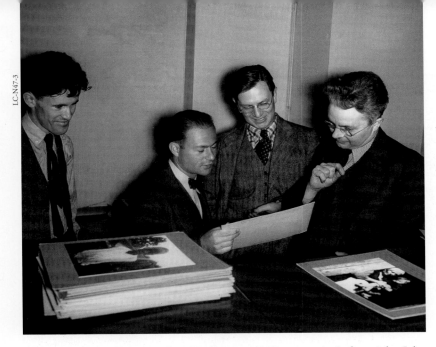

Beaumont Newhall • FSA office, Washington, D.C., ca. 1938. Left to right: John Vachon, Arthur Rothstein, Russell Lee, and Roy Stryker review photographs on one of the rare occasions all were in Washington at the same time.

and of the captions that Stryker insisted each photographer write for every photo, or apart from each other. Romana Javitz, librarian at the New York Public Library, to whom Stryker sent thousands of prints before he arranged for the file to be housed in the Library of Congress, remembered: "I felt in going through FSA you never felt it was a one-picture deal and that you always want to see the rest and that you had this sense of drive that you want to see the rest, you want to see more."[21] The file contains hundreds of stories, sequences, juxtapositions, ironies, and questions, none of which can be represented in one frame. Looking at a single marvelous FSA photo makes you admire the eye of the photographer, but looking at hundreds makes you admire the men and women who drove thousands of miles on unpaved roads, who slept night after night in strange hotels, who marshaled their courage time after time to approach new regions, new towns, new strangers.

The men and women who worked for Roy Stryker became some of the most successful American photographers of the twentieth century: Esther Bubley, John Collier, Jr., Marjory Collins, Jack Delano, Walker Evans, Dorothea Lange, Russell Lee, Carl Mydans, Gordon Parks, Edwin Rosskam, Arthur Rothstein, Ben Shahn, John Vachon, Marion Post Wolcott.

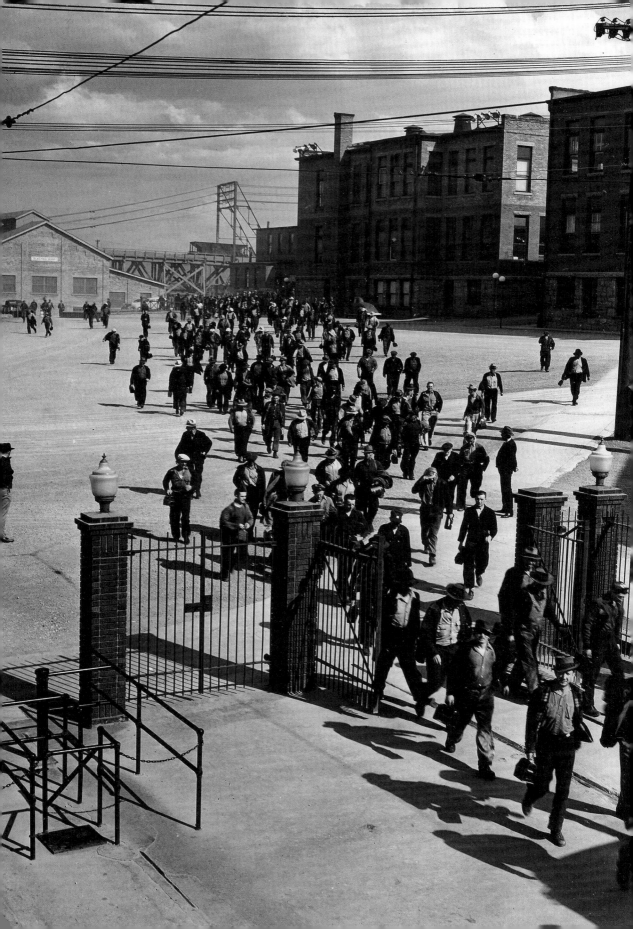

Russell Lee • Anaconda Smelter, Anaconda, September 1942. Men on the day shift leave the Anaconda smelter at the end of work. Lee took several hundred photographs here, documenting the process of smelting copper and the thousands of men who labored in the vast complex. LC-USW3-008534-D

Over the course of the project they crisscrossed the country, driving the back roads and byways of the American countryside, often away from home for months on end, working themselves into the confidence of strangers. They took thousands of frames of film, which they sent back to Washington, D.C., for developing and printing, so that they often did not see the results of their work until months later. Four of these photographers, Arthur Rothstein, Russell Lee, Marion Post Wolcott, and John Vachon, photographed Montana. In 1936 Rothstein came in search of drought-driven farmers and starving cattle, and he returned in 1939 to see how conditions had changed. In 1937 Lee photographed poverty-stricken families in Sheridan County; in 1942 he photographed the copper industry intent on war production and back at full employment. Wolcott puzzled in 1941 over how to convey the vistas of the northern Montana High Line and Glacier National Park and hunted opportunities to photograph the rebounding cattle industry. And in 1942 Stryker sent Vachon in search of shots of the rejuvenation of spring, plentiful herds, and "Mrs. America," whom, he said, "is all over and often hard to find."[22] All in all they spent only a few months in Montana. Each trip combined with assignments in other states, often part of a long cross-country tour. Nonetheless, they made at least fleeting visits to every region of Montana, and they were here through every phase of the FSA's life. They pictured Montanans' hard times and their hopes for a better future.

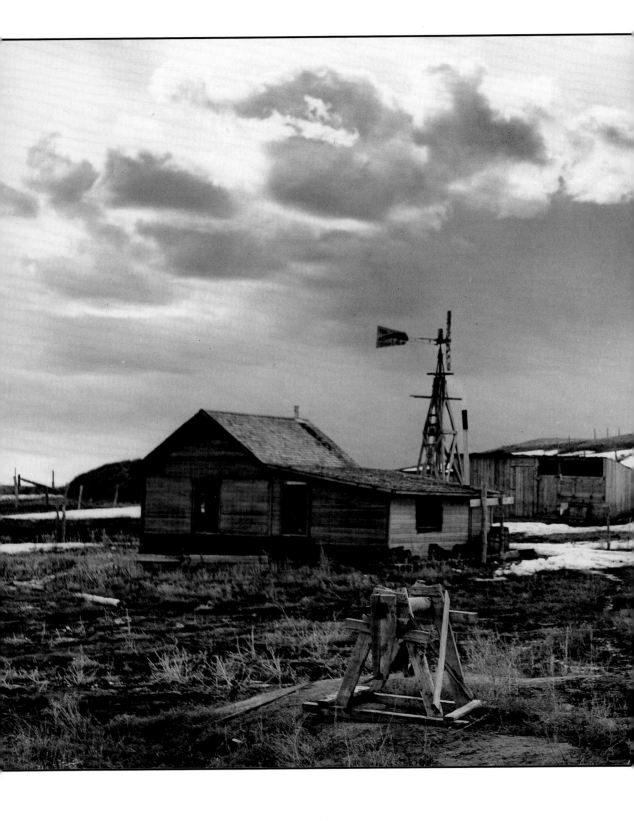

PART I

Hard
Times

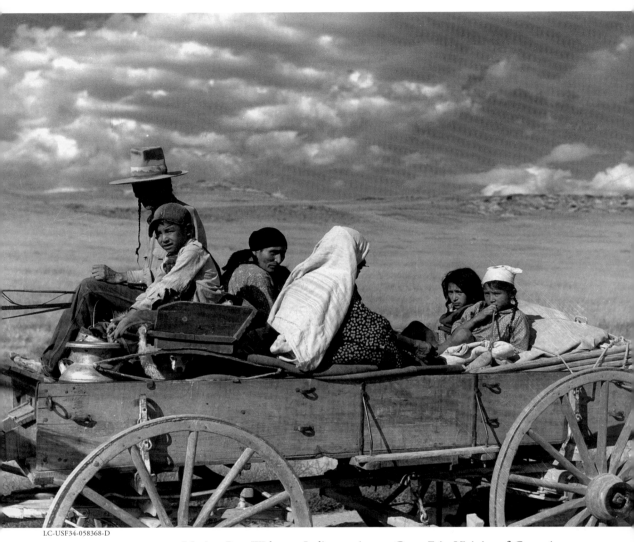

Marion Post Wolcott • Indians going to Crow Fair, Vicinity of Crow Agency, September 1941. In 1941 Wolcott accompanied a group of dudes from the Quarter Circle U Ranch to Crow Fair and en route met this family, including the two dogs, one under the seat and one under the wagon. Notice the tepee poles lashed inside the wagon. *(overleaf)* **John Vachon • Sheep ranch of Charles McKenzie, Garfield County, March 1942.**

Human history is work history.

— MERIDEL LeSUEUR

ON MAY 31, 1937, James Womble, a farmer from Jordan, Montana, sat down and wrote a letter to Senator James E. Murray. After describing the desolate state of Garfield County, he concluded with an account of his own situation: "I have only 6 work horses left, have 1280 acres of land but there is not enough grass on it for the 6 horses. I have nothing to live on, have not made a good crop since 1928. I believe it would be best for the Government to buy our land and help me get started someplace where I could make a living or at least make a garden when I planted it. All of Garfield County people need help. This never was a farming country."[1]

In a few short lines James Womble laid bare the attitude of many rural Montanans in the late 1930s. They had taken up land offered by the various federal land acts believing it to be fertile—why else would the government have encouraged people to file on it? They had labored hard, often for decades, fueled by the dream of self-sufficiency and agricultural success, only to learn that "this never was a farming country." Indeed,

many had stuck it out even longer than the government seemed to expect. In 1934 Dr. Elwood Mead, commissioner of the Bureau of Reclamation, toured the "stricken lands" of the West. The *Circle (Mont.) Banner* reported his recommendation that tens of thousands of people should be moved off the plains and the land reseeded with native bunch or buffalo grass. "I never believed we would have any thing in this country like the catastrophe I witnessed. . . . There is nothing left, no green thing. It is gone. . . . The land never should have been cultivated."[2] James Womble concurred, and, as far as he was concerned, the powers that had invited him in, now needed to help him leave.

There is no one story of rural Montana in the Great Depression, but there is a main story line, one that begins with optimism and rain, proceeds through drought and dust, declension and crisis. For some the tale ends with exile, for others with rescue, and for still others, with their ability to benefit from neighbors' hard times.

• • •

THE VAST MAJORITY of people who took up homesteads in eastern Montana in the late nineteenth and early twentieth centuries had no idea what they were getting into. Danish immigrants Peter and Bertha Josephson Anderson homesteaded near Sidney in 1899. Like many other newcomers, the Andersons were ill-prepared for the high plains. Reflecting on their first winter, Bertha ruefully described how they neglected to lay in a sufficient supply of food because they had anticipated a much milder climate. Back in Denmark the Andersons had located Montana on a map, checked its latitude, and figured that the winter temperatures would be something like those in France. Luckily, a neighbor was able to provision them until spring.[3]

The Great Plains have always been a hard place for people to live. For thousands of years Native Americans used the resources of this "stingy land," as Elliott West aptly called it, making forays onto the grasslands for hunting but retreating to better watered and sheltered riverine environments for much of the year. However, in the nineteenth century, demographic pressures and the desire for economic expansion pushed and pulled Native and Euro-Americans onto the plains as permanent residents.[4] As Native Americans lost their struggle for sovereignty and freedom, they

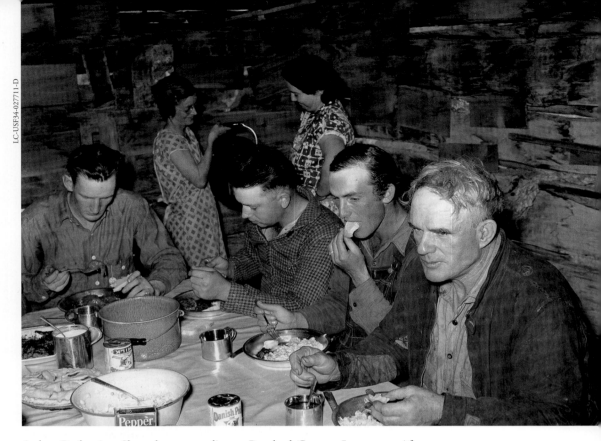

Arthur Rothstein • Sheepshearers at dinner, Rosebud County, June 1939. After washing up and combing their hair, sheepshearers sat down for a dinner of meat, potatoes, coffee, and pie. Like harvest and roundup, shearing was a labor-intensive period for male hands and the women who cooked for them.

also lost control over the land, and homesteaders and ranchers flooded the plains and prairies. By the twentieth century, when most Montana homesteading occurred, severely shrunken reservations contained the native people of Montana. Still, evidence of the nomadic horse cultures of the plains was all around the latest settlers. While Kermit Baecker worked on constructing the earth-filled Fort Peck Dam in 1934, he spent his days off hunting in the fill piles for bison skulls. He knew that the last bison in the area had been shot around 1890: "That was only forty-four years and it really makes you think how new the country was."[5]

It was a new country for the thousands of emigrants who loaded their goods into boxcars and took the Great Northern, the Northern Pacific, or the Milwaukee railroad into Montana and disembarked to face ramshackle towns and bewilderingly vast expanses of land. Many used locators, men who made a living helping prospective settlers find a piece

of land and file on it. Emil Ferdinand Madsen stepped off a Great Northern train in Culbertson in October 1906 with five companions and hired a locator. By the end of the following day, they had constructed six new homestead shacks on the rolling prairie, the kernel of a Danish immigrant colony. After christening the site Dagmar, in honor of a thirteenth-century Danish queen, Madsen began writing articles for Danish newspapers, inviting settlers to move to Montana. The Danes of Dagmar benefited from good initial choices and their communal efforts to gain a foothold on the prairie.[6] Other individuals and families, responding to the flood of advertising issued by the railroads and the State of Montana, did not choose so well. Donald Morrow remembered that his father, a plumber in Minneapolis, saw an ad about "making a fortune on 160 acres of land, free land." His parents moved to Montana in 1908 and homesteaded in the Mildred area, northeast of Miles City, on land he described as "a bunch of gumbo gullies." Only because his father continued working as a plumber—spending months away from home as far afield as Florida—were they able to keep the homestead as long as they did.[7]

Thousands of men and women like the Morrows inundated the Montana plains in the early twentieth century. Until 1901 fewer than one thousand people per year completed patents on homestead land in Montana.[8] But, at about the same time that all the watered land had been claimed, scientists and pseudoscientists began touting dryland farming as a viable agriculture for the high plains. Dryland farming is simply "agriculture without irrigation in regions of scanty precipitation."[9] Newcomers would soon learn just how scanty precipitation could be. Changes in federal land laws that allowed homesteaders to claim 320 acres, to prove up in less than five years, and to spend time away from their claims earning cash also made farming the arid West more attractive. Between 1909 and 1920, 156,988 new claims were made on Montana lands.[10] Another 28,000 entries were filed between 1920 and 1930.[11]

Wheat drew the hopeful to eastern Montana. Farmers planted other crops—oats, flax, barley—but it was the price of wheat that appeared on the front page of Montana newspapers and the tips of farmers' tongues. When soil and rain successfully conspired, high plains sod produced fifty bushels per acre in the mid-1910s. Europe's tragedy promoted sodbusters' fortunes. During World War I the federal government set the price of

wheat at roughly $2.20 per bushel.[12] Farmers scrambled to plow up more land. Many men and women who had never held a hoe took up homesteads, hoping to prosper in the boom. M. L. Wilson's 1922 study of dryland farming in north-central Montana revealed that only 50.5 percent of 550 homesteaders in the area had previous farming experience. Among the inexperienced were two circus musicians, a paper hanger, two wrestlers, six "old maids" and three "old ladies," five lumberjacks, two preachers, a dressmaker, and a deep sea diver.[13] In 1910 wheat covered 435,000 acres of Montana. By 1929, despite some years of contraction, farmers cultivated 4,419,000 acres of the golden grain.[14]

Cashing in on Montana's bonanza required hard labor. Mary Kindzerski characterized her parents' time on their High Line farm: "All their life, they just keep working."[15] Breaking sod, building a house, picking rocks, hauling water, feeding animals, caring for children, plowing, planting, weeding, harvesting, fencing, butchering, milking, cooking, canning, cleaning, laundering, mending—and the list went on. Homesteading was hard work, and no one was excused. Children had their chores, starting as soon as they were big enough to work, and work often took precedence

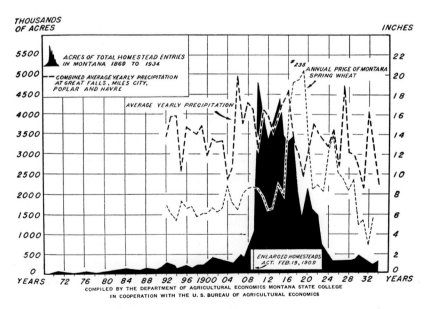

This graph, from the Great Plains Committee's *The Future of the Great Plains* (Washington, D.C., 1936), 41, illustrates precipitation and acreage claimed under homestead laws in Montana. Note the rise in claims after passage of the Enlarged Homestead Act in 1909 and the sharp decline during the post–World War I depression.

over school. Edith McKamey remembered that neither she nor most girls she knew had much education. They came from big families, and they stayed home to help their mothers. When Edith was fourteen, she was "just barely starting the fifth grade."[16] Kaia Cosgriff's father did not believe that she needed an education as much as he needed her on the farm. When she insisted that she wanted to go to high school, he said: "'You can't start school until after Thanksgiving.' After Thanksgiving I started school. Then the next year he said, 'You can't start school until after Thanksgiving.'" But at Thanksgiving he told her she would have to wait until after Christmas. She thought, "I'll have to get away from here or I'll never get to finish the grades." Without telling her parents, she answered a notice for a girl to do housework and left home at fifteen to trade her labor for room and board while she finished school.[17] Other children quit school to help maintain the farm. Rose Maltese had completed eighth grade by the time rheumatism so incapacitated her father that he could not keep up his work. She decided to get a job in order to save the cattle they had mortgaged the previous spring. Not quite sixteen, she moved to town where she "worked like a fool" as a waitress and pastry cook at the Glendive Candy Kitchen. Rose saved the cattle but "couldn't afford to get home. Had to keep on working, you know."[18]

Childhood chores prepared both men and women to run their own homesteads. When Edith McKamey married, her husband Leslie was working as a cowboy for a nearby rancher. They filed on a homestead, and Leslie's boss gave him a week off "so that he could fix that homestead shack so that the rattlesnakes didn't come right in the door." Edith navigated around more snakes each time she went to the coulee for water: "When I think of the way we had it down there I know that it must have been true love."[19] Ethel George came to Montana in 1920 to visit relatives and stayed to work on a ranch for twenty dollars a month. She met her husband at a dance and married in 1922; they had nine children. Mr. George

Arthur Rothstein • Young sugar beet worker with his dog, Treasure County, June 1939. Recruited by the Great Western and Holly Sugar companies, entire families, mostly Mexican or Mexican American, worked in the sugar beet fields of the lower Yellowstone Valley. Children labored alongside their parents hoeing, thinning, weeding, pulling, and topping the beets. LC-USF33-003272-M5

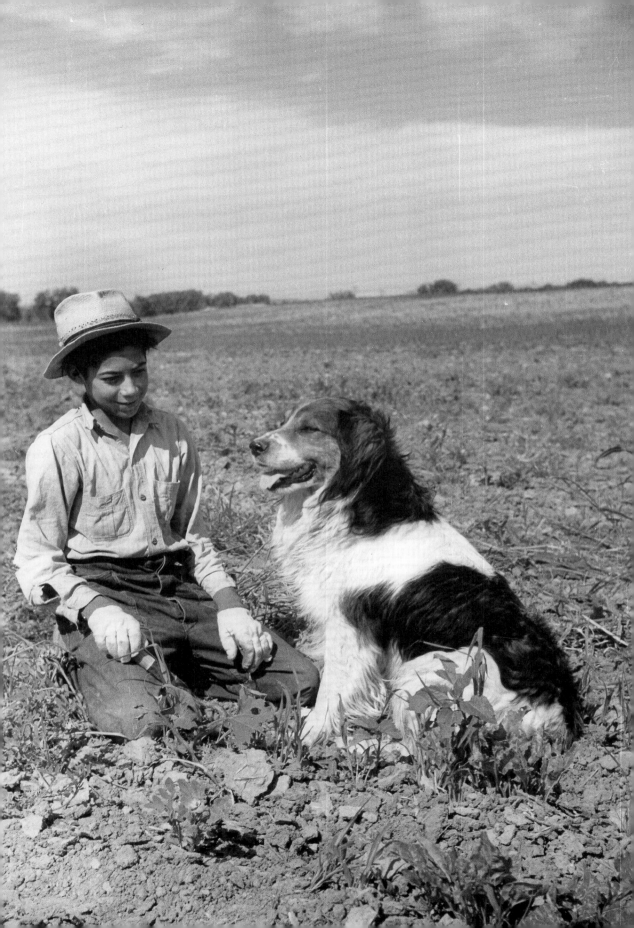

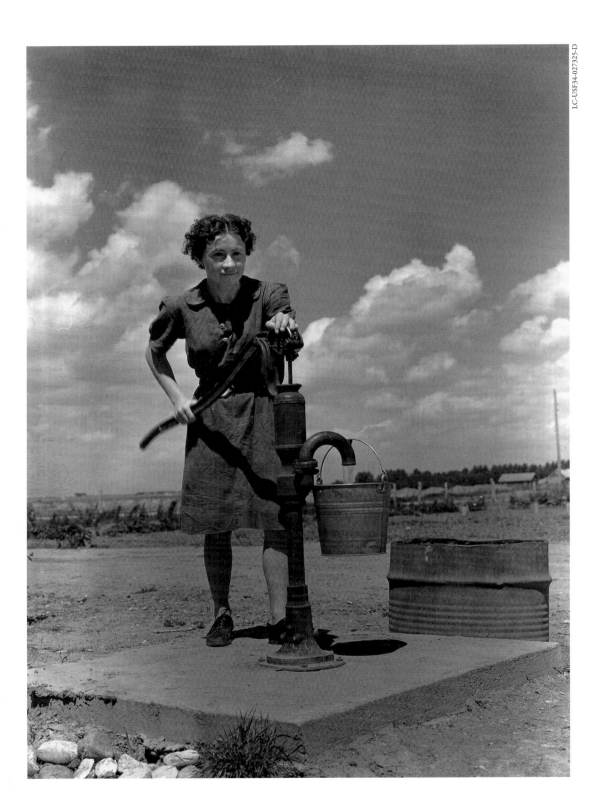

ran a thresher, and wherever they lived, including an old house that had been used as a lambing shed, Ethel kept house, tended her children, and helped run the engine for the thresher: "I made a hand. . . . I had to 'cause my husband could not afford to hire help."[20]

While everyone pitched in as needed, a rough gender division of labor still held true in farm life. Men cared for the fields; women cared for the house. In her 1930 study of forty-seven rural homemakers in seven Montana counties, Blanche Kuschke found that they worked an average sixty-five hours per week; 84 percent of that was spent in homemaking, 16 percent on farm work. Preparing and serving food was the most time-consuming task. Kuschke examined several factors to assess their impact on work time, including the family's annual income and whether women lived on dry or irrigated farms. The only factors that appeared to have significance were the age of children, the presence of electricity, and sinks with drains. Not surprisingly, children under six increased the amount of housework. Electricity and drains decreased work, but both were scarce in her sample.[21] By 1940 only 28 percent of the state's farms were electrified.[22]

Montana farms acquired labor-saving technology in fits and starts. Animal power and muscle power fueled the farms and ranches of the state well into the twentieth century. Even mechanized farm equipment was spottily distributed. Erick Olson, who went to work on the Fort Peck Dam in the mid-1930s, recalled that he "never knew what a tractor was till I got to Fort Peck." A superintendent came up to his crew one day and asked: "'Is there any man here that can drive a pick-up?' And there never was a hand that had lifted and he went on to the next crew and do you know there was not a man that could drive a pick-up." Olson learned to drive on the Fort Peck job.[23] In 1930 only 36 percent of Montana farms used tractors and 29 percent had a truck. By 1940 tractor use had risen to encompass 47.6 percent of the state's farms, and 43.8 percent had acquired a truck. The most dramatic increase in mechanization was in the wheat-growing counties.[24]

Arthur Rothstein • Farm girl pumping water, Fairfield, May 1939. Hauling water was an onerous and time-consuming chore for farm women. A good pump was a vast improvement over carrying buckets on long walks to and from creeks.

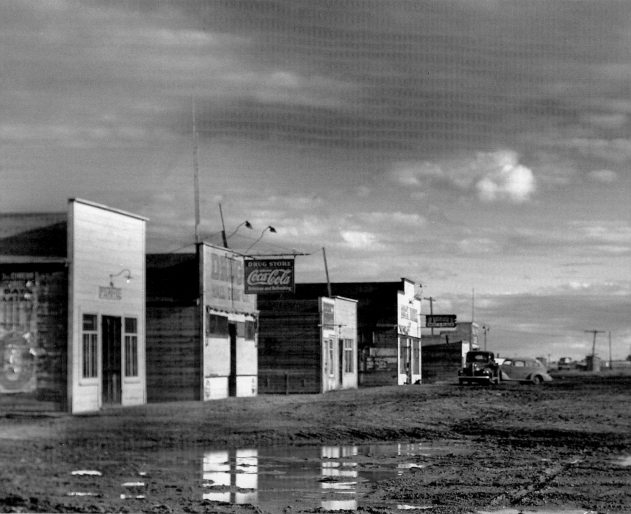

John Vachon • Boomtown of the Fort Peck construction era, Wheeler, March 1942. Vachon came to the nearly deserted town of Wheeler two years after completion of the Fort Peck Dam and the departure of thousands of workers. He wrote to his wife, Penny: "It's very strange looking, wide street with scattered cheap buildings and hotels, and lots of holes where buildings were. Other towns marked on the map aren't even faintly visible any more."

The agricultural history of early-twentieth-century Montana is an often told tale. Relatively plentiful rain in the early 1910s, high prices for grain after 1914, and easy credit encouraged farmers to buy land and tractors and plow up more and more acreage. Then drought crept into northeastern Montana in 1917 and spread steadily south and west through 1921. World War I ended, and European agriculture rebounded. Montana farmers were in debt, their lands dry and withered, and the price of wheat depressed. Tens of thousands packed up and left, and the face of

the countryside appeared bereft. Birdie Streets, whose own family left its homestead in the 1920s, recalled that "a lot of them homesteaders just walked off. Left their place. Turned their horses out, loose 'cause it was open range. . . . Just left their furniture in their house—what little furniture they had."[25] When John C. Harrison moved to Harlowton in 1928, "the homesteaders were pretty well gone . . . no matter which way you went out of Harlowton, the homesteaders' homes were collapsing, nobody lived there anymore."[26] Some who stayed would rather have gone. Lillian Stephenson remembered that during the drought in the late 1910s, she "couldn't even rake up enough money to buy a postage stamp." She would have left except that she had no money for a train ticket and nowhere to go. For her, Montana homestead life was "just desolation."[27]

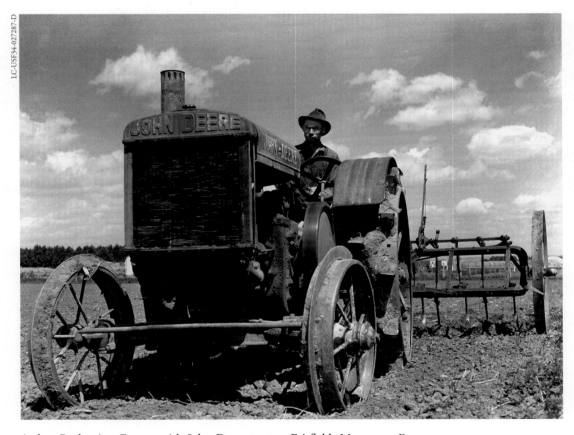

Arthur Rothstein • Farmer with John Deere tractor, Fairfield, May 1939. Farm mechanization increased during the Depression with the help of FSA loans. A Fairfield farmer shows off his new John Deere tractor and cultivator for Rothstein's camera.

Just how many people came to Montana to seek their fortune on the land in the homestead boom between 1909 and 1917 will remain a mystery, for uncounted numbers left before they could be recorded in the 1920 census. The 1920s witnessed a continued exodus. Even with an influx of determined or misguided adventurers in the 1920s, by 1930 there were 24,000 fewer people living on Montana farms than there had been at the beginning of the decade.[28] If the 1910s and 1920s were tough, the 1930s dealt the killing blow for some. When asked about his memories of that decade, Wallace Lockie replied: "The thirties I don't want to remember at all. That was bad all the way through. . . . Nobody had any money. . . . You could buy a set of overalls for 25 cents [but] nobody had 25 cents."[29]

What is often overlooked in the discussion of Montana's homestead bust is that when people left, land changed hands. In the 1920s while the farm population declined, cultivated acreage continued to increase, and the size of farms ballooned. In 1870 Montana's average farm comprised 164 acres; by 1930 it was 940 acres, and by 1940 it was 1,111.[30] The crisis of the 1920s and the Great Depression highlighted the economic truths of high plains farming. Those with more land stood a better chance of surviving. In 1930 the average acreage of Prairie County farms was 1,291.9 acres; those families receiving relief in 1934 lived on farms with an average size of 486 acres.[31]

People did not seek to prey on their neighbors' ill fortune, but land was cheap in the 1930s, and if an outfit had savings or good credit, buying more land was a bargain. If feed was available, inexpensive livestock could be had as well. Kaia Cosgriff and her family were living on an irrigated farm north of Big Timber in the 1930s. Their land, milk cows, and machinery were all paid for. They had a big garden, lambs, chickens, hogs, and cattle. A mill ground their wheat into flour and cream of wheat. Cosgriff made most of the children's clothes. All they bought was coffee and sugar, shoes, overalls, and underwear. "So we were sitting pretty." When a neighboring farmer "lost everything and the bank was selling him out," Cosgriff bought some of his stock. "I paid $26.00 for one cow and a calf and $31.00 for another cow and a calf and we walked them home and we had a lot of hay and we fed the calves and got them nice and fat and we got more for the calves than we paid for the cow and the calf."[32] Wallace Lockie's grandfather brought his wife from Scotland to a homestead in

Arthur Rothstein • Pure-bred Hereford bull, Willow Creek Ranch, Summer 1939.
At one point Stryker told Rothstein to get "more portraits—straight-on pictures—cows, steers, horses, calves, bulls, sheep."

Montana and died when his youngest son was three months old. Wallace's grandmother raised six sons on her own. In the 1930s he remembered her saying: "'Boys, we're going to buy land. All we can. We're going to take all the money we can get together and start buying land.' Course you could buy it at that time for taxes, fifty cents an acre. They started buying up land. This was in the early '30s when nobody else had any money but they took what little they had and Bill and Dave went out and worked in the '30s, sent their money home. They used it and bought land. They wound up owning a heck of a lot of land, I'll tell ya. It started in Miles City and stopped this side of Forsyth."[33] August Sobotka's desires were more modest. He wanted enough land to run a hundred cows. But he, too, was able to acquire it in 1940 when it sold for tax title. Auctions were held on the courthouse steps, but if no one bid on the land, "you could buy it for private treaty for 10 percent less. I paid forty-five cents an acre for some of it." The county was so anxious to get rid of the land that for

Arthur Rothstein •
Grain elevators on
Sheffels's wheat farm,
Cascade County,
May 1939.

a few months, until they realized what they were doing, they included the mineral rights in the forty-five-cent price. "About 1940 was the last, the last big deal of getting land cheap, 'cause then it rained. . . .You couldn't get land cheap like that anymore."[34]

Because this was "a new country," there were relatively few settlers around who recognized the regularity of drought on the plains. Between 1889 and 1936 the Great Plains suffered eleven severe drought years, but only three of them occurred between 1900 and 1917, lulling farmers into a false expectation of regular precipitation.[35] Yet even had farmers recognized the deep aridity of the high plains, some still would have stayed. Each time a rain fell, many were convinced that "we have definitely passed through this drought cycle and will have normal conditions again."[36] And many grew to love the land. Mary Frances Alexander McDorney's father came to Culbertson to be the superintendent of schools, "but he fell in for all of the propaganda about homesteading." McDorney recalled that "even my mother said that it probably would be a good thing to go out on this homestead and stay there for—what— three years, I think, in order to prove up on the homestead. Then the land could be sold, and probably they would come out of it with a couple of thousand dollars." But her father never wanted to leave, and he spent forty years on their dryland farm.[37]

By the time the Great Depression rolled around, Montana had a decade's prelude of hard times, and more drought followed. Dry years came close on each other's heels during the 1930s: 1930, 1931, 1933, 1934, 1936.[38] The two areas of the Great Plains most severely affected by the droughts of this decade were the southern plains that launched the Okie migration to California and the Dakotas and some contiguous areas, including eastern Montana.[39] A weather observer in the Circle area reported that 1931 was the driest in thirty years with total rainfall of 5.67 inches, and a farmer in Daniels County lamented in his diary, "the world is a dreary spot for Montana grain growers."[40] Sheridan County, in the far northeastern corner of the state, snug up against North Dakota, was particularly hard hit. Of the 1,402 farmers in the county in 1931, 987 applied for feed loans, the largest percentage in any county in the state.[41]

Banks, which had marketed easy credit in the great plow-up of World War I, were reluctant to loan money to farmers whose ability to repay

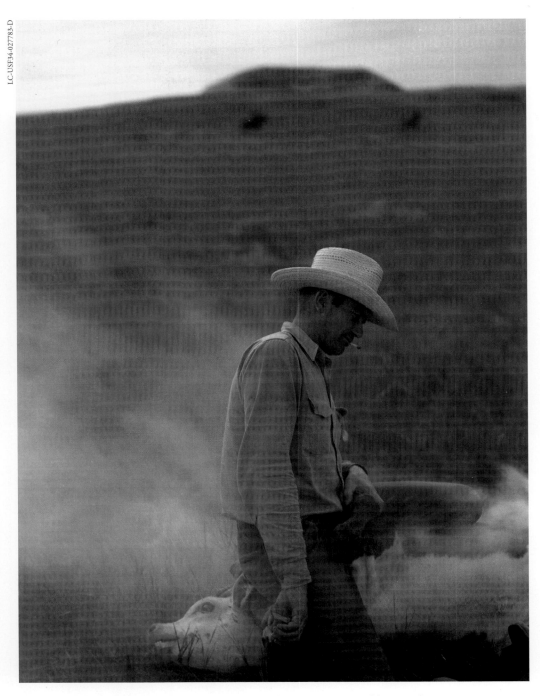

Arthur Rothstein • Branding, Quarter Circle U Ranch, June 1939. Broad-brimmed hats, sweat-stained shirts, cigarettes, and the round tags of Bull Durham tobacco bags dangling from shirt pockets were ubiquitous among the cowboys Rothstein photographed at work and at rest.

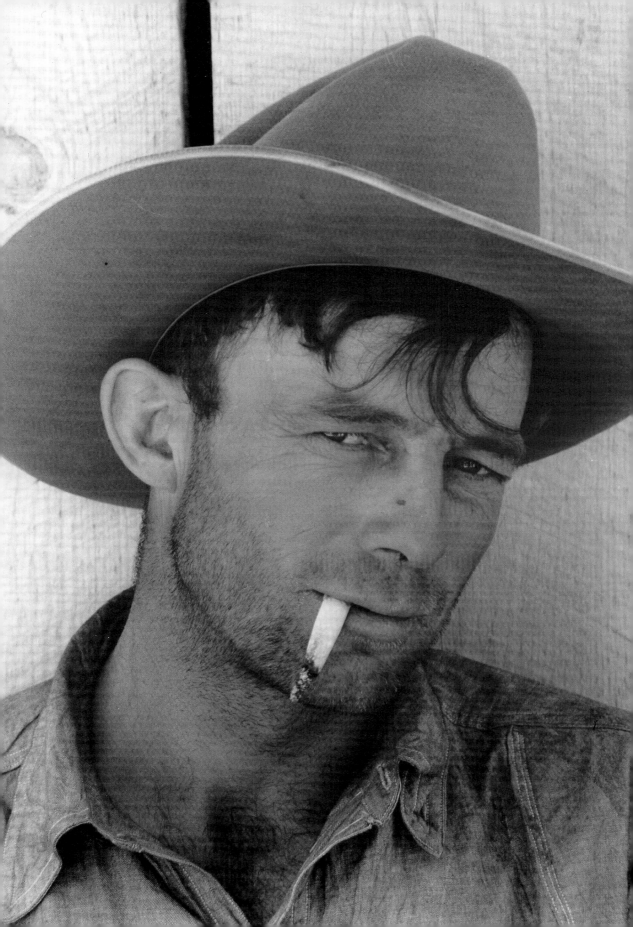

those loans seemed chancy at best. Between 1930 and 1932 Montana farmers' annual income plummeted by nearly 53 percent.[42] A worker on the Federal Writers' Project collected a story in Sanders County that captured the strained relationship between farmers and bankers: "A farmer went to his banker to borrow $300 for feed for his stock and his family for the winter. Times were hard and the banker was loath to let the money go. However, the old farmer was insistent and finally in order to get rid of him the banker, who had a glass eye, a perfect match for the good one, said: 'I'll tell you what I'll do. If you can tell me which is my glass eye I'll let you have the money.' 'It's the right eye,' said the farmer. 'You're right,' said the banker, 'but how did you know?' 'Well,' said the farmer, 'it looked a damned sight more sympathetic than the other one.'"[43]

Prior to the election of Franklin Delano Roosevelt and the inauguration of the New Deal, in particular of the Agricultural Adjustment Act, struggling farmers had recourse to private charity in the form of local institutions and the Red Cross, as well as government seed and feed loans, but those resources were limited and quickly exhausted. The FSA photographers were not around to document the deepest days of Montana's Depression. Charles Vindex remembered winter 1931–32 as "our nadir." It was exemplified by his effort to earn a little cash. In February 1931 after a spell of forty-below-zero weather, Vindex helped a neighbor cut and store ice. He got up at 4:30 A.M., walked three miles before breakfast, and ate by the light of a kerosene lamp. Then he sawed blocks of ice all day, leaving "every muscle trembling." After supper he helped pack the ice blocks into the icehouse, then walked home, and collapsed until it was time to start over. "I would have said this was the hardest a man could work for $1.25," he wrote. But the following winter, after the birth of a child, another summer of drought, and an invasion of army worms, he took on the same job for $.75 a day.[44]

In 1931 Herbert Hoover resided in the White House and John E. Erickson in Montana's governor's mansion. Hoover's commitment to limited government intervention in the economy and his faith in private charities would prove woefully inadequate to cope with the massive economic dislocation of the Great Depression. State, local, and federal officials sympathized with people's straits and offered what help they

Arthur Rothstein • Cowhand, Quarter Circle U Ranch, June 1939.
LC-USF34-027550-D

could, but it was not until Franklin D. Roosevelt and his Brain Trust came to office that imagination and authority combined to launch new, massive work and relief programs. In the meantime people in Montana did the best they could for themselves, their families, and their neighbors. They turned to the government, sometimes in personal requests to the governor, only as a last resort, and many refused to ask for help for themselves. J. Calvin Funk, a schoolteacher from Santa Maria, California, was moved to write to Governor Erickson, asking if any assistance was available for a family he met while visiting friends near Lustre, north of Wolf Point. They "told me that they had a well-sized garden as usual. This the sandstorm killed. Then they replanted it. The second garden the hailstorm destroyed. With what little they had left they started a small third garden which will probably not mature due to early frosts." They were in danger of losing their cows and chickens to creditors, but even if they managed to keep their stock, "the pastures were very dry and bare. The short and very thin grain is mostly thick full of tall thistles. . . . It seems to be too embarrassing for those brave people to ask for aid."[45]

Other equally brave people, longtime residents who had worked steadily, paid their taxes, supported themselves, but were now at wit's end, did ask. Mrs. H. Frederickson and her husband came to Montana in 1913, and she wrote Governor Erickson in 1930 that they and their six children had "worked very hard to try to make a home but it seems as if we can not raise means enough to do so any more." Four years earlier an accident had disabled her husband, so she and the children were doing the heavy farm work. Like many other supplicants, her chief concern was for her children. She feared she could not send them to school after the eighth grade, for they had not been able to raise a crop for three years, and they lost their savings when the bank failed: "So no money to pay taxes and intrests and we have never waisted a cent for shows and dances and so on. . . . I can not get a job and work for there is no work to be gotten here and I don't like to seperate my family. Can you advice me what to do we have always payed our honest debts when we could rase the money to do so, it was never spent for finery I am not to nice to wear cast off shirt and overalls of my husbands and work in the field. If only we could raise a crop again we could live."[46] Petitioners, such as Steven and Louise Watts, also wanted the governor to know they were not

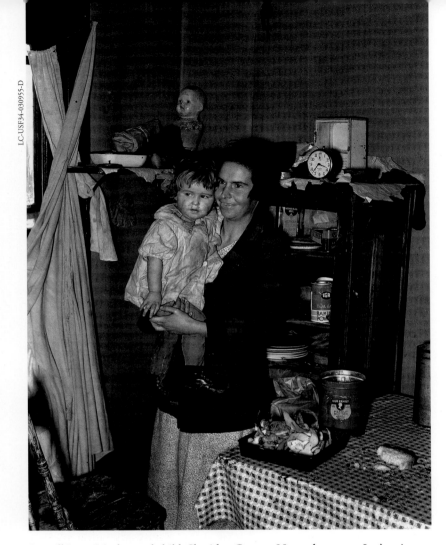

Russell Lee • Mother and child, Sheridan County, November 1937. Lee's poignant portrait of mother and child in the kitchen of their farmhouse is full of symbolism, from the clock ticking away on top of the cupboard to the dirty, armless doll perched above the head of the little girl in her worn shoes and stockings.

making frivolous requests. The Watts arrived in the state in 1910 with a goodly amount of money, acquired 960 acres of land in Daniels County, and began raising wheat. In 1916 they built a modern house with a good barn and had forty head of cattle, twelve horses, and twelve cows. Louise made and sold butter and vegetables as well as helped in the fields. The couple estimated they had paid over fourteen thousand dollars in taxes since their arrival but now had "no machinery, horses, cattle . . . and only two cows." Their earnings from crops for the last four years had not brought enough to pay their taxes. They were seventy-six and sixty-seven

years old, and they wanted to know what Erickson was going to do so that they could keep the home "we have been a lifetime making."[47]

Neither the Watts's nor Mrs. Frederickson's stories were unusual. Investigators in the 1930s found that most people seeking relief in the drought area were longtime settlers. In a study of several Montana counties, 46.6 percent of drought-relief recipients had been in their current residence for twenty or more years, 26.1 percent for more than ten years; only 10.8 percent had been on their farms for five or fewer years.[48] Their stories also highlight a complicating factor in administering relief during the Great Depression. Close scrutiny of some Montana counties revealed the fact that not all people who benefited from New Deal programs were victims of only the Great Depression. New social service programs assisted the chronically poor and disabled as well as those struck by recent drought and unemployment. For example, in a 1937 study of 217 families on relief in Prairie County, Ruth McIntosh determined that most of the families had moved to the county between 1910 and 1920 and that the heads of families were aging and suffering from perennial lack of medical care.[49] By 1930 the percentage of people sixty-five and older on all Montana farms had nearly doubled from 1920.[50] Of those adults on relief in Prairie County, one in ten, presumably people like Mr. Frederickson, suffered from disabilities that made them unemployable regardless of the state of the economy.[51] By the time the New Deal arrived, deep-rooted poverty had weakened the overall health of the population. Prairie County employed a public health nurse from 1928 through early 1930. On her home visits she diagnosed problems far in excess of what she could remedy or what the county would pay to treat. Many relief clients preferred not to be told the nature of their children's ailments, since they could do nothing about them. McIntosh concluded that over 20 percent of the county's families on New Deal relief would likely need long-term assistance.[52] In his statewide study, also conducted in 1937, Carl Kraenzel discovered that one in five heads of 1,104 relief households had been unemployable prior to going on relief. They needed help regardless of the crisis of the Depression.[53]

Whenever and for whatever reason their hard times began, Montana's working poor stretched their resources as far as they could. Mrs. Charles Vindex remade her worn-out dresses into clothing for their children,

and when her husband's clothes could sustain no more patches, she tore them into strips and knitted them into rugs with a pair of needles he made out of a springy wire barrel hoop. Mr. Vindex recalled, "We became shy of other people during those patched and shabby years."[54] In 1931 Jim Kelsey of Kirby, Montana, wrote to the governor, asking to mortgage his 1927 Model T Ford coupe, "in pretty good shape," for the seventy-five dollars he estimated he needed to keep his family through the winter. He had found work in only five months of the previous year; at a dollar a day, his total income was a hundred and fifty dollars.[55]

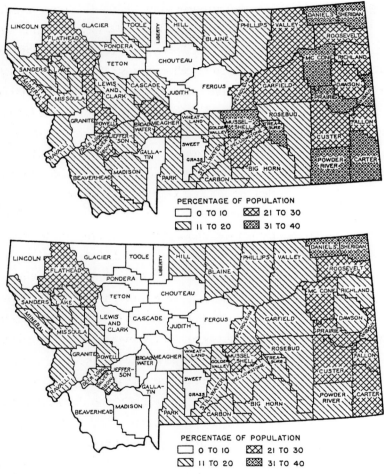

These maps indicate the percentage of Montanans on relief in February 1935 (top) and June 1935 (bottom), two years after the institution of the New Deal. From Carl F. Kraenzel, with Ruth B. McIntosh, *The Relief Problem in Montana: A Study of the Change in the Character of the Relief Population*, bulletin no. 343, (Bozeman, Mont., 1937), 10.

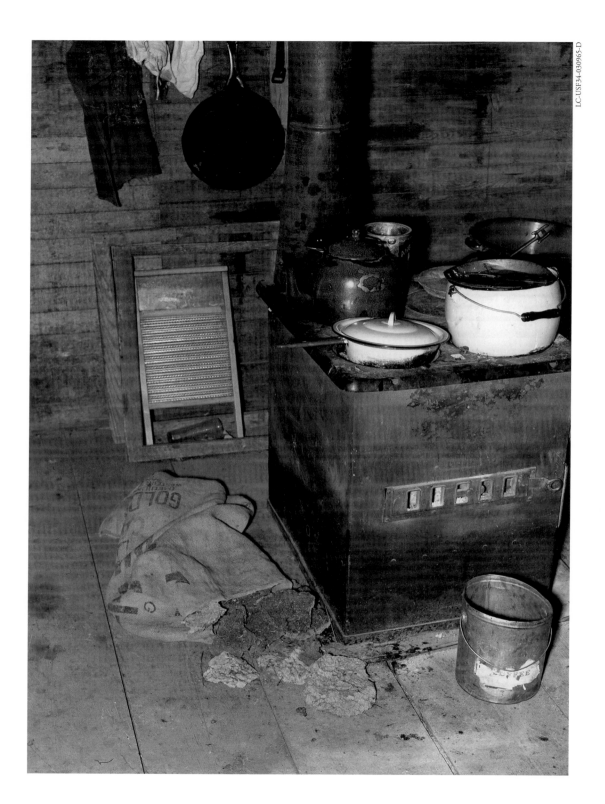

Other Montanans wrote to the governor offering schemes to propagate relief. In August 1931 Mrs. L. R. Lang, manager of the Women's Exchange in Wolf Point, suggested asking merchants in every Montana town to put 5 percent of their daily receipts into a "helping" fund, from which farmers could borrow.[56] A. W. Ricker, editor of the *Farmers Union Herald* in St. Paul, Minnesota, informed Erickson that the Farmers Union, which had twelve thousand members in Montana, was "conducting a census of our individual membership for the purpose of separating those who have some resources with which to help themselves and those who are completely impoverished." The union planned "to assign the counties of Montana to counties here in Minnesota and Wisconsin, and have one county here take care of our membership in one county in Montana. When I say take care, I mean provide food for the family and clothing. We must rely on the various governmental agencies to take care of the livestock, we cannot undertake that job."[57] A report from the Circle Red Cross committee in 1931 stated that the group was trying to feed the hungry but had no funds for clothing. The secretary urged people to "write friends and relatives back home and ask them to send what they can spare." The Red Cross had already shipped more than two hundred freight-car loads of donated food and clothing to the Montana– North Dakota drought area in the month of October.[58] One of the most imaginative ploys for generating relief monies came from Wencil Vanek, living in the hamlet of Brooks in Fergus County. In both 1931 and 1932 Yellowstone National Park offered Montana "surplus" bison from the park herd. The size of the herd was fixed at one thousand head, based on the amount of hay available for winter feeding. Some of the excess animals were sent to zoos, but the remaining surplus could be slaughtered for meat for the unemployed. The Park tendered Montana fifty bison. Vanek inquired as to the disposition of the bison heads. As a taxidermist, he proposed to mount the heads for nominal cost and sell them to "monied men from the east," turning over the proceeds to the Red Cross.[59]

Russell Lee • Kitchen stove, Sheridan County, November 1937. Another of Lee's revealing interior photographs, this one highlights a family's kitchen stove, the sack full of cow dung used as fuel, battered pots, and a washboard—a collection of objects that speaks eloquently of poverty and hard work.

LC-USF34-027688-D

Arthur Rothstein • **Tromping a bag of wool in a sheep-shearing pen, Rosebud County, June 1939.** A wool tromper sews up the top of a jute sack full of three to four hundred pounds of fleece that he has "tromped" with his feet into the bag. The Milwaukee and Northern Pacific railroads shipped millions of pounds of wool out of Rosebud County.

Despite people's determination, hard work, and creativity, by 1932 local resources had been consumed. In August 1932 a citizens' emergency relief committee in Cascade County was caring for over a thousand families. In that same month other communities began petitioning Governor Erickson to facilitate federal relief, as both the coffers of the Red Cross and local charities were depleted.[60] Also that month M. L. Wilson, after a long conversation with the state Red Cross director of relief, reported to the governor that he doubted the national organization would return to the state to render assistance. He believed that if the Red Cross did resume operations, it would expect that the contribution with which it would work would have to come from Montana.[61] But Montanans had nothing left to give.

It was only in these dire straits that people turned to the government, and they did not ask for charity, but for work. "I am taking the liberty of writing you to see if there is anything you can possible do for the unemployed people of Sanders County," penned John Hauge, a grocer who had already extended more than three thousand dollars of credit to his community and could no longer pay his own bills. "Work is what they want not dole. The world owes no man a living, but it certainly owes all of its people a chance to make a living." Hauge called upon the governor to exercise state power, the kind of power wielded in wartime, "for it certainly ought to be more important to raise money to save life then destroy it."[62]

On November 11, 1932, wheat farmer James Bennett recorded in his diary, "Democratic landslide in Valley Co. as well as in the nation."[63] Montanans had helped propel Franklin D. Roosevelt into the presidency. They also sent a full complement of Democrats to the United States

House and Senate. Republicans retained a majority in the Montana senate and held onto the office of state superintendent of public instruction; otherwise every elected statewide office became Democratic. In 1934 Democrats would take the Montana senate as well as the house.[64]

Even people who did not like FDR felt an upsurge of optimism with his election. John Harrison recalled that his father disliked Roosevelt

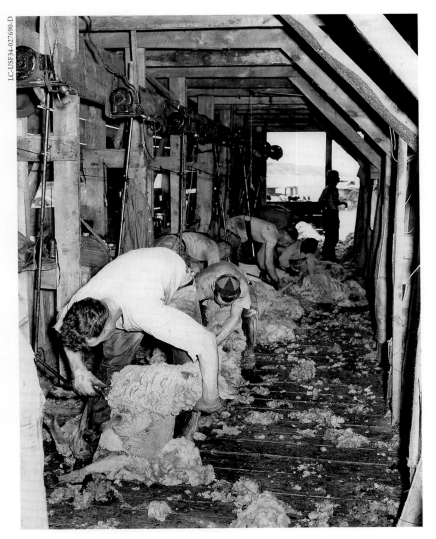

LC-USF34-027690-D

Arthur Rothstein • Shearing sheep, Rosebud County, June 1939. Crews of sheepshearers traveled throughout the West, wielding their shears in the sheds of the region's woolgrowers. These sheepshearers are using electric cutters that had become common by the early 1910s. One worker uses a belt to brace himself during the grueling day bent over grasping sheep and shears.

John Vachon • The New Deal Cash Grocery, Judith Gap, March 1942. Montanans demonstrated their support for the New Deal and Democratic politicians by naming businesses and even towns in their honor. Butte had the New Deal Bar, and some Fort Peck Dam workers lived in the hamlets of New Deal and Wheeler, the latter named for Montana's influential senator, Burton K. Wheeler.

"with a passion," but he acknowledged that "when you listened to Franklin D., you were listening to *hope*."[65] Roosevelt's political skill led people to identify him as the personal architect of the New Deal edifice. His stamp of approval was enough to give people confidence. When nineteen-year-old Herbert Jacobson heard Roosevelt describe the Civilian Conservation Corps in a fireside chat, he went to the courthouse in Sidney and signed up; later he went to work on the Fort Peck Dam because it paid more. He recalled, "Fort Peck and the CCC camp was a life saver for an awful lot of young boys like me." Doris Gribble's husband considered FDR "great because he had provided work. . . . He was the one that started that Work Project Administration." The Morrow family, several of whom worked on the Fort Peck Dam, "thought that Roosevelt was a regular god because he really saved the day for all of us."[66]

Walter Aitken wrote to the president from Bozeman, "the 'forgotten man' feels that you remember him."[67] In turn, people did what they could for the president. Beginning in 1934 communities across the country held fund-raising birthday balls in honor of Roosevelt. The money was for the treatment of crippled children, a portion sent to the Warm Springs Foundation in Georgia, the rest for local use. By 1937 over fifty Montana communities joined in Roosevelt's birthday celebration.[68] Citizens also repaid Roosevelt's efforts with political allegiance. David Gregg, a laborer

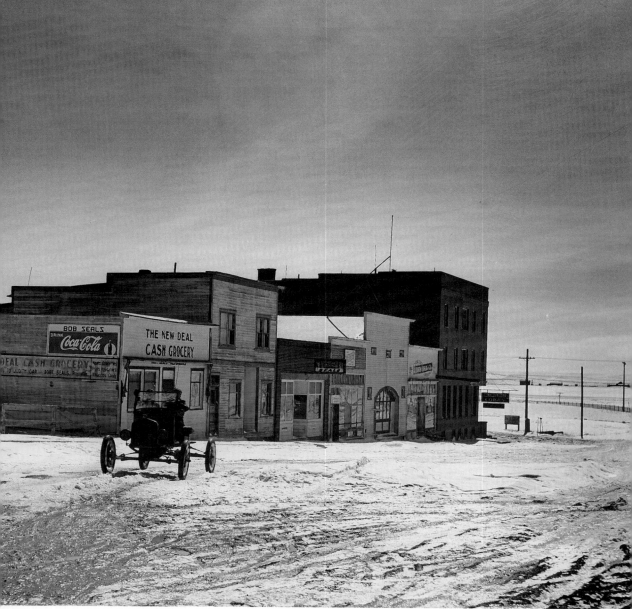

reflecting on the impact of the Fort Peck Dam, summed up, "I think it made a lot of Democrats out of a lot of Republicans."[69]

Federal work programs came to Montana "in the nick of time" in October 1933.[70] Uncle Sam dipped his toe in the waters of work relief with the Civil Works Administration (CWA); hastily organized, it put twenty thousand Montanans to work within three months. But review disclosed that not all workers were actually in need, and many in need did not obtain the work intended for them.[71] The Federal Emergency Relief

Administration (FERA) supplanted the CWA. It initially supplied direct relief, later supplemented with work. At one point during the FERA's tenure, nearly one-fourth of all Montanans received some kind of assistance. By far the largest work relief program and the one that in many people's minds came to stand for the New Deal was the Works Progress Administration (WPA), launched in July 1935 to create jobs for the unemployed on useful public projects. On July 1, 1939, the agency became part of the newly created Federal Works Agency and was renamed the Work Projects Administration.[72] Designed to give work to "breadwinners," the WPA employed nearly twenty-one thousand Montana men and women by September 1936, the peak of New Deal employment in the state.[73]

For each WPA project the federal government provided money for labor and required a local sponsor to match that contribution in funds or equipment; those were often in short supply, especially in the early days of the program. Consequently, as one report noted, "many projects were carried out which were of necessity of temporary value" because there was no money for supplies or equipment.[74] The chorus of criticism that followed the WPA, castigating "leaf-rakers" and men who propped up shovels and hoes, was perhaps sparked by these initial projects. As more sponsors lined up, the quality of projects improved. Eva MacLean, who entered the relief office for the first time "outwardly defiant but with inward self-loathing," was very suspicious of the efficacy of work programs. However, when she became the cook at a dormitory built and run by the WPA so that rural children could attend school in town, she changed her mind. The project allowed children to stay in school, eased the financial burdens of their families, and gave MacLean pride in her own labor. At the end of the school year, she untied her apron "with a sense of achievement."[75] Joe Medicine Crow also remembered that Roosevelt "kind of artificially created jobs here and there." But there were benefits for the Crow people. "Up to that time there were no jobs for Indians here . . . the Crows found work, employment from the government, maybe only $30 a month. Dollar a day. But they are making money. Something new." Even more valuable were the skills Indians acquired "doing this and that government program. . . . They learned to become professionals in carpentry and heavy equipment operating."[76]

The WPA eventually built or renovated many long-lasting structures

on the Montana landscape, including schools, roads, bridges, dams, stadiums, parks, swimming pools, tennis courts, fairgrounds, golf courses, water and sewage systems, airports, fish hatcheries, fences, sidewalks, and curbs. While the overwhelming majority of WPA construction was on public facilities, perhaps the most appreciated edifices were the eight thousand privies built on farms and ranches across the state as part of the WPA sanitation project.[77] Montana roads were in grave need of the services of

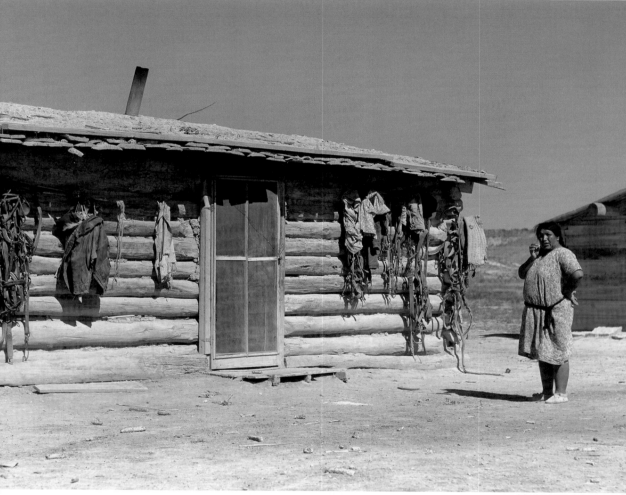

Marion Post Wolcott • Cheyenne Indian's home, Vicinity of Lame Deer, August 1941. A woman in a cotton print dress and moccasins stands outside her government-built cabin on the Northern Cheyenne Indian Reservation. A variety of tack and clothing hang off the log structure. Wolcott took a few pictures in Lame Deer, likely on her way to photograph the Ashland rodeo.

WPA crews, and more work hours were spent on road building than on any other WPA project.[78] Joseph Conway, a seasoned world traveler, claimed the roads he traversed in Montana were worse than anything he experienced in Egypt, Portugal, or India. Complaining that he and his traveling companions had been confined to bed to recover from injuries sustained driving through the state, Conway informed the governor:

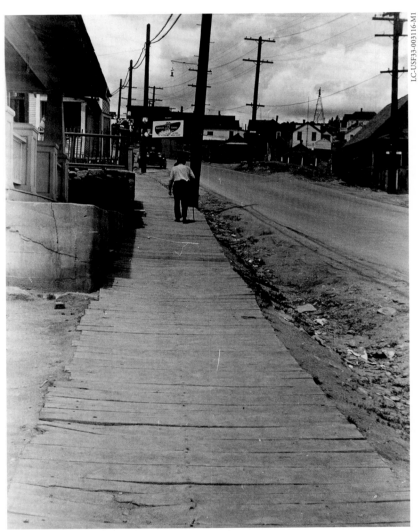

Arthur Rothstein • Board sidewalk on Main Street, Butte, June 1939. The man with his cane making his way up the worn plank sidewalk next to the refuse-filled gutter of North Main Street highlighted the need for improved infrastructure in Butte, much of which was accomplished by the WPA. As one resident recalled, the WPA "finally got Butte out of the mud and gave us decent streets."

"This is my first visit to Montana—needless to say, it will be my last. I hope for the sake of those who must live here, that things will be better."[79] Thanks to the WPA, 7,239 miles of roads were built or improved by 1940.[80]

The WPA engaged in more than construction. "Professional" projects hired men and women to catalog library books, inventory government records, conduct archaeological excavations, kill predators, do clerical work, provide dental and medical exams, and administer vaccinations. Under the Federal Writers' Project, writers penned thousands of pages, and the artists employed by the Federal Art Project created 267 pictures, posters, and miscellaneous pieces of art. Women in WPA sewing rooms manufactured over eight hundred thousand garments, rugs, and household articles for relief clients. Lunch programs served nearly one hundred thousand meals to school children. Government-sponsored gardens produced tons of food, much of which workers preserved in WPA-run canneries. Workers cut firewood, mended shoes, and refurbished toys. Thousands enrolled in WPA education programs or played in WPA recreation centers.[81]

While the WPA was the best-known work project, another ten thousand people toiled under the auspices of a plethora of new and old federal agencies: the Public Works Administration (PWA), Resettlement Administration (RA), Farm Security Administration (FSA), National Youth Administration (NYA), United States Forest Service (USFS), Civilian Conservation Corps (CCC), Soil Conservation Service (SCS), National Park Service (NPS), Bureau of Public Roads, Biological Survey, Department of Entomology and Plant Quarantine, and the War Department. Between 1933 and 1939 Montana received more than $530 million in federal grants and loans, or $986 for each resident, ranking second only to Nevada in per capita expenditures nationwide.[82]

Depression relief began under state regulations. In 1933 a special legislative session organized the Montana State Relief Commission, which was revamped into the Montana State Board of Public Welfare in 1935. Regardless of the nature of the New Deal program, local boards of county welfare determined individuals' eligibility for relief. In many counties the welfare boards were the county commissioners. This system certainly guaranteed local control over the distribution of resources, but it could also lead to favoritism, nepotism, cronyism, and outright abuse.[83] As one

woman from eastern Montana recalled, "Jobs distributed according to need rather than according to pull was an ideal scarcely understandable to the average local ring which was invariably put in charge."[84] Another man complained to Governor Erickson that the chairman of relief work in his county gave jobs only to people who owed him money.[85]

It was no secret that the WPA was an enormous patronage program. According to historian David Kennedy, Franklin D. Roosevelt shamelessly used the program to secure political alliances, not always with Democrats.[86] In Montana the first director of the WPA was Ray Hart, a Republican and friend of Senator Burton K. Wheeler. According to

John Vachon • Saturday afternoon in Kalispell, March 1942. Vachon spent a Saturday afternoon walking up and down Kalispell's Main Street "looking for pictures." A young man with "glasses, new green suit and hat, awfully clean shirt and appropriate tie whizzed by me on a brand new bicycle . . . he is a sign of the times."

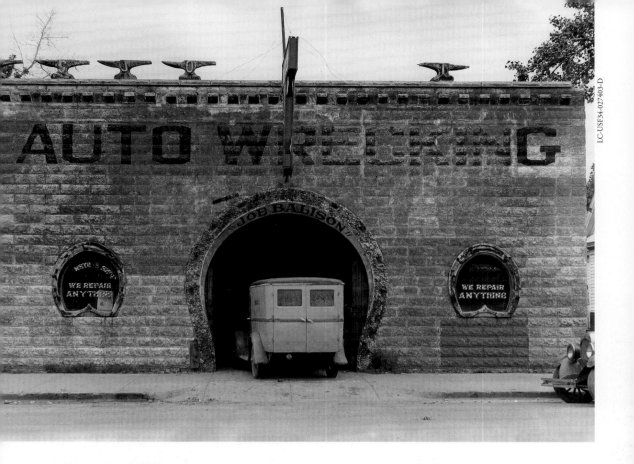

Arthur Rothstein • Blacksmith shop now used as an auto repair shop, Glendive, June 1939. The photographers were always on the lookout for engaging and quirky signs that reflected American culture. The horseshoe door and windows and row of cast concrete rooftop anvils on this wonderfully whimsical blacksmith shop, which had made the transition to automobile care, would have been irresistible.

Senator James E. Murray, Hart thought the best way to implement the "non-partisan" character of the program was to appoint only Republicans to the top positions, arguing that there were no Democrats with proper qualifications. Murray intervened and had a Democrat, Joseph Parker, replace Hart, but the administration insisted that Parker not fire any administrative officials already in office.[87] Watching the results of years of this political laddering, L. W. Fenske, a resident of Savage, south of Sidney, wrote irately to Murray that "surely our Montana grants are being completely dominated by powerful, subversive Republicans. . . . These same Republicans while milking the top Democratic jobs bone dry, stand along the Main Street curbs and loudly denounce the terribly wasteful

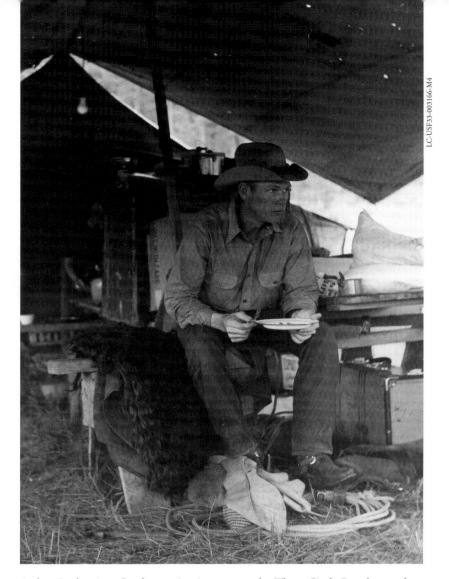

Arthur Rothstein • Cowboy eating in camp at the Three Circle Ranch roundup, Custer National Forest, Powder River County, June 1939. Men worked hard on a roundup, and food was important, including the ritual of eating prairie oysters, or calf fries. An old cowhand told a WPA worker collecting Montana stories that "it may have been my youth or the long hours we worked, from sunup to sunset, which caused me to be continuously hungry, but in between meals, man oh man, were those calf fries good."

Democratic spending."[88] Murray was well aware of the situation. Writing to Colonel F. C. Harrington, a WPA administrator in Washington, D.C., Murray noted, "Some of these counties in Montana are strongly Republican and the Republicans being in the majority get the majority of the jobs and, of course, when the Republicans are at the head of the set up

they probably only give consideration to Republicans."[89] Murray was a great supporter of the WPA, but he was also concerned about the "terrible jealousy and bitterness" that the program sparked: "Every Democrat who has an inferior job is green-eyed with jealousy and bitterness toward the Republicans he sees occupying the soft jobs, the same situation occurs, of course, when the reverse is true. I hear some of the Senators around here claiming that the WPA is a liability instead of an asset to the Party and I am inclined to feel that this is true."[90]

Journalist Edna Mae St. Claire obtained a WPA job writing publicity for the New Deal; partisan politics directly affected her work. She submitted her stories to the *Lewistown (Mont.) Democrat*, which published them with little editing. "I always used 'WPA' as many times as I possibly could. Everything was WPA. . . . The civic center had been built with WPA money. The post office had been built with WPA money. The fish hatchery had been built with WPA money. . . . They had a woman that was going around teaching crippled children. Her salary was paid with WPA." Then St. Claire got a promotion and transferred to Billings, but the *Billings Tribune* was a Republican paper, "so they didn't like all the WPAs. I would write the article about a project, an archeological project that was going on . . . and they would write it up as I turned it in, but they would leave out that it was a WPA project."[91]

Patronage and politics aside, the welter of regulations and the inexperience of people assigned as caseworkers occasionally led to confusion and the misdirection of goods and services. While most counties had some kind of preexisting welfare committee or poor relief system, none of them were prepared to take on the volume of paperwork and cash and commodity distribution that the New Deal programs spawned. Elmer Linebarger, a WPA commodity clerk in Garfield County, dealt with a farrago of demands and complaints as well as new rules for administering relief. At one point a caseworker instructed him to remove a woman from the list of commodity recipients, as she "has cattle, is getting transportation from the school district, and . . . recently invested in a new car."[92] Sometimes shortages of professional workers held up the allocation process. According to regulations, only people certified eligible by a Department of Public Welfare caseworker could receive commodities and only the amount and kind designated by the caseworker. In some

counties caseworkers managed anywhere from three hundred to a thousand cases per month.[93] Garfield County had no caseworkers, and the job of determining eligibility devolved to the commodities clerks, who ended up giving everyone the same amount of goods no matter their eligibility.[94] In other counties caseworkers were WPA workers subject to periodic layoffs. When they were dismissed, no one could certify other workers in need of jobs. For example, in Judith Basin County the caseworker was laid off and the county had no certification forms, so the entire process ground to a halt while men came to the office each day looking for work, and a soil conservation project waited for sixty laborers.[95] In November 1935 Butte had men and projects, but no winter clothing, and relief administrators felt it was "inhuman" to ask the men to work outside so ill-clothed.[96]

Arthur Rothstein • Finnish steam bath, Butte, June 1939. Many Finnish miners lived on Butte's East Side and patronized commercial steam baths, such as this one located in the back of the Broadway Bar (later the Helsinki Bar), which used its smokestack as a billboard.

Notwithstanding the politics, confusion, and complaints, most Montanans who participated in New Deal programs were pleased to have the work and felt they accomplished something worthwhile. For many the most difficult part of the process was acknowledging that they needed help and then dealing with the stigma of going on relief. Donald Morrow went to the courthouse to apply for the WPA, but the applications clerk was a girl with whom he had gone to school, and he was too embarrassed to approach her. His wife finally talked him into going back. Jean Stanley's father worked on a WPA dam and her mother in a WPA sewing room, but they would not accept commodities: "We just took money for the work we put out and that was it."[97]

Applying for relief was not necessarily the end of embarrassment. Julia Trees, for example, recalled the mortification her mother and other

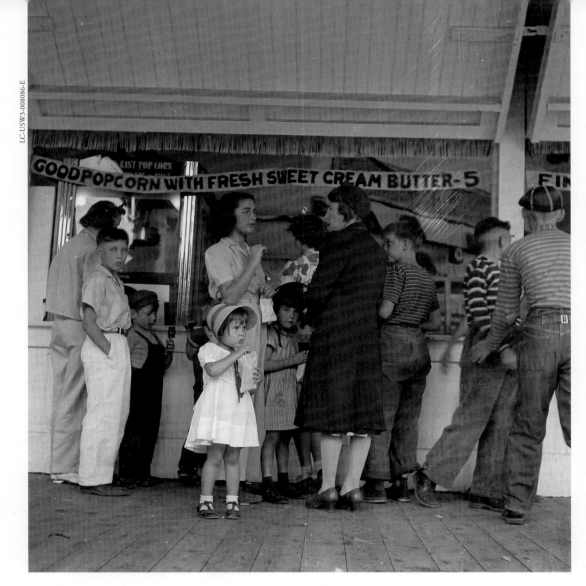

Russell Lee • Columbia Gardens, Butte, August 1942. The Columbia Gardens amusement park was long a favorite pleasure spot for Butte residents. Lee noted that when he visited Butte in 1942 city buses provided free transportation to children every Thursday during the summer, just as streetcars had done decades earlier.

women experienced while employed on a WPA sewing project because they were required to wear uniforms. Her mother had taught school, worked as school clerk, and later—during and after World War II—ran the county newspaper. She was, as her daughter recounted, "a very, very capable person." Yet the "awful shapeless dresses, all alike, . . . proclaiming to the whole town each day that they were on the welfare projects" undermined her self-esteem and her public image of capability. "They

were good sewers and made nice clothing and flannel sleep wear for distribution to needy people," Trees continued. "They didn't mind the eight hour days bent over a machine but never should they have been singled out in this way with uniforms."[98]

Despite her qualms about WPA women's uniforms, Julia Trees believed strongly in the New Deal. A National Youth Administration (NYA) clerical job helped her finish high school, and when she began teaching, she wore WPA dresses and slept under WPA wool and cotton quilts. To her the WPA was a "needed," "wonderful" program. Trees knew several widows who were able to support their children through WPA work, and in retrospect she thought that "my dad should have gone to work for the WPA and it would have been easier for us to have . . . eyeglasses and things like that."[99] Workers for whom life close to the bone was a normal condition saw people on relief receive goods usually considered luxuries. Claribel Bonine, teaching in a country school, recalled the children of two families on relief bringing oranges in their lunch. "People had oranges only at Christmas time," she remembered, "and they would give them new Mackinaw coats, mittens, caps and overshoes . . . the government did that."[100] Eyeglasses, oranges, new mittens— hardly extravagances, yet beyond the reach of so many. New Deal programs introduced standards of everyday life that were revelatory to many Americans. Jane Phelps also had an NYA job and graduated from high school in 1937, but it was not only Jane who benefited from the program. The previous Christmas Jane had given her younger sister Elizabeth a pair of snow pants to wear on her long walk to school; she paid for them with five dollars she had saved from working for the NYA. Elizabeth remembered Jane's gift as "really a wonderful thing."[101]

In addition to providing much-needed income, work relief programs could sometimes change workers' lives, occasionally in unexpectedly complex ways. Eva MacLean once penned a poem titled "Ranch House Blues":

> *One day ends the same as another*
> *And begins again in the same old way*
> *Ambitions and aims are but born to smother*
> *And I just mark time for another day.*

Oh Life! Is this all you have to offer
In pay for the best that I have to give?
Do you hold naught for me in your coffer
But to just mark time when I want to live?[102]

For a time the New Deal lifted MacLean's blues. Cooking for the WPA dormitory in Glendive gave her satisfaction, then a supervisory position in the WPA Recreation Division proffered "a chance to build a career and launch a new social service, a challenge to ambition, capability, aggression, vision—oh everything." She relished the opportunity to help her family, "to release my husband from common labor, to educate my boys, . . . to dress them and us all well." What she did not foresee was her husband's increasing resentment of her professional success, a situation that eventually led her to conclude, "I must either give up my 'career' or my family . . . no earthly power could reconcile the two." Eva MacLean resigned her job and moved with her husband to Washington where she had time "to approach the artistry of homemaking." When the county planning board in her new community sought her advice about hiring a home demonstration agent, she was reluctant to attend the meeting. "I am a bit afraid to even skirt the public life, like any burned child."[103]

The New Deal smorgasbord of programs tried to meet the needs of millions of Americans in wildly different settings, some more readily accommodated than others. For instance, it was much easier to design work programs in Montana cities than in rural counties where projects were less viable, equipment scarcer, and extravagant distances made it difficult to gather work crews.[104] Yet farmers were desperate for work. In 1937 the Northern Valley County Drouth Committee meeting in Opheim sent a petition to President Roosevelt, Secretary of Agriculture Henry Wallace, WPA director Harry Hopkins, and the Montana congressional delegation asking for work. Over four hundred farmers attended the meeting and approved the petition, which declared that "the majority of those living in the drouth area have been here over twenty years, they do not want to leave their established homes, many could not do so if they wanted to, they have no place to go, many of the drouth victims are men over fifty-five years of age and physically disabled." The committee requested that the WPA or some other agency set up a works program for

Arthur Rothstein • Copper miner's home, Butte, June 1939. The headframe of the Neversweat Mine looms above workers' houses in Finntown. Rothstein suggests the inseparability of work and home life in this photo.

sparsely populated areas, perhaps building small reservoirs in order to irrigate garden tracts so families could raise vegetables for themselves and feed for their stock.[105] Farmers in Phillips and Richland counties echoed the committee's request. Noting that "this calamity of drought may be nobodys fault, but it is our misfortune," they solicited "a work relief program where they can feel that they have earned their bread by honest labor," since they had "lost all but our selfrespect."[106] In Dagmar three hundred farmers met to "insist that the Government take immediate steps to provide work for the farmers."[107] Heeding their calls and overcoming the difficulties inherent in running rural projects, the WPA hired more than twelve thousand farmers in 1936.[108]

Other farmers came to the painful decision that no amount of assistance would allow them to make a living on the lands they presently occupied, and they petitioned the government to initiate a resettlement project. Resettlement projects, one of the New Deal's more radical ideas, combined two goals: to give farmers a leg up by moving them to more productive lands and to conserve land by converting acreage used inappropriately for farming to timber or grazing reserves. First implemented by the Resettlement Administration and then by the Farm Security Administration, the program relocated over ten thousand families nationwide before it was dissolved in 1945.[109]

In Montana many farmers welcomed the resettlement project with open arms, glad of the chance to leave their dried-out farms and begin

anew somewhere else, somewhere with more water. In August 1936 Warner Just sent a petition signed by 817 people, 90 percent of the resident landowners of Garfield County, to Senator James Murray. The petition asked the federal government to initiate a submarginal land buying program in the county, so they could sell out. Just stated that they "all realize that there is no future in this County, that [it] is a submarginal land area, never intended for farming. We have been able to produce only one

LC-USF34-027278-D

Arthur Rothstein • Model farm unit, Fairfield Bench Farms, May 1939. Chickens forage in the yard of a model FSA farm at Fairfield. Rothstein's photograph shows the new farmhouse, barn, and combined garage and tool house that the project provided to each new settler. The power pole carefully framing the right side of the picture indicates that the farm houses were electrified, and the antenna on the roof reveals the family had a radio.

crop in the last eight years. The last four years, due to drought and grasshoppers, have forced nearly every farmer and rancher out of business. There is very little live stock left in Garfield County. Many people will even be forced to sell their work horses, milk cows, and chickens, as we have no feed or grass, and the cost of feed is prohibitive. The ranchers who were fortunate enough to have a little money left, after selling their live stock, have moved out. They plan on letting their land go for taxes. The County has already taken title to over one quarter million acres." Garfield County had no railroad, and with no rain for gardens everything had to be purchased and trucked in at great expense. Asking the government to

buy them out was not a decision these farmers made lightly: "Many of us have put in the best years of our life out here; we know what hardship, privation and hard work means. We realize that we must start over some where else, as we have lost faith and confidence in this part of the country. It isn't easy for us to give up our homes and admit defeat but we must admit that we are done. . . . There is no future on the relief rolls. . . . Giving us the chance to move out, and the opportunity to become self-supporting citizens is the real solution to the drought problem in Garfield County."[110] In other places ranchers saw in the resettlement program the prospect of reclaiming grazing land from farmers. In Custer County thirty-two ranchers petitioned the government to facilitate resettlement of nearby farmers, turn their lands into a grazing district, and "enable stock-men to mature plans for the rehabilitation of the livestock business."[111]

Fairfield Bench Farms was a resettlement project created when the federal government purchased approximately thirteen thousand acres of irrigated land in Teton and Choteau counties on which to relocate dry-land farmers whose "submarginal" lands had been purchased by the govern-ment in order to take them out of agricultural production. Administrative work on the Fairfield Bench project began in 1934, and construction was completed in 1938. The FSA divided the land into 129 farms, averaging 98 acres. Each had a house, either new or refurbished, and a variety of outbuildings, including barns, poultry sheds, privies, and combined garage-tool sheds. All the houses had central heating, a kitchen sink, and electricity. A new community center housed a school, a library, meeting rooms, and administrative offices. The Cooperative Health Association hired a doctor and a dentist. The Greenfields Cooperative Sire and Mar-keting Association fostered livestock production. There was also a co-op milk testing association and a co-op oil station. The settlers were drawn from a pool of dryland farmers in Prairie, Musselshell, and Petroleum counties and included a large number of Germans from Russia and their descendants.[112] Initially settlers rented their farms from the government. The modern facilities and cooperative associations were designed to improve their chances of financial success so that they would eventually be able to purchase their farms.

The town of Fairfield, twenty-seven miles northwest of Great Falls, was platted in 1916, a community built on the promise of agricultural

Arthur Rothstein • Farm wife feeding her chickens, Fairfield Bench Farms, May 1939. A few months before Rothstein's visit to Fairfield Bench Farms, the local newspaper reported that the resettlement project had built close to 150 chicken brooder houses and ordered "an astounding number of baby chicks." Egg and butter money, generated by women's labor, often provided the only steady source of cash on many American farms.

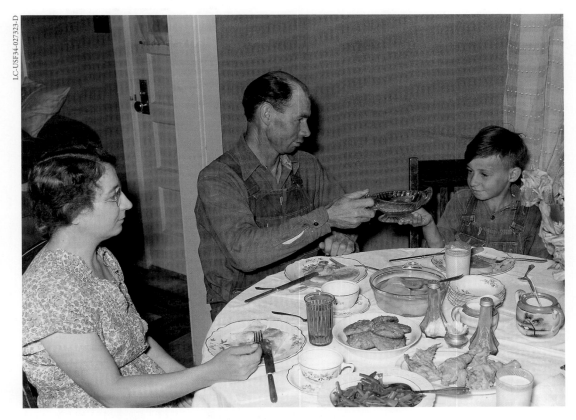

Arthur Rothstein • Farm family at dinner, Fairfield Bench Farms, May 1939. One of the chickens fed in the previous photo may well be the centerpiece of this dinner. The FSA encouraged subsistence agriculture, and the products of this family's labor are evident on the supper table, adorned with a vase of irises and laden with fried chicken, vegetables, and canned fruit.

plenty watered by the Sun River Irrigation Project and shipped on the Milwaukee railroad. By the mid-1930s, when the resettlement project began, the area was well acquainted with government-sponsored agriculture projects. As the *Choteau (Mont.) Acantha* boasted in 1916: "Uncle Sam has almost outdone mother nature in preparing a rosy future for Fairfield. He has sent his reclamation men to put water on the fertile acres that Nature placed on the Greenfield's bench."[113] Fairfield welcomed the resettlement project; everyone from the Teton and Cascade county commissioners to the local school superintendents endorsed it. The local newspaper reported each stage of the project's development, even including the social activities of resettlement officials in a regular "Resettlement

Notes" column. The project generated business for the town, which grew significantly with the influx of settlers.[114]

However, the relocatees' experience was mixed. A survey of several resettlement projects conducted in 1941 pointed to problems in economy of scale and in management at Fairfield. The project had been planned for horse-drawn equipment, which proved impracticable, but the farms were too small for cost-efficient use of tractors. Heavy-handed paternalism on the part of supervisors was another problem. The attitude was patently obvious in a promotional pamphlet the managers issued, in which they proclaimed: "The dry land farmer is a gambler. The irrigation farmer is a builder of a home and a farm. This being generally true, it has been the task of project officials to make builders out of dry landers by

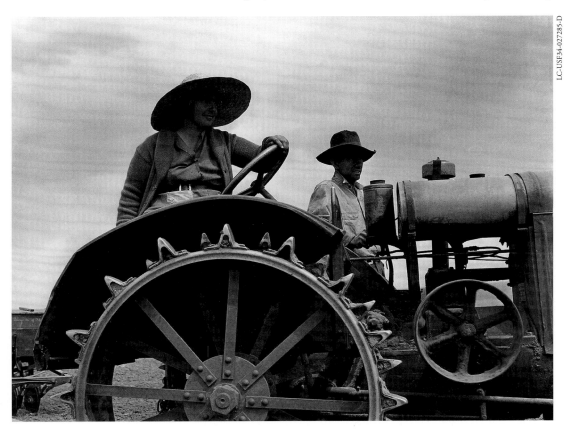

Arthur Rothstein • A farm couple and their International Harvester tractor, Fairfield Bench Farms, May 1939. Agriculture on the irrigated farms at Fairfield was more labor intensive than on the dryland farms of eastern Montana, and women found themselves more actively involved in fieldwork.

education and example."[115] Outright hostility came to characterize the relationship between managers and farmers, who organized the Resettlers Adjustment Association to negotiate with the FSA. When that proved unsatisfactory they took their grievances to the Montana Farmers Union and Senator Burton K. Wheeler, both of whom intervened with FSA officials.[116]

Perhaps most difficult was the transition from dryland to irrigated farming. Very few of the relocatees who came to Fairfield Bench had any experience with irrigation. Upon his first view of a moveable canvas dam, one newcomer to Fairfield mistook it for a grasshopper trap. Farmers had to raise unfamiliar crops with unfamiliar methods, in a vastly more labor-intensive environment that led one woman to describe herself as "an irrigation slave."[117] The difficulties relocatees faced at Fairfield moved many families to leave. However, 48.4 percent of the original settlers did successfully purchase their farms.[118]

The New Deal dispersed less equivocal opportunities for others, especially men working on the Fort Peck Dam. Fifty thousand people constructed the dam between 1933 and 1940; it was the single largest public works project in Montana and attracted people from all over the country.[119] Melvin Hanson, only seventeen and away from home for the first time, grew up "pretty fast" working on the dam. He credited the experience with giving him the work habits he embraced over a lifetime. William Fly was also "green as grass" when he arrived at Fort Peck in 1934. In his years on the dam he steadily climbed the civil service ladder and came to feel that he was not on a project that was "just putting people to work, but you were accomplishing something big." Working on the dam "made a rolling stone" out of Owen Williams, who grew up in Custer, Montana. After Fort Peck he decided he wanted to see more of the world, and went to work on several other dams, traveling widely. James Wiseman, raised on a cattle ranch in Garfield County, never went back to ranching. He learned to be an electrician on the dam: "It changed me from a small farmer/rancher to a worker." The project also altered people's attitudes toward the federal government. Bill Whisenhand, who ran a pool hall in the construction boomtown of New Deal, witnessed the optimism the dam generated. Fort Peck "was one of the things that really gave the people more, should I say, courage to go on and insight in our

government to feel as though maybe they're doing something for us, maybe everything's going to work out."[120]

Workers' attitudes toward government work and relief were muddled. The initial mixture of embarrassment and gratitude frequently gave way to an appropriation and tailoring of the program—a process in which workers applied their local knowledge to government designs in order to make them work and to make them their own. Sometimes this meant contravening the program guidelines in order to better serve the community. Red Killen worked on an AAA project to slaughter nonmarketable sheep. He agreed with the blueprint of the program: to get "old ewes" off the market and off the range. Workers were supposed to turn in the pelts and destroy the meat. Yet when Red and his fellow workers had "some dry ewes that would be in pretty good shape," they ignored the rules, risked being fined, butchered carefully, and gave the meat to local people.[121] Wallace Lockie had a similar experience. Supervising federal seed loans, he visited a family near Ingomar. The husband was running a grain drill in one of his fields but asked Lockie to go back over the hill until he was finished, saying, "'I don't want you to look at this.'" Lockie complied, realizing that what "he was doing was just making tracks in the ground. He had ate the wheat 'cause the wheat ain't going to grow anyway. I put it in that he had planted the wheat, you know, because there was a lot of people did that. There was something to eat, and that's what they lived on."[122]

Juggling federal rules and on-the-spot judgments is a pattern that runs through the memories of many people who lived with the New Deal. On the Fort Peck Dam workers learned all kinds of new skills, but they also brought with them accomplished craftsmanship that allowed them to refine tools, tailor work processes, make improvements, and claim ownership in that gigantic endeavor. Relief workers also reasserted their autonomy and reclaimed their dignity by pointing out the absurdity of some government projects. Nicknames for the WPA, such as "we poke along" or "we piddle around," illustrated laborers' recognition of the make-work nature of some of the projects without denigrating the skills they might have employed on them. David Rivenes worked as a drafts-man for a rural WPA recreation center in Prairie County. It had tennis courts, a softball diamond, dance hall, stage, kitchen, and showers, every-thing a community could enjoy. The only problem was that all the nearby

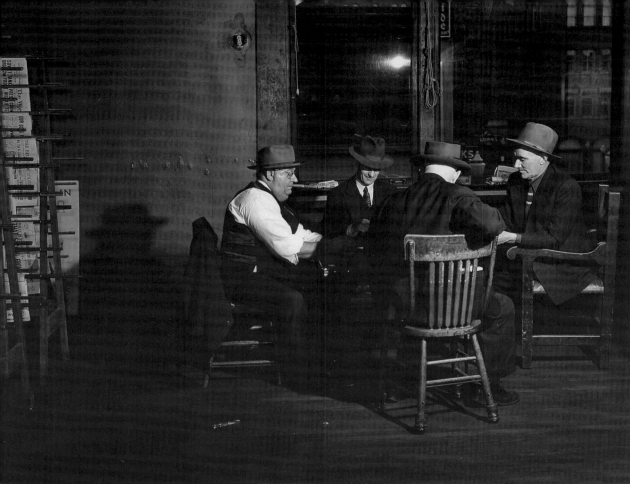

Russell Lee • Playing cards in the Miners' Union Hall, Butte, October 1942. Lee took an extensive set of photographs of activities at the Miners' Union Hall, which included socializing as well as official business, such as meetings and getting out the union newspaper.

residents had been moved by the Resettlement Administration to more productive lands, so that by the time the center was completed, scarcely anyone was there to use it.[123]

While New Deal projects brought cash and jobs into the state, no bureaucracy could change the climate, and drought continued during the Roosevelt years. The dessication that led to hunger and hard times was marked in people's memories by the two most unforgettable environmental events of the 1930s, dust storms and insect invasions. Dust storms earned the decade the moniker "the dirty thirties," and they were most common in the southern plains. But the most famous "black blizzard" originated in Montana and Wyoming. On May 9, 1934, a windstorm blew

tons of topsoil from Montana and Wyoming to the east, picking up more dust in the Dakotas until the air was saturated with 350 tons of dirt. That evening Chicagoans experienced dust falling like snow, and two days later dust rained down on Boston, New York, Washington, D.C., and Atlanta. Montana dirt coated the decks of ships three hundred miles off the Atlantic coast a couple of days later.[124] In 1937 a storm blasted the state with winds measuring seventy-six miles per hour in Billings, covered the Great Falls area with an inch of dust, and buried railroad tracks under a foot of displaced soil. One newspaper noted, "we have still to find an old-timer who has ever seen its equal."[125] When Rose Maltese visited her father after one such dust storm, he dragged her out to the east fence to show her the structure of six-foot poles and four strands of barbed wire submerged in dust.[126] Yet while dust storms remain vivid in people's memories, it is grasshoppers and Mormon crickets that evoke their most visceral descriptions.

Grasshoppers had periodically invaded the plains for decades, but no one could remember swarms like the ones that descended on eastern Montana in the 1930s. When journalist Ernie Pyle traveled through Montana in 1936, he found that "the grasshopper opened and closed every conversation."[127] Grasshoppers attacked in two stages. First sweeping the fields for food, they left devastation and then eggs in their wake. A mature, healthy female—well fed on wheat—could lay four to six pods of twenty-eight eggs each. The eggs, deposited about an inch below the surface in loosely cultivated fields, remained dormant until they hatched in the spring at about the same time wheat began to sprout. The fledglings grazed on the new vegetation for the six to eight weeks it took to grow wings, then a new generation began another reproductive cycle.[128]

Another pest that wrought devastation in eastern Montana was the Mormon cricket, which infested Montana and surrounding states between 1936 and 1941. Mormon crickets look like large wingless grasshoppers, and they invade on foot. The insects earned the nickname "Mormon crickets" after a famous incident in 1848 when seagulls swooped into the Great Salt Lake Basin to devour the crickets eating Mormon settlers' crops. Searching for forage in the 1930s, the crickets moved in enormous bands. Entomologist Ely Swisher described armies of crickets that carpeted the ground with "as many as 100 crickets per square yard."

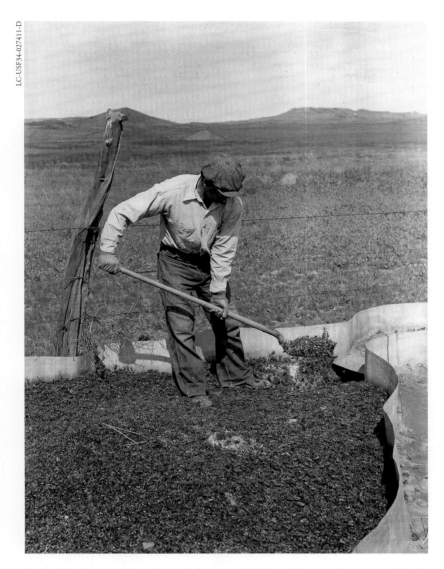

Arthur Rothstein • Cleaning a cricket trap, Big Horn County, June 1939. Hordes of Mormon crickets infested eastern Montana between 1936 and 1941. Farmers defended their crops from the invaders by building metal barriers around grain fields to stop their march and then dusting the insects with poison to kill them.

He recalled posting signs to warn motorists of slippery conditions on Highway 87 south of Billings, where crickets marched across the road for nearly two weeks, fodder for unprecedented road kill.[129]

While each year farmers hoped that spring would bring the return of "good years," the 1930s seemed to deny them at every turn. As the *Circle*

Banner lamented on June 5, 1936: "Here we are with almost a week of June gone and no rain. Many early crops are ruined already for lack of moisture and grass on the range is suffering." The last part of May had been extremely hot with high winds, and then the weather turned cold.

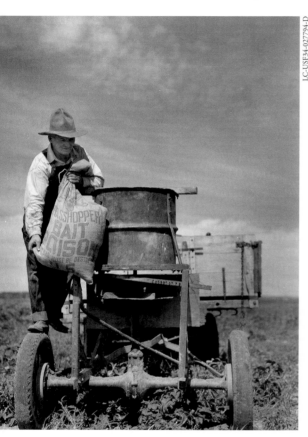

LC-USF34-027794-D

Arthur Rothstein • Farmer loading a spreading device with grasshopper poison, Forsyth, June 1939. Farmers spread a mixture of water, sawdust, arsenic, and amyl acetate, which smelled like bananas and attracted the grasshoppers, over their fields. The bait killed grasshoppers, but the smell was nauseating, and workers had to be careful not to get the mixture on their own bodies.

"To top it all off comes reports for several communities that grasshoppers are hatching out in the millions."[130] Prophetically, many of the stories of grasshopper invasions begin with the insects turning day into night. Russell Evans had heard people "talk before about grasshoppers flying so thick they would cover the sun," but the first time he saw the phenomenon was when he got off his horse to open a gate and heard a strange humming. He looked up and saw a swarm "shut off the sun." Ethel George recalled that clouds of grasshoppers made noon seem like twilight. And when the grasshoppers left, they "took the fields" with them.[131] So little was known about how far or in what pattern grasshoppers could fly that in 1938 entomologists painted 3,500 grasshoppers captured northwest of Sidney with gold paint on the same day that colleagues in North Dakota painted a like number silver. They asked that anyone catching a gilded grasshopper send it the State College in Bozeman, so scientists there could begin to chart their travels.[132]

For settlers familiar with the Old Testament, the plagues of grasshoppers that visited them must have recalled Biblical stories and warnings. Yahweh frequently invoked the curse of locusts on the agricultural people of Israel and Egypt who had ignored his word or become prideful or faithless. "You will cast seed in plenty on the fields but harvest little, for the locust will devour it"; "All your trees and all the produce of your soil will become the prey of insects."[133] When settlers described the sky darkened

by grasshoppers, wings whirring in the air, their imagery might have been shaped by their reading of Revelation, of the locusts that dropped from a darkened sky "like horses armoured for battle," as "the noise of their wings sounded like a great charge of horses and chariots."[134]

Entomologists working with the United States Department of Agriculture (USDA) devised a variety of defenses against the onslaught of grasshoppers and crickets; the ground troops were New Deal employees. To deal with crickets the USDA in conjunction with county extension agents devised a three-pronged attack: "oiling irrigation ditches, building metal barriers with traps, and dusting the insects with a 33 per cent sodium arsenite dust."[135] Workers deployed the oil barriers almost exclusively on irrigated lands south of the Yellowstone River. Crude oil was dribbled onto the water in irrigation ditches and suffocated millions of crickets as they tried to cross. The insects and the oil then had to be skimmed off the ditch before the water could be used. At one point a mound of dead crickets, one hundred feet long and three to five feet deep, accumulated south of Billings, emitting a foul and lingering stench, as the crickets, soaked in oil, resisted decomposition.[136] Agents and farmers also built nearly one hundred miles of small metal fence around crops to divert the crickets, who could not fly over nor crawl up the smooth surface. But crickets could defeat even these traps. "One night," remembered Joe Medicine Crow, "we could hear them coming, crickets off the hill there about a mile away. You could hear 'zzzzzz' as they walked, you know. . . . They tried to stop them by digging trenches clear across the country about that deep and lined with sheet metal so once they get in there, they can't climb out." The trenches trapped thousands of crickets, but when they were filled, the remaining insects simply trod over their brethren. The next morning when people went out to check their gardens they found "their corn, squash, watermelon, the whole bit, just chewed off to the ground. . . . The only thing that was standing is a couple rows of onions."[137] The most widespread weapon was poison. A mixing plant in Billings produced hundreds of tons of sodium arsenite dust that workers spread over infested fields in Montana and Wyoming. Swisher recalled that plant workers were reluctant to wear face masks made of sanitary napkins that the scientists bought at Woolworth's, but working in the dust soon made them overcome any embarrassment.[138]

In 1938 it looked as if the Circle area was finally going to have a good year. Plentiful rain fell in July, and the paper predicted a bumper crop throughout the county, "the first real crop in many years." But a week later devastation hit. On Friday people began noticing grasshoppers appearing in the air, by Sunday and Monday the county was under siege by millions of the insects swarming onto fields and gardens. After stripping the crops, they defoliated the trees. To rescue something from the situation, farmers in advance of the swarm cut their grain fields for feed. People must have wondered what they had done to deserve such a fate, when on that same Monday a hailstorm hit, destroying what crops the grasshoppers had skipped in the Sand Creek, Vida, and Nickwall area. A week later the grasshoppers had moved on, leaving a "pitiful" countryside behind.[139]

Were plains dwellers being punished, like the Egyptians and the Israelites of old? Rebuked for plowing up land that had sustained grazing and hunting cultures for millennia but not large-scale agriculture? Chastised for their arrogance in thinking they could create a new society on the northern grasslands? Perhaps some people thought in retributive terms. Others shared James Womble's sentiment, blaming the federal government for their plight, and, like Anna Schultz, remembering advice they had received many years ago. "I feel, had the Government not put its stamp of approval on these parts as agricultural lands thru the survey and plotting of 'Homestead' land these people, myself included, would never have dreamed of farming here. It is pathetic to recall our experimental 'dry farming.' It is pathetic now to recall the arguments between the Homesteaders and the Ranchers thirty years ago. The Homesteader argued stoutly feeling he was standing securely on the experiments and wisdom of the government. These drouth years have proven the words of the Rancher."[140]

Anna Schultz may have come to the conclusion that eastern Montana was better suited for ranching than farming, but drought had dried up the range as well as crops. When customs collector William Bartley traveled through northern Montana in 1937, he passed through Scobey, where people were staging a mock celebration on the anniversary of their last rain. What else could they do? "Winter wheat had not come up and spring wheat could not be planted. Cattle and horses were chasing themselves to death looking for a little grass and some sheep men were killing

Marion Post Wolcott • Sweat lodge on Cheyenne Reservation, Near Lame Deer, August 1941. Wolcott's photograph of the frame of a sweat lodge juxtaposes old and new on the Northern Cheyenne reservation. While the sweat lodge and bison skull predominate, in the background are a tepee and tent, log cabins, and an automobile.

lambs at birth in an effort to save the primary stock."[141] Drought compounded overgrazing and erosion, and by the end of 1933 the AAA estimated there were from 8 to 10 million cattle alone that the public lands could no longer support.[142] John Vukonich's family, ranching near Joliet, had a neighbor with a hundred head of cattle he could no longer feed once the bank stopped extending credit: "Every one of those cows died." The calamity seared teenage Vukonich's memory: "For years there was those cockeyed piles of bones in all those different coulees and I can always remember those cows bellering because they was starving to death. That still stayed with me." Wallace Lockie, rounding up horses for shipping to a slaughterhouse, remembered the orphan colts he came across:

"I have seen fifteen, twenty colts in the bunch where the mares had already died and they'd come running up to you as you were riding. It was pitiful. It was pitiful." The cowboys shot the colts before they starved to death.[143]

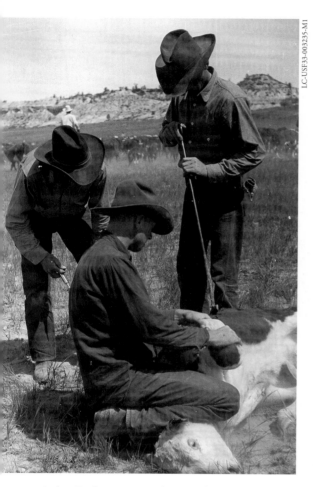

LC-USF33-003235-M1

Arthur Rothstein • **Branding a calf during the round-up, Quarter Circle U Ranch, June 1939.** Stryker sent Rothstein a detailed shooting script for the cattle industry, instructing him to get photographs of, among other things, branding and vaccination and the working clothes of cowboys, all of which came together in this picture.

In 1934 Congress passed the Jones-Connally Farm Relief Act, which provided funds to purchase starving animals. By September 1934 the government had bought two hundred and sixty thousand drought cattle in seventeen eastern Montana counties. Ranchers sold just under half the stock in McCone County. In some cases, those who had no feed left sold their entire herd. By December 1934 more than half a million sheep had also been purchased and skinned by FERA workers, their pelts stored in Miles City until relief tanneries could process them. More relief workers turned the wool into winter garments for Montanans receiving assistance.[144]

The government's action resurrected the cattle industry, and by January 1935 cattle prices were on the rise.[145] But the experience of culling the herds had been traumatic. Charlotte Edwards worked as a secretary in the AAA office in Broadus during the cattle-buying program. It was a growing-up experience for her to watch ranchers selling off the stock that had been the source of their livelihood and life in the region: "I'm sure I didn't realize the enormous tragedy that this was for the individual ranchers because they were losing everything. . . . I had never seen grown men cry and many of them did when they came in to sign their forms. . . . I realized that life was not a carefree fun time. . . . Many people left Powder River County during that period and sought jobs or lost their places and never came back." She also witnessed the sorrow of the men who had to do the killing: "It was

hard on them. They didn't like to do it. It was a rough job. It was rough on everyone."[146]

The vivid memories of starving livestock, infested fields, and mushrooming dust clouds represent only a part of Montanans' experiences of the Great Depression. Unemployed men loitered on the streets of Montana's cities (unemployed women were less visible); the state's western valleys hosted exiles fleeing the dried-out fields of the Dakotas and eastern Montana. Carl Kraenzel found almost one in every four households in Montana receiving assistance in February 1935. Across the board, young people, with little time to build up resources, were on relief disproportionate to their numbers in the state.[147] In Missoula four lumber mills laid off from 33 to 89 percent of their workers between 1929 and 1932.[148] The price of copper plummeted from eighteen cents per pound in 1929 to five cents in 1933, and massive unemployment dogged Butte,

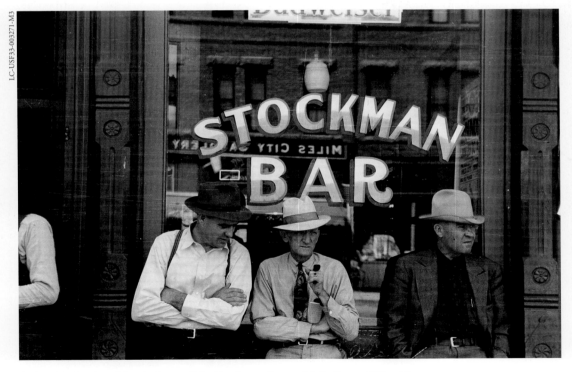

Arthur Rothstein • Men in front of the Stockman Bar on Main Street, Miles City, June 1939. One of the main topics of the FSA photographers in Montana was the cattle business. In this picture Arthur Rothstein extends the range of his assignment to include one of the many "Stockman" bars in Montana and the male visiting that took place in and outside of them.

Anaconda, and Great Falls. There, too, New Deal programs provided men and women with work and commodities, and the same psychological challenges that rural people faced accepting relief.[149]

Still, not everyone was hurting in the 1930s. In the majority of Montana counties—in at least forty-seven of the fifty-six—cattle numbers rose between 1930 and 1935.[150] Men and women on irrigated farms fared better than their dryland counterparts. Sugar beet growers prospered. In 1925 sugar beet farmers harvested 333,110 tons of beets worth nearly $2.6

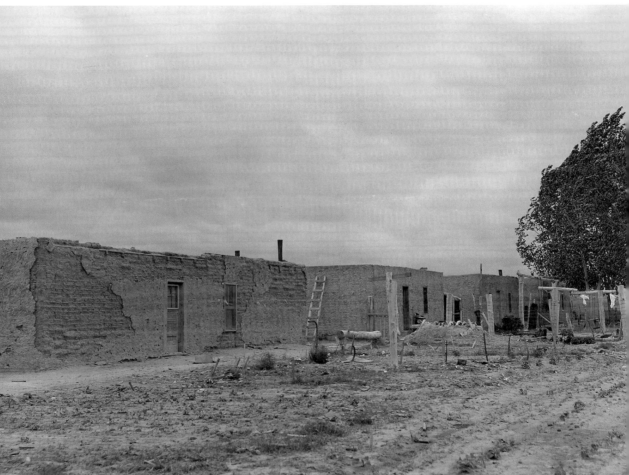

Arthur Rothstein • Houses for sugar beet workers, Hysham, June 1939. In an effort to encourage Mexican families to become year-round residents in order to build up a readily available labor force, the Holly Sugar Co. built adobe colonies to provide housing. Still, in 1940 two-thirds of the people working in Montana's beet fields were migrant workers.

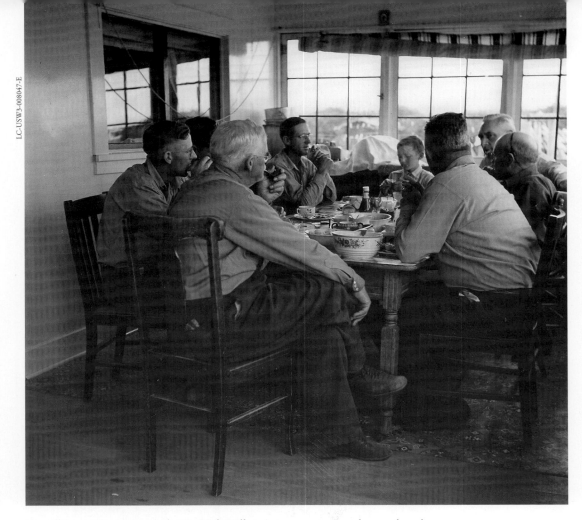

Russell Lee • Dinner at ranch, Big Hole Valley, August 1942. Ranchers and cattle buyers from the Midwest talk over dinner. As one ranch cook recalled, no matter who was working or visiting, "However much was put on the table, it disappeared like a snowball in August."

million. Ten years later, in the midst of the Depression, when wheat production had dropped by 50 percent, the sugar beet crop had more than doubled in tonnage and garnered $3.8 million.[151] The Amalgamated Sugar Company factory in Missoula County increased employment 33 percent between 1929 and 1932.[152] Mary Frances Alexander McDorney, teaching school in Thompson Falls in the early 1930s, watched freight trains full of men heading west to look for work, but times were not quite as bad in town. The Montana Power Company dam gave some economic security to the community, which meant that she always got paid, unlike many other Montana teachers who received warrants—promises of

future pay—from school districts that had no money. McDorney even went to Chicago to the 1933 World's Fair: "And that tells you that I was one of the rich people!"[153]

Economic diversity cushioned some communities from the full effects of the Depression. As the state capital and county seat, Helena, for example, provided layers of government employment that remained fairly stable during the 1930s. Helena also served as the market town for the Prickly Pear Valley, but agriculture there was quite different from the dry-land, grain-growing areas of eastern Montana. At least ten thousand acres of the valley's farms were irrigated, and farms were diversified, producing vegetables, poultry, and dairy products for a local market. Still, cash was often in short supply, and, as in many places in the country, people

Marion Post Wolcott • Freight trains, Havre, August 1941. Havre was a division point for the Great Northern Railway. Wolcott took this photograph looking west into the freight yard and showing tank cars used for shipping petroleum products, as well as a variety of boxcars and flatcars for carrying miscellaneous freight. The passenger station is in the upper left.

Russell Lee • Anaconda Smelter, Anaconda, September 1942. In this scene at the Anaconda smelter, molten copper being poured from the converter into the ladle splashed violently to make a dramatic photograph.

turned to barter to meet their needs. One elderly couple provided two dozen eggs each week for over six months in exchange for a used gasoline engine. But compared to other parts of the state, Helena, as Edward Bell found, "came through the Depression with only a moderate amount of inconvenience and suffering."[154]

The 1930s were tumultuous years. Despite the New Deal's myriad programs, neither the country nor Montana marched up a steady ramp of recovery. Rain would fall, but drought returned; industry rallied, but slumped again. In 1937 22 percent of the Montana work force was out of work, the highest unemployment rate of any state in the Union. Montana was not immune to the farm and labor unrest that rattled the rest of the

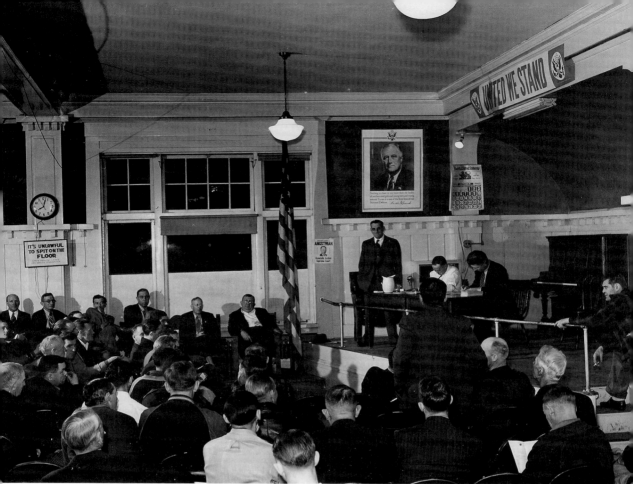

Russell Lee • Miners' union meeting, Butte, October 1942. With the support of the National Industrial Recovery Act, copper miners reorganized the Butte Miners' Union, Local No. 1 of the International Union of Mine, Mill, and Smelterworkers. Here they meet under the benevolent gaze of FDR.

country.[155] In 1931 Leverne Hamilton wrote to Governor Erickson, urging the government to take action against the Depression, reminding him that "the people of Montana are desirous of observing the social regulations and laws of the state, but we must remember that 'Hunger knows no law.'"[156] The following year, the Roosevelt and McCone County Farmers Holiday Association refused to take their grain to market; they protested declining prices with a grain strike.[157] In 1934, heartened by passage of the National Industrial Recovery Act, which gave workers the right "to organize and bargain collectively," miners in Butte reorganized the Butte Miners' Union No. 1 after working in an open shop for twenty years. Strikes in Great Falls and Anaconda resulted in new contracts also

honoring union shops.[158] Even workers on relief got caught up in the struggle for workers' rights. In 1937 the Workers Alliance staged a sitdown strike at the Great Falls WPA office seeking a raise in the WPA quota for the county.[159]

As remote as Montana might have seemed in the 1930s, the nature of its extractive export economy linked it to a much broader world, and Montanans were well aware of the unnerving events swirling around them. On January 1, 1939, wheat farmer James Bennett commented on the past twelve months: "A queer year has just ended. Undeclared wars have been waged. Dictators have bluffed the rest of the world. Raped smaller and weaker countries and got away with it. Jews have been ostracized, mistreated and it looks as tho Hitler would take their belongings in its entirety. Chamberlain proved to be the most liberal man of all times with other peoples territory and countries. Most of tradition has been upset and it looks like Europe is in for another 'dark age' and may eventually drag us into it. The New Deal thinks only in Billions and where they end, is anyone's guess. . . . Roosevelt says we can spend our way to prosperity. Wallace says the answer is produce less, in the meantime we are hanging on the ropes and betting that 39 cant be any more cockeyed than 38 no matter what the hell happens."[160]

In this tangle of stories from the Great Depression—stories about the reluctance of people to accept welfare, gratitude for that help, the ineptitude of government programs and the ability of common people to make those programs work, faith in FDR, and wonder at this "cockeyed" world—is a turning point in westerners' attitudes toward the federal government. The government had been a shaping hand in the West since it bought the Louisiana Territory and paid Lewis and Clark to go up the Missouri River. The government mapped, surveyed, and distributed land, removed Indians, and subsidized railroads—all in order to facilitate white settlement. But all that action seemed only to set the stage for individual and familial accomplishments. During the 1930s the hand of the government was made glaringly obvious in government paychecks and government projects in every nook of the country. Between 1933 and 1939 the West led all other sections of the country in per capita payments for loans and work and direct relief; Montana was one of the most generously endowed western states. The New Deal planted physical reminders of

Arthur Rothstein • Pool parlor, Fairfield, May 1939. Seeking to document the traditional as well as the modern aspects of small American towns like Fairfield, the photographer framed the water pump in front of the "Drink Coca-Cola" sign on the local pool parlor and barbershop.

people's newly configured relationship with the government all over the landscape: roads, bridges, sewers, culverts, schools, stadiums, outhouses, windbreaks, and dams bore the builders' plates of half a dozen New Deal agencies and the craftsmanship of millions of American workers. During the 1930s government infused the daily lives of citizens in unprecedented ways. As a result people had to revise their ideas about that once seemingly distant institution, to accept the level of social security it could provide and yet convince themselves that government support did not constitute a lessening of individual competence. In these stories we see the seeds of consciousness that came both to accept and defy government planning, regulation, and assistance—an uneasy truce that continues in the West to this day.

PART II

On the
Road

John Vachon • Road into Bannack, Beaverhead County, April 1942. Vachon drove his Plymouth into Beaverhead County in spring 1942 with the assignment of photographing stock raising. After several days he wrote to Roy Stryker that he had found "the purest most undiluted West I've ever seen." *(overleaf)* **Marion Post Wolcott • Sign at a crossroads, pointing to nearest telephone, vicinity of Birney, August 1941.**

They were a sort of Peace Corps of photographers.

—Jonathan Daniels

Soon after he drove his bald-tired Plymouth into Montana on a March day in 1942, John Vachon stopped to take a picture of a man simply because he was wearing a big hat. His subject turned out to be a sheep rancher on his way to deliver supplies to his herder, and he invited Vachon to go along. At the herder's camp Vachon photographed the sheep and the herder, although he later wrote to his wife, Penny, that he felt he did not get any pictures that were "really dramatic, telling, symbolic. Nothing that will get at the strangeness, to me, or lonliness of that damn herder's job."[1] Staying for lunch, Vachon got to ride a horse for the second time in his life; a few days earlier a cattle rancher near Jordan had initiated him to horseback riding.[2] On the way back to town, the truck bogged down, and they had to spend the night at the camp. Vachon enjoyed the delay. They "sat around all evening hearing coyotes howl, and telling tall stories —mostly about the weather, how cold it got, etc. Western as hell." He was delighted that the sheep rancher called him "Slim," which made him feel "very Western," but he regretted his new companions' generosity

John Vachon • Dryland farm, McCone County, March 1942. From Glasgow Vachon wrote to his wife, Penny: "I'll leave here tomorrow for Circle, Jordan, and slowly westward to Lewistown. That area according to my guide book is very authentic ranch and cowboy country. It's also very isolated. No railroads go through any of a whole section of Montana."

when he found the bed they insisted he take was made up of greasy blankets. In the morning Vachon devoured three eggs, eight sourdough pancakes, and "several thick wonderful slices of bacon" before a team of horses pulled the truck out of the mud and returned him to his car. Having had "a great time," he enthused to Stryker, "Wish I could run into things like that more often."[3]

As they made their way along the pot-holed, gumbo-laden roads of Montana, Vachon and the other FSA photographers did "run into things like that." None of the four, Arthur Rothstein, Russell Lee, Marion Post Wolcott, or John Vachon, had been to Montana prior to their FSA assignments. Lee and Vachon were from the Midwest; Wolcott and Rothstein

from the East Coast. All of them were struck by the beauty of the country. All of them struggled with how to photograph its grandeur and subtlety. Even the quality of the light was different. Rothstein wrote from Great Falls asking Stryker to wire him an evaluation of his recent photographs; he feared he might be overexposing his film since "the light in this altitude seems intensely bright."[4]

Sometimes they and their cameras were met with suspicion, more often with vaunted western hospitality. Lee, slightly older and better traveled, seemed less susceptible to preconceptions about the West that influenced the photographers' choices of stories and subjects. Rothstein and Vachon, in particular, became enchanted with the cowboy West. It was hard not to be when they seemed surrounded by movie characters and studio sets come-to-life. Arriving in Bannack, Montana's first territorial capital, Vachon pronounced that it had "much the appearance of a western movie location."[5] A devoted movie fan, he attended several Westerns while he was working in Montana, including *They Died with Their Boots On* and *Wild Bill Hickok Rides*. He informed Penny that when he returned home he planned to go to many more Westerns than he had in the past. In 1939 Arthur Rothstein photographed a Butte theater marquee advertising Gary Cooper and Merle Oberon in *The Cowboy and the Lady* and spent an enjoyable day in Billings where he came across the inaugural "Go Western" parade, organized by the Billings Commercial Club to drum up tourist business.[6] Rothstein took a number of photographs of the crowds, street vendors, floats, and western costumes. His comments to Stryker indicate he imbibed the spirit of the occasion: "People out here are becoming colorful and tough—the frontier spirit is rampant. Some of the men around here now use sulphuric acid as an after-shaving lotion and the rattlesnakes are all carrying anti-tetanus serum, just in case they might bite one of the local boys." Kidding concluded, he continued: "This Hollywood style cowboy stuff is a concession to the patrons of the dude ranches who annually bring millions of dollars into the state. I think it can be summed up in a shot I got of some fancily dressed cowhands loafing in front of a modernistic, glass-brick cocktail lounge in Billings."[7]

On the same trip Rothstein also photographed a rodeo in Miles City and dude ranch activities at the Quarter Circle U Ranch near Birney. In

Arthur Rothstein • Dudes in town, Billings, June 1939. *Vogue* magazine advised dude ranch guests, "If you want to be really swell, have one silk 'show' shirt with six or eight button cuffs—the kind that cowboys have custom-made when they're flush."

Arthur Rothstein • "Go Western" parade, Billings, June 1939. A handsome group of cowgirls march in the "Go Western" parade sponsored by the Billings Commercial Club. Riding in a stagecoach, the governor led the parade, which included hundreds of horseback riders and dozens of floats.

Arthur Rothstein • Shadows on tent at roundup, Quarter Circle U Ranch, June 1939. This cowboy silhouette is a good example of the romantic views of ranch life that Rothstein created in his portfolio of Quarter Circle U photographs.

discharging their FSA assignments, the photographers sought scenes that reinforced their existing ideas and made pictures that portrayed Montana as a quintessentially western place of wide open landscapes, peopled on the one hand by hard-working cowboys, sheepherders, and assorted grizzled characters and, on the other hand, by dudes enjoying a sanitized version of that life. Their photographs achieved their desired effect, at least for some viewers. One visitor to an exhibit of the FSA prints commented: "Now, more than ever, have I learned to realize what our West is like. I have seen it in person, but at the time was only sightseeing."[8]

Stryker's letters and the discussions he had with the photographers before they headed west also fashioned the ways in which the FSA photographers represented Montana. Although Stryker had left the West of his youth, its landscape had formed the measure of his vision. Sharply

rising mountains, undulating plains, cottonwood-rimmed streams, and red scoria bluffs had imprinted their colors and forms on his mind's eye. John Collier, Jr., another FSA photographer, believed that nothing that had happened to Stryker after he left the West—his experiences in World War I, his years at Columbia and in Washington—ever "dimmed that early flavor and love of the land."[9] Stryker's secretary Helen Wool remembered that years after he had moved to Washington, he often said, "I'm still a Westerner."[10] Stryker's western experiences also shaped his vision in a political sense. Collier believed Stryker's youth was crucial to comprehending his passion and drive: "To understand Stryker's deep concerns, we must think of Stryker as a boy in the Far West, a poor boy in the cattle lands of Colorado, who did make his first living in the lonely wastelands, a cowboy who might have loved to be a rancher, had not the first World War catapulted him into the world."[11]

The terrain of his past seeped into the letters Stryker wrote to direct the photographers' work. In one he urged John Vachon to "turn your camera loose on Spring in the Rockies . . . where the ground is damp and wet; where you can begin to see the fresh grass springing up at the edge of snowdrifts; trees just beginning to come into leaf . . . don't forget the clumps of willows down along the little stream."[12] Tongue-in-cheek, he instructed Rothstein to "please get some pictures of prairie dog towns and prairie dogs. No set of western pictures is complete without these."[13] After traveling in the West for weeks in 1941 with no word from Stryker, Marion Post Wolcott wrote to ask why she had not heard from him and whether he had any instructions for her return route. He had obviously conveyed to her a clear sense of what constituted the West, and she used that to chastise him for his long silence: "Do you have any preference which route I take—or do you even remember that you sent me out to *YOUR* west to take pictures? Are you mad at me—do you think my pictures are lousy & not what you wanted & not a *part* of the west?"[14]

When Roy Stryker retired, he returned to Montrose, the Colorado town in which he grew up, and eventually he donated his papers, including his private collection of FSA-OWI prints, to the University of Louisville. We do not know how he chose these prints. They may have been ones he admired as great photographs, ones that represented a particularly remarkable trip or reflected his relationship with that photographer. He lived

Russell Lee • A beaverslide stacking hay, Big Hole Valley, August 1942. The Big Hole Valley was famous for its wild hay and for its distinctive way of stacking it. In 1907 two Big Hole ranchers invented the device in the photograph. Buckrakes load hay at the bottom into the wide basket made of protruding wooden tines. A horse team—later a tractor—pulled it up the incline by cables run through pulleys, and the basket dumped the hay over the top to form a stack. Patented in 1910 as the Beaverhead County Slide Stacker, it became known simply as the beaverslide and is still in use today.

with the making of these photographs for nearly a decade and came to know them as no other single individual did. I have to suspect, though, that some of them he kept because they reminded him of home. Of those FSA photographs, over fifty are from Montana; the only western state better represented in the collection is Texas.[15]

Many factors conspired in the production of the FSA's Montana photographs, including the political concerns that dictated the project's agenda at the particular times the photographers came to the state.

John Vachon • **Mr. Bailey, FSA borrower, Flathead Valley, March 1942.** Work was a central theme of the FSA photographs since the agency sought to demonstrate that recipients of New Deal assistance were workers, not slackers. Thus the photographers created portraits like this one of Mr. Bailey, with his boots, gloves, worn coat, patched pants, "True Temper" pitchfork, and resolute expression.

Regardless of when it was and which photographer operated the camera, all of them fell a little bit in love with the place, just as all of them were a little wary of it. Their photographs of Montana depict a country where people worked with dignity and determination in a landscape both beautiful and intimidating. They have the beguiling quality of a place and people both attractive and enigmatic.

• • •

ONE OF THE MOST remarkable things about the FSA photography project is that it was a collective, collaborative endeavor, in which very few of the people ever actually worked together and in most cases hardly knew each other. With the exception of the occasional traveling companion or spouse, the photographers worked alone, never in teams. While over forty photographers contributed to the project, no more than five or six were ever on the payroll at one time, and during one lean period only Russell Lee and Arthur Rothstein were on the job.[16] Some were always out in the field, and meeting together in Washington, D.C., to discuss their experiences or evaluate their photos as a group was never part of Stryker's plan. Arthur Rothstein and Marion Post Wolcott shared an apartment in Washington, D.C., but were on the road so often they only met twice. The way in which the FSA photographers collaborated was by studying each other's pictures when they were back in the office and by following in each other's footsteps in the field.

Among the first photographers Stryker hired were Arthur Rothstein, newly graduated from Columbia University, where he had worked as Stryker's research assistant and been a founder of the university's camera club; Ben Shahn, who had joined the Resettlement Administration as a poster artist; Walker Evans, already employed by the Department of Interior's Division of Subsistence Homesteads, which was absorbed by the Resettlement Administration; and Dorothea Lange, who had been

photographing Dust Bowl exiles in California. Shahn and Evans, though neither were to work long for the agency, trained Stryker's eye during long sessions studying and talking about photographs. They established standards of artistry and compassion that subsequent employees sought to emulate. Arthur Rothstein recalled that Shahn and Evans were not interested in simply making a photograph, but "making a picture that had meaning." They raised his awareness "of the elements that go into photography—that go beyond just the content of the picture—the elements of style, of individual approach, of being able to see clearly, being able to visualize ideas."[17] Later Edwin Rosskam also brought an articulate eye to the project. Marion Post Wolcott remembered overhearing discussions between Stryker and Rosskam when she was in the office writing captions: "I could hear Ed educating Stryker about the composition, the impact, the beauty or ugliness of an image."[18] Dorothea Lange came to Washington only occasionally, but her work forged a heart that inspired all the photographers who passed through the office. In describing her influence on him, Rothstein spoke for all: "She made me realize that you had to photograph people with sympathy and understanding in order to get good pictures."[19] And so when they were back in Washington, they studied each other's prints, pouring through an ever increasing file: Evans's signs, Lange's portraits, Lee's interiors, Wolcott's landscapes. John Vachon was more directly tutored. Originally hired as an assistant messenger and assigned to copy captions on the back of eight-by-ten-inch glossies, when he received a promotion to file clerk, he took on the task of organizing the FSA file and came to know the collection intimately. As his interest in photography blossomed, Ben Shahn and Walker Evans taught him how to use a variety of cameras, and Stryker began sending him on short assignments in 1937.[20]

Out in the field the photographers sought to find fresh approaches to places their colleagues had already been or to emulate work they admired. Vachon, who esteemed Walker Evans's work, found and photographed in 1938 the same Atlanta billboards that Evans had shot in 1935.[21] Rothstein wrote to Stryker in 1936 that he hoped to get photos of migrant camps in Washington's Yakima Valley like the ones Lange had taken in California.[22] Marion Post Wolcott, shooting on the Quarter Circle U Ranch in Montana in 1941, photographed a cowboy's boot and spur in the left stirrup

(above, left) **Arthur Rothstein • Cowboy's boot and spur, Quarter Circle U Ranch, June 1939.** *(above, right)* **Marion Post Wolcott • Detail of a cowboy's boot and spur at the rodeo, Ashland, August 1941.** Whenever they were back in Washington, D.C., the photographers reviewed the FSA file, and Wolcott undoubtedly saw the picture that Rothstein took in 1939. Although she tried not to duplicate his work when she visited the Quarter Circle U in 1941, she took a photo that was nearly a mirror image of Rothstein's, unconsciously revealing the photographers' impact on each other.

of a saddle in the same manner Arthur Rothstein had shot a right stirrup in 1939. Vachon spent a wonderful day photographing a cattle outfit in Montana but said, "damn if I can see what I can get that won't duplicate Arthur and Russell Lee, who have done this whole thing thoroughly."[23]

Stryker orchestrated his fieldworkers from his office in Washington, D.C., rarely leaving the capital. He informed them of what each other was doing, directed their work, passed on news of someone's experiment with a new film or flash. Stryker liked to be the sole conduit through which his staff received information. When Edwin Rosskam, who worked as project writer and editor, began corresponding with the photographers, Stryker reined him in, saying, "If you want to write the photographers and tell them what to do, do your writing through me. Talk to them all,

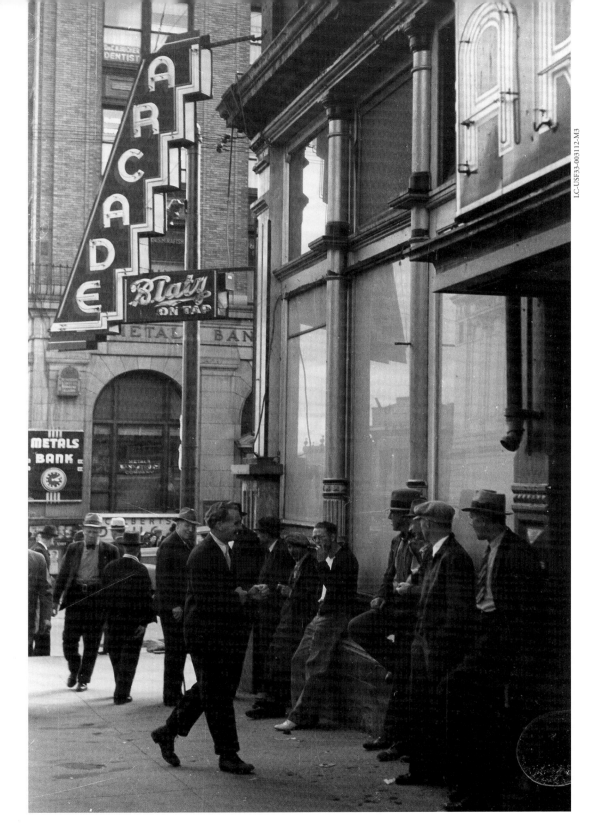

but don't start writing memos to them. I'm going to take that over myself. If you want anything, tell me because photographers can't take directions from everybody."[24] Yet however much they learned from studying each others' prints or kept in touch through Stryker, in retrospect, nearly all the FSA staff said that the single thing they would have liked to change about the project was their segregation from each other.[25]

Stryker's insistence that all communication flow through him meant that the photographers were often isolated because he did not have the time to keep up the level of correspondence they needed and desired. A major difficulty for all the photographers was the fact that they often worked for months without knowing if the images they were shooting were coming out correctly exposed. While photographers were sometimes able to develop their film in hotel bathrooms rigged out as makeshift darkrooms, they had no way to make prints on the road. Most often they would send packets of exposed film to Washington where the Historical Section's lab developed and printed contact sheets, which were sent back to the photographer in the field. However, there could be considerable delays if there was a backlog of work in the lab or the photographer was on the move and mail took a while to catch up to him or her. In the meantime the photographers had no way of knowing if their equipment was working well, if they were getting the effects they were aiming for, or if they were taking the type of pictures that Stryker wanted. In 1939 Arthur Rothstein wrote to Stryker expressing a frustration shared by them all: "I am very grateful for the information you send me about my negatives, but I would appreciate your remarks much more if they were not so confusing. For example, the first telegram I received said my flash-shots with the wide-angle lens were a little underexposed. As a matter of fact, I haven't used my wide angle lens on any flash shots at all so far. This last message says, '*more* pinholes in negatives check *camera* for dust.' Does that mean I have had pinholes in all my previous negatives and suddenly they have reached this aggravating total? Also which camera the miniature or the

Arthur Rothstein • Men lounging in front of the Arcade, Butte, June 1939. In 1937 the WPA set up a recreation room for single men in the basement of the Arcade Bar and Café on the corner of Park and North Main streets. There they could listen to the radio, read the newspaper, and play checkers and cards.

Linhof? If you only knew how important it is to a photographer in the field to receive frequent information about his work."[26] Stryker, however, never had the time to give each of them the critique and review they craved. Even when he did write, letters had a way of falling behind the photographers' trails. In 1942 a letter Stryker wrote to Vachon caught up with him after having been forwarded from Williston, North Dakota, to Hamilton, Montana, via Glasgow, Lewistown, Helena, and Kalispell. As Vachon told Penny, "Had I received it when I should have there'd been a different story sung over the past month. It was full of the kind of advice and ideas I languished for back then."[27] The correspondence between Stryker and the photographers reveals a litany of technical problems that resulted in whole batches of out-of-focus, streaked, scratched, over- and under-exposed negatives. In retrospect it seems amazing that the project generated as many marvelous photographs as it did.

• • •

THE FSA PHOTOGRAPHERS continually ventured into landscapes, physical and cultural, that were new and strange to them. One has to wonder, tracking Marion Post Wolcott journeying from New Jersey to Louisiana, Arthur Rothstein driving from New York to Montana, Russell Lee sojourning from Illinois to Oregon: how did these few individuals, these strangers, who always seemed to be in motion, take pictures that reveal such intimate details of people's lives, such unguarded expressions of woe and of hope?

Scholars discuss at length the ethics of fieldwork, of approaching people to appropriate their stories and their pictures, pieces of their lives to be taken and used for purposes outside of their control. Relatively little attention has been turned to the physical and psychological wear months in the field inflicts on fieldworkers, out of touch with family and friends, traveling bad roads, searching for places to stay and to eat, and repeatedly having to approach strangers and ask for those bits and pieces of their lives. Dorothea Lange remembered: "We found our way, slid in on the edges. We used our hunches, we lived and it was hard, hard living."[28] Marion Post Wolcott invested hours gaining the confidence of the people she wanted to photograph. In 1940 she described her approach: "I sometimes hang around and talk and help peel potatoes, wash and dress the

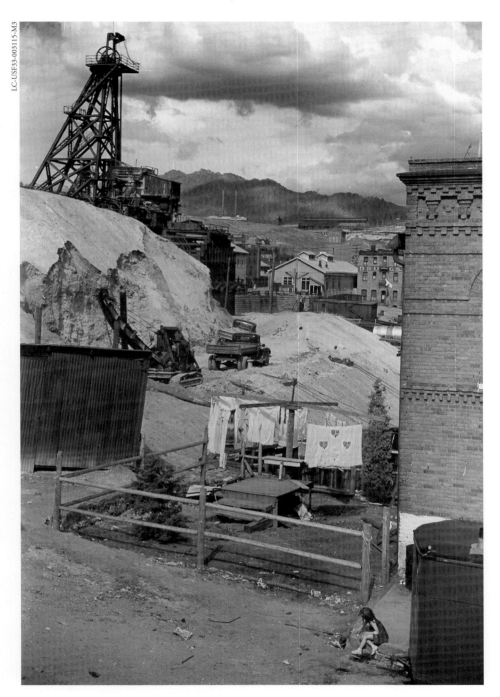

Arthur Rothstein • Copper mine in town, Butte, June 1939. A quilt patterned
with idealized cabins hangs from a clothesline flanked by a pair of scraggly trees,
testifying to a family's attempt to create a homey place in the shadow of the Original
Mine. A young girl, however, finds more intriguing play next to the gutter.

children, help hang out the clothes or see that the beans don't burn. I may give them a lift to town or perhaps do five minutes shopping for them in the evening and bring it back the next day."[29] Fieldwork could indeed be exhilarating but also tremendously taxing.

Marion Post Wolcott faced particular trials as a young, single woman traveling alone. As she once said, "Many people mistrust a young girl who drives alone in the country and stays away from home and family very long."[30] Even with her FSA credentials and Stryker's endorsement, there were places she was not permitted to photograph because she was a woman. She had to fend off the unwelcome advances of men and the suspicions of women. Interacting with strangers all day, day after day was exhausting. "Also, being a woman, people were curious that I was out there doing that kind of job . . . they would ask more questions, watch where I went, what I did. I was much more conspicuous. I was gossiped about. They noticed where I stayed—and I couldn't stay in certain tourist cabins otherwise my reputation would suffer. . . . On a couple of occasions I was 'arrested,' taken down to the police headquarters and questioned, or stopped by sheriffs and taken to their offices. They were just curious and didn't have anything better to do."[31]

Wolcott found a sympathetic ear in her mother, who had firsthand experience of such travails. Nan Post organized birth control clinics and sold birth control devices throughout the United States and, in fact, had worked in the West Virginia coal mining camp to which Wolcott was sent on an early FSA assignment. Wolcott and her mother were very close, and Post was an important influence on Wolcott's social conscience. Post gave Wolcott support, reassurance, and advice, one time telling her: "You won't have any problems in the field. It's a great experience. Look at the clotheslines if you want to find out what's going on in a family or how many children they have."[32]

While Wolcott's gender brought her particular problems, the strain of fieldwork was widely shared. In 1940 John Vachon wrote to his wife,

John Vachon • Last Chance Gulch, Helena, March 1942. Vachon found Helena a "strange, surprising town . . . full of steep hills, narrow winding streets, tall buildings, Chinese restaurants, lots of bars, theaters. Right at the foot of a big mountain." It reminded him of San Francisco.

LC-USF34-065063-D

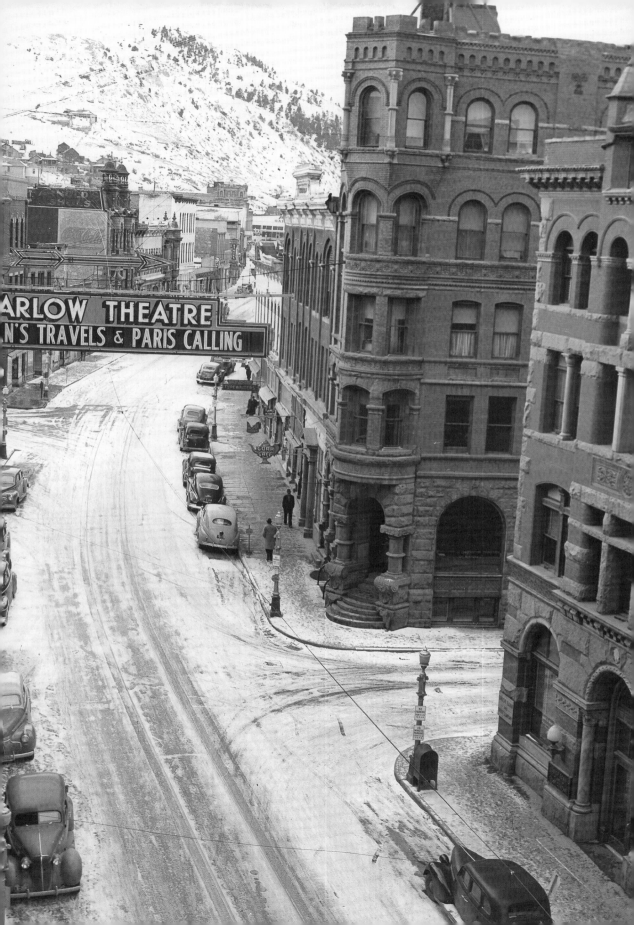

Penny, from Scranton, Iowa, where he had gotten off the train to find no hotel, no one who would take in boarders, and "everyone, wherever you go, drops everything and their eyes follow you as long as you are in sight."[33] Two weeks earlier he had written from Dubuque: "Always the first day is discouraging. Self-conscious, afraid to take good pictures when I see them. Two young couples, very young, obviously just married, came out of the justice of the peace office looking like fine photographs. But I

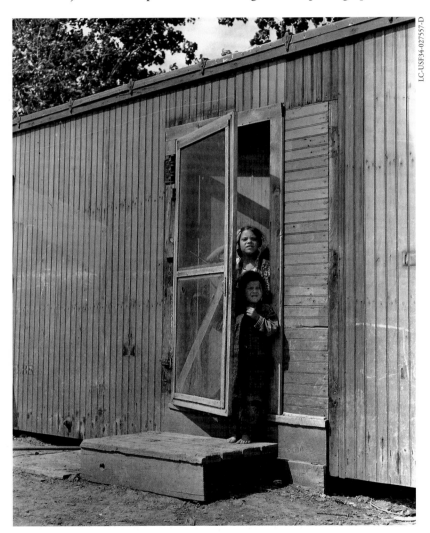

Arthur Rothstein • Sugar beet workers' children, Treasure County, June 1939. By 1930 more than a thousand Mexicans and Mexican Americans worked in the sugar beet fields of the lower Yellowstone Valley. Families often lived in makeshift dwellings like this modified railroad refrigerator car.

couldn't do it. Maybe in a week, I'll be able to."[34] Experience helped, but each new place posed its own challenges. Two years later in Montana, Vachon again wrote to Penny: "Maybe I've lost my sense of it all, and also my guts. When I see a cowboy on the street, I can not sidle up and ask him for a picture. It is now kind of serious. Over a week since I've done anything."[35] Arthur Rothstein, young and away from his family for the first time, was lonely. He loved traveling and seeing new parts of the country, but "it was a lonely life. . . . I would get to meet people on the road and then have to drop them. They would go back to their lives, and I would go on to something new. I had many lonely evenings, many lonely experiences."[36]

Not hearing from Stryker aggravated the disorientation the photographers sometimes felt. Wolcott recalled that once she received no prints and no commentary about her work for about three months. In 1942 with the agenda of the project shifting and Stryker absorbed in bureaucratic wrangling to preserve his Historical Section, workers were left at loose ends. John Vachon wrote to John Collier: "I was awfully glad to hear from you, and realize that someone else is still out making pictures. It's been so long since I've heard from Stryker I thought possibly the section had been dissolved and in the rush it had been forgotten that I was out on a field trip."[37]

From the project's beginning it had been customary for photographers to spend months at a time in the field. Russell Lee estimated that between 1936 and 1942 he was in Washington for no more than a total of six months.[38] Apart from the personal toll such marathon trips took, especially on single photographers or those who traveled without their spouses, a sense of alienation from the familiar could also affect their work. Wolcott recollected: "If the trips are too long there's a danger for me of going stale, mechanical, almost empty or dead inside on certain days, of becoming just an observer of life, as if one were sitting in a movie or newsreel. One has the feeling of not belonging anywhere, of having no roots or base . . . of being suspended, of never being relaxed or at home or accepted for whom or what one really is or has been or believes. . . . It's not good to feel always that one must go on, leaving everything unfinished and incomplete, usually not able to return, both work and human relationships unfinished and incomplete."[39]

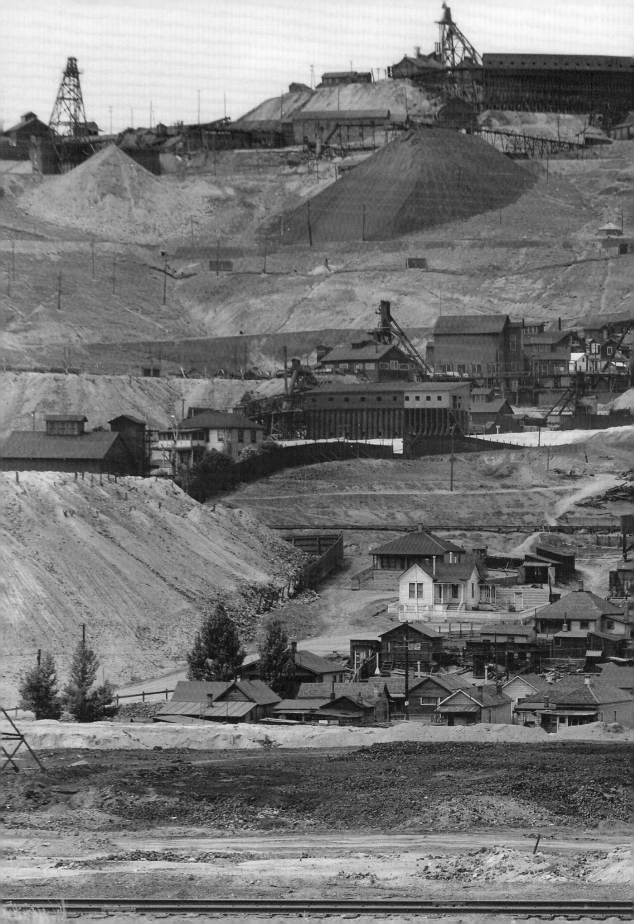

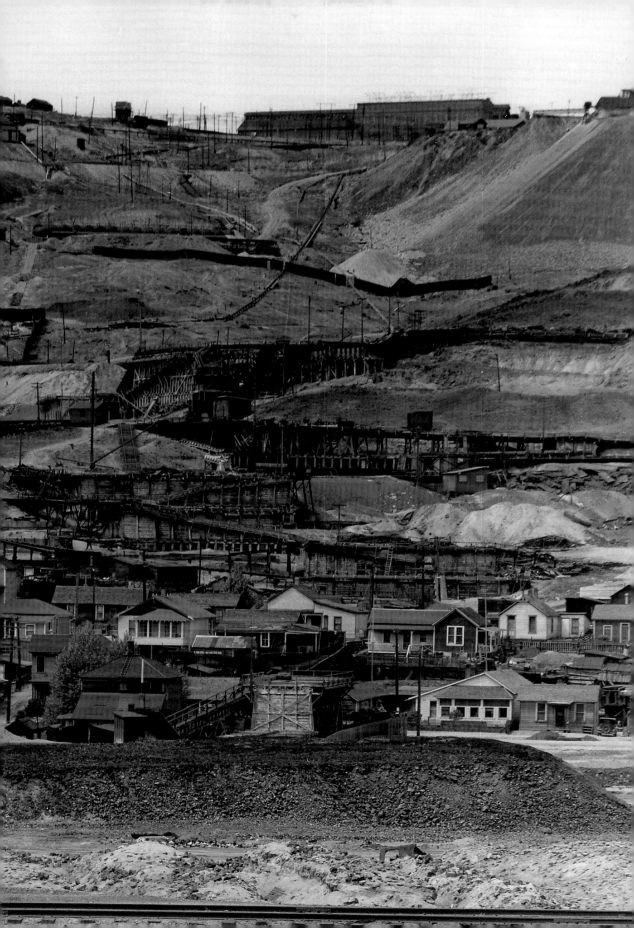

(overleaf)
**Arthur Rothstein •
Copper mines and
miners' homes,
Meaderville, May 1939.**
LC-USF34-027346-D

Some photographers were fortunate to be accompanied by their
partners or spouses at times, and the Historical Section reaped the benefits
of capable unpaid labor, for the partners often proved adept at making
conversation with the photographers' subjects, helping with equipment,
taking notes, and writing captions. Russell Lee traveled with Jean Smith,
a journalist whom he had met in Texas. They married in 1939 after Lee
and his first wife, artist Doris Emrick Lee, were divorced.[40] Irene Delano
accompanied Jack Delano on many of his trips. Dorothea Lange and her
husband Paul Taylor worked in tandem. Taylor, an agricultural economist,
interviewed people for his own studies while Lange took their pictures.[41]
A few months after they were married, Lee Wolcott joined Marion Post
Wolcott for a week in the West, shortly after she had finished photo-
graphing in Montana. Marion had planned to take a few days' leave,
hoping her husband could see her "without three cameras hanging around
my neck, & one in each hand, & film coming out my ears."[42] She
thought they might go to Yellowstone National Park or Jackson Hole. But
when Lee did arrive, he insisted that he travel with her and help her work,
hoping to make her overall trip—and her time away from home—
shorter. Lee Wolcott took over much of the driving and navigating, and
Marion reported to Stryker: "In just those few days I realized more than
ever how much more interesting & alive this kind of job can be when
there are two people (if compatible, etc.) doing it. What a difference it
makes!"[43]

While the lack of direction from Stryker sometimes left the photogra-
phers feeling adrift, it also gave them a wide latitude in choosing where
they would go and what they would photograph. All the photographers
left Washington carrying Stryker's "shooting scripts," topical outlines of
the kinds of photos he wanted, ranging from categories as vague as "group
activities of various income levels" to specifics such as "wall decorations
in homes."[44] However, he would also say, "But, of course, if you don't find
any of these things, you do what you want to anyway."[45] Vachon recalled:
"Well I would drive to a town because I liked the sound of the name.
There was a place in North Dakota called Starkweather, and it seemed
that there should be some great pictures there so I went there."[46] Fre-
quently, as Vachon described, they came cold into a town, with no intro-
duction or direction and no alternative but to act on their own initiative.

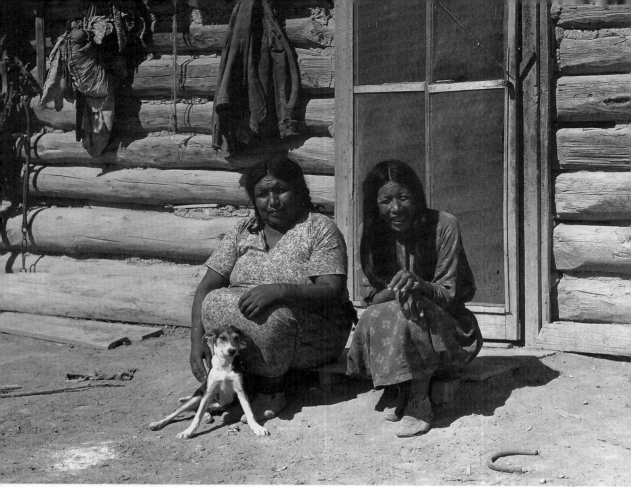

Marion Post Wolcott • Cheyenne Indians, near Lame Deer, August 1941. Two women pose for Wolcott in front of a log cabin on the Northern Cheyenne Indian Reservation. Wolcott became well known for her ability to put people at ease and capture graceful moments.

It is commonplace now to speak about the empathy of Dorothea Lange, the warmth of Marion Post Wolcott, the friendliness of Russell Lee, to chalk up their ability to get great photographs to wearing their hearts and politics on their sleeves. But as anyone who has done fieldwork knows, charm and the right politics are not enough to be successful. Working hard to know the region, the industries, and the background of the people is crucial; so is having contacts. While the photographers had shooting scripts to guide their work, in some cases the specific places they landed had more to do with having a contact there than with any sense of the representativeness or significance of a particular community, town, or ranch or its inherent visual appeal. Contacts proved invaluable since

Russell Lee • Scrap salvage campaign, Butte, October 1942. The first scrap drives in support of World War II were organized in 1942, partly to collect materials like metal, rubber, and kitchen fat but also to mobilize civilians in the war effort. Children from the Webster School pose atop a heap of salvage they helped collect. Note the preparedness of the young boy on the top left with his toy (?) rifle.

the photographers did not always have very much time to ingratiate themselves into a community.

In many cases these touchstones were USDA agents, some of whom proved helpful, others annoying. Family also eased the way. At one point Russell Lee based himself in Aledo, Illinois, his first wife's hometown.

Vachon produced a picture story about a farm family in Minnesota, for whom his brother once worked.[47] Stryker told all the photographers if they got to Bozeman, Montana, to look up the librarian, whose husband had grown up with him in Colorado. He sent Marion Post Wolcott to a southern plantation owner, who was "friendly and interested in photography and the project." It was through him and his son that she got access to the black community; she took some of her best-known photographs when the plantation owner's son accompanied her to an African American juke joint.[48]

They also followed each other's trails. Arthur Rothstein, because of his seniority on the project and extensive travels in the early years, served as an ambassador for the FSA in communities that welcomed later photographers. Vachon wrote to Penny from Iowa that "Arthur Rothstein really made a name for himself out here. . . . I'm introduced as 'the man who was sent out here to take Rothstein's place,' and that commands respect."[49] In 1939 Rothstein photographed at the Quarter Circle U Ranch; in 1941 Marion Post Wolcott returned there, telling Stryker, "I will try not to duplicate Arthur's stuff, as well as I, & we, can recall it."[50] Wolcott also followed Rothstein to Gee's Bend, Alabama, and Belle Glade, Florida. Russell Lee shot pictures in Butte, Montana, five years after Rothstein did, and both Lee and Vachon photographed in Wisdom, Montana, in 1942. In some cases they wanted to document changes that had occurred over the course of the New Deal. But in other situations, these were simply the easiest places to go—places where people were comfortable with the FSA photography project.

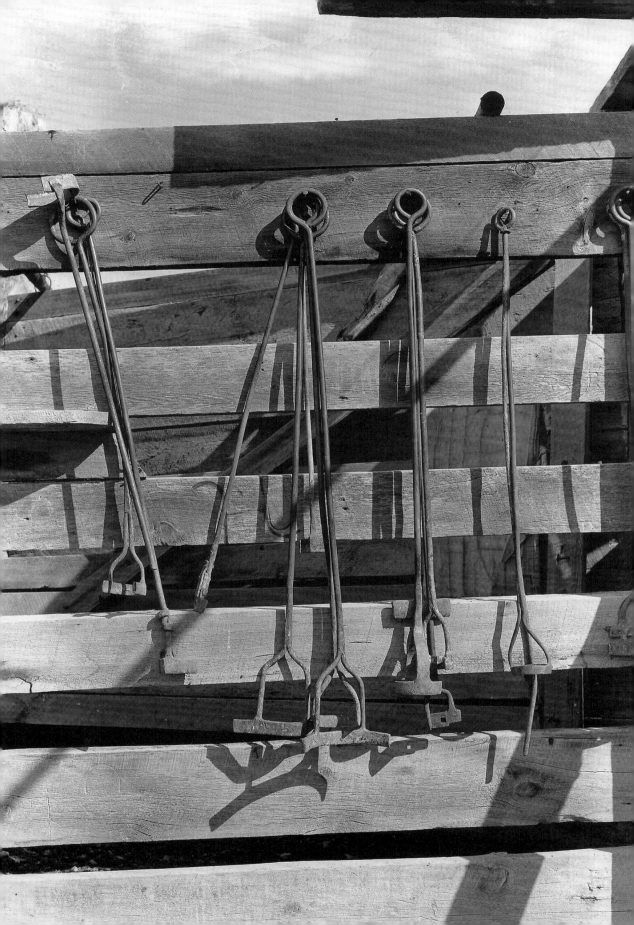

Arthur Rothstein

THE FIRST FSA PHOTOGRAPHER to picture the West, apart from Dorothea Lange, who lived in California, was Arthur Rothstein, who once wryly commented, "The trouble with working out here is that you have to travel so far to get anywhere."[51] Rothstein liked the West. By one account his favorite assignment for the FSA was the time he spent on the Quarter Circle U Ranch outside Birney, Montana, in 1939.[52] He also enjoyed Nevada where the people were refreshingly eager to be photographed.[53] In fact the only western state he complained about was California, and like many before and after him, he found it different: "From what I have seen of the state I like it the least of the western states. My impression is that everything is commercialized. The police & city officials are corrupt grafters, there is little of that gracious western hospitality & most of the people are of that reactionary, super-patriotic, fascist-minded type. Practically every newspaper features a daily red-baiting article with two-inch headlines that condemn Gov. Olson, the NLRB or Prs. Roosevelt."[54]

Later in his life, Rothstein produced two books drawn from his FSA work. One was a general overview called *The Depression Years*; the other was *The American West in the Thirties*. Judging by the photographs in the latter, what Rothstein liked best about the West were cowboys. The first plate in *The American West* is a photograph of a Montana cowhand, leaning on his saddle horn, eyes squinted against the sun, hand-rolled cigarette tucked in the corner of his lips. Nearly a quarter of the photos in this book are from his Montana work. Rothstein once calculated that he had been in every one of the country's three thousand counties, but no other region captured his imagination like the West.[55]

Stryker met Arthur Rothstein at Columbia University where he hired the young undergraduate to copy photographs for *American Economic Life*. A gift of a camera at age thirteen had captivated Rothstein, who proceeded to found the camera club at Columbia and invite photographers such as Edward Steichen and Margaret Bourke-White to campus. He had considered pursuing graduate work in medicine or chemistry, but when

(facing page)
**Arthur Rothstein •
Branding irons,
Quarter Circle U
Ranch, June 1939.**
LC-USF34-027648-D

Stryker offered him a position in Washington for thirty-five dollars a week, the twenty-year-old accepted. Rothstein set up the darkroom in Washington and then began the traveling that would characterize his next five years. He bought a new 1936 Ford, stocked it with tripods, flashbulbs, cameras, food and water, and everything else he anticipated he might need: "I had a sleeping bag in the car, and an ax to chop down trees that got in the way . . . a shovel to dig myself out of snow or mud, a water bag and a Coleman stove."[56]

Young and untraveled, Rothstein had never been west of the Hudson River. As he once recollected, "I never got out of Manhattan except to go home in the evening, which was in the northeast Bronx."[57] His youth and inexperience made everything new and fresh, and the West was terrifically exciting. Finding himself out in the Great Plains "was a revelation."[58] In looking back on his experience he speculated that his photographs were successful because "I was approaching things with fresh eyes, with a certain naiveté and lack of sophistication."[59]

Jack Delano • Jack Delano Papers, Library of Congress. Fellow FSA photographer Jack Delano drew cartoon portraits of his colleagues. These of Arthur Rothstein played upon his experiences in the West.

Arthur Rothstein • Farmers meeting with the Great Plains Drought Area Committee, Miles City, August 1936. In August 1936 a committee of federal officials toured the Great Plains from Texas to the Dakotas, talking with farmers and assessing the state of the region. The turnout in Miles City demonstrated the depth of farmers' concerns and their willingness to meet with government representatives. In its report the committee wrote, "The land may bloom again if man once more makes his peace with Nature."

In 1936 Rothstein made an extended trip through the Midwest and West; chief among his tasks was documenting the Dust Bowl. He was getting acquainted with the country. Part of the time he traveled with the Great Plains Drought Area Committee, a group of eight men and their staffs from a variety of federal agencies, who toured the area, inspecting the land and meeting with farmers in order to assess drought damage and make recommendations for future land use on the plains.[60] In the semi-serious, tongue-in-cheek manner in which much of the FSA correspondence was carried out, Ed Locke, Stryker's assistant, wrote to Rothstein

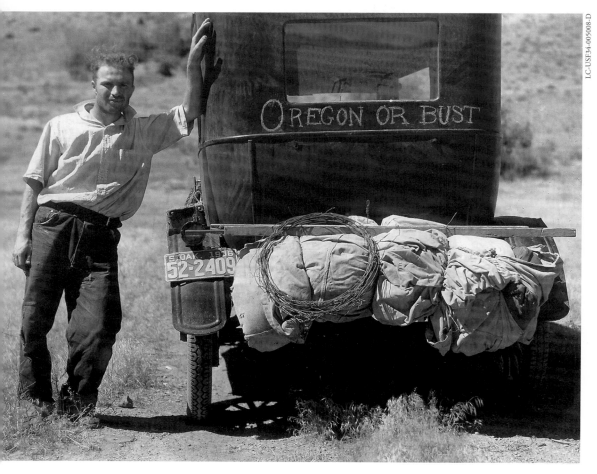

Arthur Rothstein • Drought victims heading to Oregon, Vicinity of Missoula, July 1936. Rothstein photographed Vernon Evans and his family near Missoula en route to Oregon, where the family had heard "there was grass up to the cow's belly, and there was fruit free for the picking."

while he was on the road: "How marvelous it must be to travel around with Ford and camera, seeing new sights, experiencing new thrills, and chatting with new grasshoppers every inch of the way. As one of F. D. R.'s new roughriders, I salute you."[61]

Arthur Rothstein did not spend a great deal of time in Montana in 1936, but he did take some of his most famous photographs on that trip and fulfilled Stryker's hope that "you have the good luck to be on hand when some family is packing up, ready to leave for parts more moist."[62] He was napping in his car outside of Missoula when a honking horn and

shouting woke him. On the back of the car that had startled him awake he spied the inscription, "Oregon or Bust," and gave chase, flagging down Vernon Evans and his family in order to take several pictures. Evans and his family had left dried-out Lemmon, South Dakota, hoping to get work picking hops in Oregon or Washington. For the most part the photographers never knew what happened to the people they photographed, especially migrants they met along the road. But Marie Braught, Evans's sister-in-law, sent Rothstein a letter after he sent her some prints. She reported that once they reached Oregon conditions had indeed improved for them. Her brother-in-law got work on the railroad, her brother and his friend found jobs picking peaches, working in a lumber mill, and doing other casual labor. Most encouraging was the fact that they all had work at the same time. Her sister had borne a child and her parents had followed their children west to a farm near Lebanon, Oregon. Their gamble had paid off, she concluded. "We all like it fine and certainly haven't regretted coming even though we had no idea when we came what we were going to do out here."[63]

Stryker insisted that all of the photographers study their assigned areas before they left Washington, D.C. In preparation for work in Montana and Idaho, Rothstein read about the economics and geography of the region, talked with the editor of a cattle trade journal, and perused Francis Parkman's *Oregon Trail*.[64] Rothstein returned to Montana in 1939, still on the track of agricultural disasters. From Fargo, North Dakota, en route to Montana he dropped Stryker a note: "Grasshopper damage may be serious this year. If control methods are not too complex, will take a few pictures."[65] However, this time he was also looking for photographs to round out a file illustrating a recovering America. He came armed with an extensive shooting script for the cattle industry. Stryker wanted photos of a cow town, including scenes that would emphasize "the fact that it is a cattle town," shots of stockyards and cattle cars and every aspect of ranch life from fence poles to cowboys' clothes.[66] The script did not mention anything about the cowboy entertainment of the dude ranch business, but that side of the western cattle industry would shape Rothstein's experience in Montana and the photos he took.

In Bozeman Rothstein consulted people at the college, including Stryker's friend, librarian Lois Payson, in order to get some ideas of where

and what to shoot. His discussions proved so fruitful that he wrote to Stryker, "I wish I had come sooner." He sent to Washington, D.C., a proposed schedule that had him looping from Bozeman through Butte and Great Falls, then back to northern and eastern Montana to cover FSA resettlement projects, grasshopper control, sheep shearing, sugar beet cultivation, and cattle ranches. In addition, he wanted to photograph projects on the Flathead and Crow reservations, in which the Farm Security Administration was cooperating with the Indian Bureau on handicraft and art projects, to take a look at the cut-over forested area north of Missoula, and to visit Petroleum County, "where the crude oil flows and the best wheat grows," in order to capture its rapid boom and bust.[67] Stryker approved his plans, with one caveat: "The Indian pictures are fine, but I doubt if we ought to get too far involved. There are so many

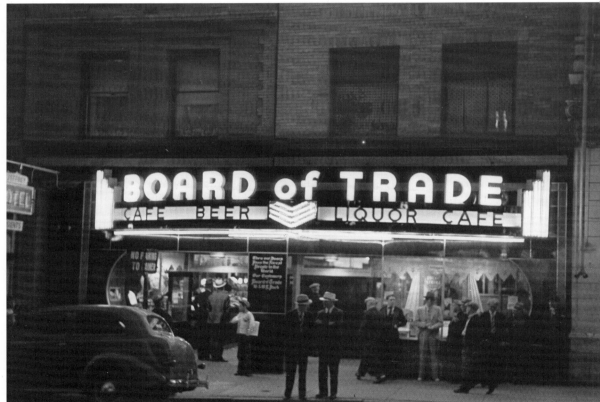

LC-USF33-003128-M4

Arthur Rothstein • Board of Trade, Butte, June 1939. Butte was famous for its nightlife. Rothstein conveyed that sense of action outside the Art Deco facade of the Board of Trade on East Park Street, where a newsboy hawks papers to the passers-by.

Arthur Rothstein • Gambling for housewives, Butte, June 1939. Women as well as men gambled in "wide open" Butte. Uptown keno parlors catered to women in the afternoon, and at least one female patron appreciated that fact. As she remarked, "The only places us women's got to rest our feet after shopping is some keno joint."

other things to be done." Then he confessed: "You know I just don't get too excited about the Indians. I know it is their country and we took it away from them—to hell with it!"[68] Rothstein ended up taking only a few photographs of Native Americans in Montana, although he later photographed Indians in New Mexico, Oregon, and Nevada.

He did swing through Butte, his view of the city shaped by a conversation with Joseph Kinsey Howard, Montana's own muckraking journalist, whose articles in the *Survey Graphic* and the *Nation* lambasted the power of the Anaconda Copper Mining Company and its influence on Butte and the state. Howard gave Rothstein the skinny on the mining city, but using him as a reference did not get the photographer very far in dealing with "the big shots" in Butte, whom he judged "thoroly hated" the journalist. In fact Rothstein found his reception in Butte decidedly cool, noting that Butte looked upon photographers and newspaper reporters— "in Butte they call them yellow journalists"—with suspicion. He did not realize that as victims of a captive press—most of the state's major newspapers were owned by the Anaconda Company—residents of Butte in

Arthur Rothstein • *Venus Alley, Butte, June 1939.* Rothstein ventured into Butte's infamous red-light district to take several photographs, including this one of a shadowy figure reflected in a prostitute's lace-curtained crib. In Salida, Colorado, Rothstein discovered that "the line," another name for a red-light district, was on the same block as the FSA office.

particular and Montana in general had little trust in the journalistic tradition.[69]

In 1939 Stryker was little concerned with getting photographs of copper production; the rural scene was key, and he reassured Rothstein, "anything we can get out of Butte is velvet."[70] Without support of "the big shots," Rothstein did not have access to many mine yards, but he took evocative pictures of the uptown streets, of men congregating on the sidewalks, leaning up against the buildings, smoking, and talking. His landscapes captured the intimate relationship between mine yards and the housing nestled up against them. He also successfully experimented with some night shots of men and women outside bars and movie theaters. Butte's night life was notorious, and while red-light districts were not on the list of Stryker's desired topics, Rothstein ventured into Butte's infamous "Venus Alley" and took a couple of photographs of prostitutes' cribs.

While Butte was not a high priority for Stryker in 1939, FSA-funded projects were, and Rothstein headed north from Butte to Fairfield Bench Farms to take pictures on that resettlement project. A significant proportion of the FSA photographers' work was documenting projects funded by the Resettlement Administration and the Farm Security Administration, and the farmers who received loans from the agencies. FSA or county extension agents frequently accompanied photographers to introduce them to farmers and to the projects. While each cooperative, model farm, or community center was unique to the local populace, after a while they became tedious and repetitive for the photographers. In 1936 Stryker had instructed Rothstein to make sure he took photographs of "agricultural advisers talking with clients . . . home demonstration advisers conferring with wives regarding gardens, canning, etc. . . . pictures of the present state of the projects, good views of the houses, people working in the gardens," and so forth.[71] That formula molded a virtual template for photographs resulting in, for instance, an enormous number of pictures of women posed in front of prodigious amounts of canned fruits and vegetables. By the 1940s there was little fresh to photograph about an FSA project, and Vachon confessed to Penny that he had deceived one agent, only pretending to take the photographs he had suggested. The agent was "a good guy" and had gone to great lengths to help Vachon, but the photographs he proposed "were of no use or interest."[72]

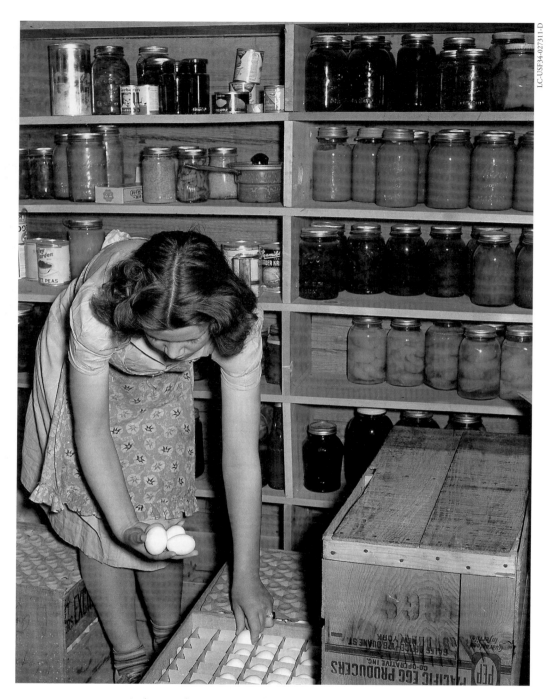

Arthur Rothstein • **Farmer's daughter in storage cellar, Fairfield Bench Farms, May 1939.** Canning was a mainstay of rural women's work and strongly encouraged on FSA projects. Daughters learned food preservation skills from their mothers and through such social groups as the "Seal 'em Tite" girls' canning club.

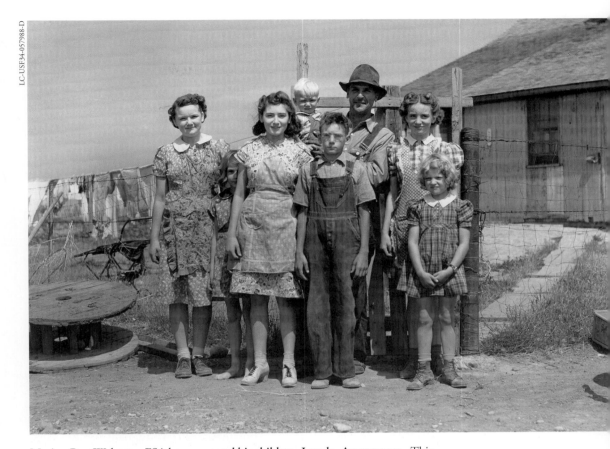

Marion Post Wolcott • FSA borrower and his children, Laredo, August 1941. This photograph was typical of the kind that Stryker wanted in order to convey the success of the FSA program. In contrast to the pictures of grim-faced parents and barefoot children taken early in the project, this photo—taken eight years after FDR took office—shows a clean, smiling, well-dressed, and well-coiffed farm family.

Pictures of resettlement projects or of farmers who had received FSA loans always accentuated the positive. A photograph Marion Post Wolcott took of an FSA borrower and his children in Hill County is typical of this genre. The family stands outside a house that is by no means fancy but has a good roof and plumb windows. The children are all well dressed and smiling. The girls' hair has been freshly curled, one boy wears glasses, one daughter sports a string of beads, another a wristwatch. Laundry and a box of canning jars in the background testify to hard work, but clearly the family is doing well enough to provide for health care and a few trinkets. This portrait stands in sharp contrast to photographs of grim-faced

parents and barefoot children common in the earlier 1930s, presumably before the FSA had much effect.

Rothstein's photographs of Fairfield were also classic examples of this propagandistic mode of FSA photography. He took pictures of the new houses and the community center, the grain elevator and the shelterbelt, of the doctor visiting children and the veterinarian examining livestock, of men and women driving tractors and teams of horses, of men working in the irrigation ditches and inspecting crops, of women with their canned goods and chickens. Rothstein did his usual yeoman's job at Fairfield, but the assignment elicited no comment from him other than informing Stryker that Fairfield was "interesting" and he took "a lot" of photographs there.[73] A week after leaving Fairfield, Rothstein would encounter a place that engaged his imagination in a much livelier fashion.

Rothstein's most enjoyable assignment also came as a result of liaisons within the Agricultural Adjustment Administration. Stryker needed photographs of the cattle industry and the AAA referred him to Burton Brewster, a range supervisor for the AAA and son of Grace Brewster, one of the owners of the Quarter Circle U Ranch near Birney.[74] Sometime in the 1880s George Warren Brewster, native of Boston and adventurer in Nevada, California, and Montana, heard there were still buffalo in southeast Montana, and he set out in pursuit along the Tongue River. Brewster did kill a buffalo bull, but he also took a squatter's right on a site three miles south of the present hamlet of Birney. Over the years he amassed a ranch of twenty-four thousand acres through homesteading, desert land claims, and purchase. In 1896 he married Grace Sanborn, and the couple had three sons, Warren, Lyman, and Burton, all of whom grew up riding broncs in local rodeos and working on the ranch. In 1913 George died, and four years later Grace married Jack Arnold. The boys went off to college and law school, but all returned to Montana. Burton went to work for the AAA and became one of the web of USDA agents who showed FSA photographers around their territories. In June 1939 Arthur Rothstein accepted Burton Brewster's hospitality and went to the Quarter Circle U Ranch.[75]

Although dude ranches dated back to 1881 when Howard Eaton accepted paying guests on his ranch in the Black Hills of South Dakota, depressed cattle prices in the 1920s had galvanized several ranchers into

initiating dude operations to supplement their regular business. By 1936 Montana catered to those who could still afford vacations on its 114 dude ranches, more than any other western state possessed.[76] The Quarter Circle U, also known as the Brewster-Arnold Ranch, began hosting dudes in the 1920s. Jack and Grace Brewster Arnold erected a bathhouse, a dining hall, and some tent houses around which Grace planted hollyhocks. They joined the Dude Ranchers' Association and started entertaining easterners who responded to advertisements that promised, "The old West has changed but there are still sections of the country where the romance and the glamour of the past still remain."[77] During the Depression years dude ranching kept many western ranches from bankruptcy. For example, in 1931 the Quarter Circle U earned more from hosting dudes than from stock raising.[78]

Arthur Rothstein • Dudes harmonizing in the back room of the beer parlor, Birney, June 1939. Prohibition was long gone when Rothstein visited Montana. Both he and Wolcott photographed dudes from the Quarter Circle U Ranch drinking and dancing in the bar down the road in Birney.

Arthur Rothstein • Cowhands singing after a day's work at the roundup, Quarter Circle U Ranch, June 1939. Cowhands on dude ranches were also entertainers. Jim Ryan, playing the guitar in this photo, had come to the Quarter Circle U as a dude wrangler in the 1920s. He was a talented musician and cartoonist, who made whimsical signs announcing ranch activities.

When Rothstein arrived in 1939, he found not only dudes in residence, but also a movie crew making a film on grazing for the Forest Service. As Rothstein drolly observed, "It looks pretty bad for the Dept. of Agric. when all the photographers and cameramen in the state converge on one ranch." Amidst this orgy of New Deal propaganda was "a record crop of dudes," and facilities were stretched. The men from the Agriculture Department ate in shifts and slept on the floor.[79] At first the family was skeptical of the photographic project but became increasingly interested and helpful, inviting Rothstein back to photograph roundup in October.

He regretfully declined because he was scheduled to shoot the sugar beet harvest in Colorado.[80]

William McLeod Raine visited the Quarter Circle U in the late 1920s and reported on his vacation for *Sunset Magazine*. Met at the train in Sheridan, Wyoming, by owner Jack Arnold, "a lean broad-shouldered cattleman" who answered questions "laconically," they drove to the ranch in a cloud of yellow dust, arriving in time for supper. Raine discovered he was the only guest in a jacket, which he soon exchanged for the dude's uniform of a cotton shirt, vest, trousers tucked into cowboy boots, a loosely tied bandanna around his neck, and a Stetson on his head.[81] Dude ranches were so popular in the 1930s that *Vogue* magazine ran a feature, "Dressing the Dude," which advised the prospective vacationer

Arthur Rothstein • Dudes at dinner, Quarter Circle U Ranch, June 1939. Lyman Brewster, who returned to the ranch in 1936 after a stint working for the Department of the Interior in Alaska, presides over the dinner table. The room is decorated with Native American artifacts, many purchased by the family from Northern Cheyenne Indians who lived nearby.

Arthur Rothstein • Jack Arnold, Quarter Circle U Ranch, June 1939. Rothstein took several pictures of cowboys rolling cigarettes, presumably not something he saw everyday on the streets of Manhattan.

on dude ranch couture: "practical" underwear, blue jeans, cotton and flannel shirts, a leather jacket, silk neckerchief, riding gloves, western boots, and a Stetson hat—"the latter not obligatory." The fashion arbiter also suggested that the jeans should be Levis, "the copper-riveted narrow blue denims that you can buy anywhere in the West or in New York at Best and Altman's."[82]

Arthur Rothstein • Anna Fjell cutting steaks, Quarter Circle U Ranch, June 1939.
Anna Fjell and her husband Avon both worked for the Quarter Circle U. Anna was
a renowned cook, and her daughter-in-law remembered they "worked like mad"
when dudes were in residence.

Arthur Rothstein • Dry goods counter in general store, Birney, June 1939. The general store in Birney carried supplies for local residents and clothes and souvenirs for guests at the area's dude ranches. The shelves hold work gloves and boxes of underwear. The counter case shelters Kodak film, postcards, neckerchiefs, and Indian beaded bags.

The Quarter Circle U was well known for its fairly unusual practice of allowing dudes to participate in roundup. The opportunity provided guests a chance to feel they were having an authentic western experience. The ranch also offered camping trips to the Crow Fair and the Little Big Horn Battlefield, following "the same trail which Custer used."[83] Raine partook of the usual array of activities: all-day horseback rides, swimming in the Tongue River, scrimmage polo, archery, bridge, "a little dancing in high heeled boots to the music of a victrola." After enjoying a rodeo at Lame Deer, Raine joined the roundup and even tried to bulldog a calf. It gave him "a little thrill to be riding circle on a real roundup." Successful

dude ranches, like the Quarter Circle U, gained their reputations from loyal customers, visitors who returned season after season. When Raine departed, he knew, "beyond argument, that next year he was coming back again to this outdoor world of the West that had now become his."[84]

Rothstein became as much a fan of the Quarter Circle U as Raine. He made an extensive set of photographs, including portraits of the owners and cowboys, the landscape around the ranch, as well as all the buildings, cowhands and dudes at their respective dinner tables, and ranch work. He zoomed in on boot scrapers and branding irons, chaps and saddles, the dinner bell and fence corners, and he stood back to capture the dust, action, and many participants in roping and branding. Undoubtedly also with introductions from the Quarter Circle U, Rothstein photographed on the nearby William Tonn and Three Circle ranches and then used his newly acquired knowledge of cattle culture to take photographs of a rodeo in Miles City. Reminiscing about his time on the FSA project, he recalled his experience on the Quarter Circle U Ranch as the stuff of movies, "to be in with real-life cowboys and eat at the same table with them and ride a horse, which I never had done before, to ride a horse over the range with them and take pictures of their various day-to-day activities was very exciting."[85]

(pages 136–137) **Arthur Rothstein • Three Circle Ranch roundup, Custer National Forest, Powder River County, June 1939.** Rothstein's photograph of cowboys rounding up cattle against a big sky proved to be extremely popular and was reprinted many times, but Walker Evans called it "that silly, sentimental picture."

LC-USF34-027599-D

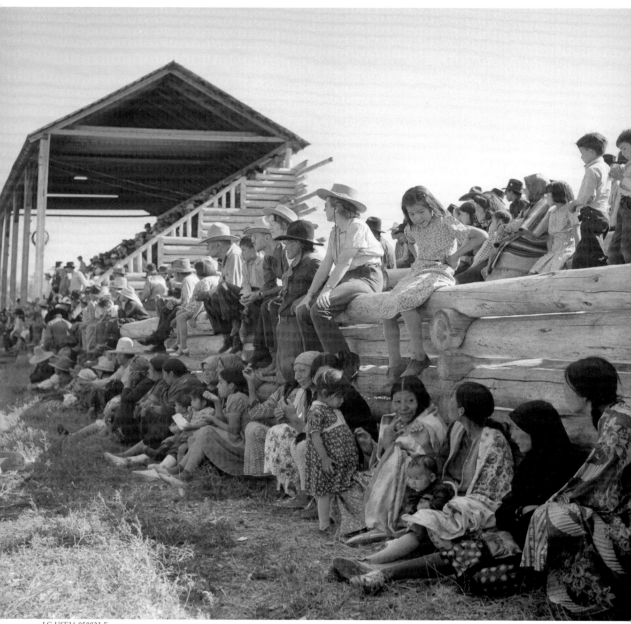

Marion Post Wolcott • Crow Fair, Crow Agency, September 1941. Indian women don a variety of shawls, blankets, and headscarves while female dudes are dressed in jeans and cowboy hats to watch activities at the annual Crow Fair. Inaugurated in 1904 to display the Crows' agricultural productivity, over the years Crow Fair became an important occasion for tribal cultural expression.

Marion Post Wolcott

IN JOHN COLLIER, JR.'s reminiscence about his FSA work, he wrote, "While I was wandering through this strange wilderness of New England with tradition so alien to my experience, an Eastern girl brought up in New England was for the first time driving into the Rocky Mountains and photographing all that presented itself that was new and wonderful." That eastern girl was Marion Post—Marion Post Wolcott after her marriage to Leon Wolcott in 1941. She grew up in New Jersey, not New England, but for Collier, who grew up in California and New Mexico, the two were close enough for conflation.[86]

Wolcott came to photography after experimenting with another art form, dance. Born in 1910, the child of a small-town New Jersey doctor and his far more free-spirited wife, Wolcott had a difficult childhood. Her parents divorced amidst scandal when she was thirteen, and she was sent away to boarding school, in part to protect her from gossip. Her mother moved to New York City and began working with Margaret Sanger, establishing birth control clinics throughout the country. Wolcott studied modern dance with Ruth St. Denis and Doris Humphrey and continued when she went to Europe in the early 1930s. Dance became part of her commitment to progressive education. A few weeks before she left Vienna, where she had been staying with her sister, Helen, who was studying photography with Trude Fleischmann, she was given a Rolleiflex camera and began taking pictures. Looking at the world through a camera lens coincided with witnessing the rise of Nazism. Wolcott later reflected: "Nazism was very real to me, a major threat to the future of the world and civilization. That experience made me

Jack Delano • Jack Delano Papers, Library of Congress. Jack Delano's cartoon of Marion Post Wolcott depicted the often unwanted attention she got from men when she was out in the field.

very anti-Fascist, anti-Nazi, as well as against any form of racial intolerance."[87] Fleischmann and Helen had encouraged her to continue using her camera, and when she returned to the United States in 1934, she began taking photographs for the Group Theater, a theater company that had emerged in the Depression with the intention of producing socially relevant plays, and she attended meetings of the Workers' Film and Photo League. She also became involved with the League Against War and Fascism. Her work for the FSA was imbued with a social conscience shaped by her mother's work, her education, and her experiences in Europe and New York.[88]

Wolcott applied to the FSA in 1938 with an introduction from her mentor Ralph Steiner and a letter of recommendation from Paul Strand, a well-known photographer committed to combining strong design and

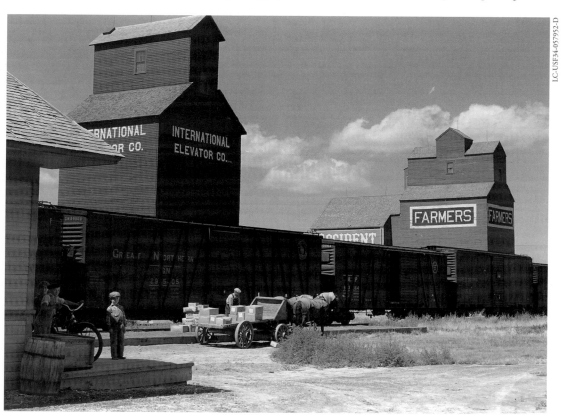

LC-USF34-057952-D

Marion Post Wolcott • Loading freight, Froid, August 1941. After riding their bicycles to the Froid railroad station, three young boys watch as Wolcott photographs a drayman loading boxes of freight the train has just delivered.

Marion Post Wolcott • Contour plowing and strip cropping of wheat fields, Great Falls vicinity, August 1941. Soil conservation was an important part of the New Deal's agricultural agenda. Contour plowing and strip cropping helped to prevent wind erosion and keep topsoil in place.

realistic portrayal in camera work. Shortly after her return from Europe she had begun teaching at Hessian Hills School in Croton-on-the-Hudson, where she also took photographs of the students. She quit teaching to devote her full attention to photography, and in late 1936 she became the only female photographer on the staff of the *Philadelphia Evening Bulletin*. A year and a half later, bored with her role as society photographer, she asked Ralph Steiner if he had any ideas for other work. He suggested the FSA and helped her put together a portfolio to show Stryker in June 1938; she was in the field by September. Wolcott spent the vast majority of her time in the South, and by late 1940 she was tired. She wrote to Stryker: "I think after Louisiana I will have had a temporary

Marion Post Wolcott • Harvesting wheat, Froid, August 1941. Wolcott documented the use of animal labor in harvesting as well as the latest agricultural technology during her time in Montana. Here, combines harvest wheat on the Schnitzler Corporation farm.

'bellyful' of the dear old South. *Sometimes*, I even have the faintest suspicion that I already have. At other times I know damn well I have. . . . You know I have never been west at all—hardly even middle west. Don't you feel sorry for me? Just a little bit?"[89] Whether Stryker felt sorry for her or simply decided that she needed a change of scene, he scheduled a western trip for her in summer 1941.

As always, Stryker sent her off with a long reading list and a comprehensive shooting script. He suggested that she peruse the works of historians and novelists Walter Prescott Webb, Everett Dick, O. E. Rölvaag, Willa Cather, Mari Sandoz, and John G. Neihardt, among others. By 1941 the worst effects of the Depression and Dust Bowl had eased, there were

many established FSA projects, and Stryker's instructions to Wolcott were different from those he gave Arthur Rothstein in 1936 when he first headed west. Stryker suggested that Wolcott look for "shots which give the sense of great distance and flat country . . . railroad track, telegraph poles stretching to horizon. Search for ideas to give the sense of loneliness experienced by the women folks who helped settle this country. . . . Again get the sense that there is nothing in the world that matters very much but wheat. Wheat & wheat just as far as the unaided eye can see. . . . The spare, bronzed and wrinkle-faced men of this section."[90]

Wolcott spent about a month in Montana from early August through early September 1941. She traversed the High Line, seeking to fulfill Stryker's requests. She documented the wheat harvest on the huge

LC-USF34-058137-D

Marion Post Wolcott • Freight train, Carter, August 1941. Wolcott is only one of many photographers who have been struck by the sight of trains traversing the Great Plains. This Great Northern train running between Havre and Great Falls carries mixed freight, including a flatcar of locomotive driving wheels. The Highwood Mountains are visible in the background.

Schnitzler Corporation farm in the northeast corner of the state, unpaved rutted roads, contour-plowed fields, and strip planting. Froid, Homestead, and Carter appear as lines of grain elevators and small frame buildings flanking the railroad. She used the telephone poles, fences, grain elevators, and freight trains of northern Montana as punctuation marks in her essay on the landscape of Big Sky country. She found the plains beautiful and, like all the photographers who worked in the region, daunting to photograph. She was eager for some response from Stryker indicating whether her attempts to capture the feeling of space, distance, and solitude worked. Like many plains visitors before and since, Wolcott wondered at the human cost of inhabiting these spaces. Speaking of the vast fields of wheat she had seen, she wrote: "I never imagined such expanses—& that beautiful rich golden & brown color. But god—at any other time of the year, how *do* they stand it! That flat space, & nothing stimulating. I can't even begin to comprehend it. And what it *must* do to the people." Stryker responded: "You have to get acquainted with the plains. It takes time. They have to be courted."[91]

Wolcott did not have a lot of time; she had other subjects to photograph, and she wanted to get home. She had recently experienced a whirl-wind courtship of her own. In the spring she had met Lee Wolcott, a widower with two children who worked for the USDA and lived on a ten-acre farm in Virginia. They fell for each other like the proverbial ton of bricks and were

Marion Post Wolcott • Going-to-the-Sun Highway, Glacier National Park, August 1941. In Glacier National Park Wolcott focused on "America-the-beautiful," even though it was not part of her assignment. She found the altitude made her "so dizzy & lightheaded & headachey . . . that I am not to be held completely responsible for the results."

married six weeks later in June 1941. A few days after the wedding Wolcott went to New England on a job, then with scarcely any time in her new home or with her new family, she headed west. What a year earlier had been a much anticipated trip, now took on the dimension of semi-exile. It would be her last field trip for the FSA, but she carried it out with her usual good humor and professionalism, and she liked the West she was finally getting to see.

"Having gotten an eyeful, cameraful, and earful of wheat, flatlands, & sun," she spent a brief weekend in Glacier National Park.[92] Wolcott is known for the strong landscape photography she produced for the FSA.

Marion Post Wolcott • Dude at rodeo, Ashland, September 1941. Not all Americans were poor and unemployed during the Great Depression, as Wolcott showed in this photo of a Quarter Circle U guest, dressed in her spanking new western gear and perched on the hood of a gleaming Buick.

In later years she said of this work: "The fact that I did take some pretty pictures was a result of my own feeling about the country. I would do them as I drove along because I felt good, I thought it was beautiful and I thought we needed that kind of thing in the files."[93] Her trip to Glacier was a perfect example. While she planned to "recuperate" in Glacier, "the weather & cloud effects were so dramatic, & such a startling change, & the mountains so terrific, that I just kept taking pictures . . . trying to get the weird, strange, quality & feeling that a human sometimes has in seeing mountains & being 'on top of the world,' & not exactly a part of it anymore." She told Stryker, "I didn't think you'd object to a little of that kind of America-the-beautiful in your files."[94]

Wolcott made no apologies for taking beautiful photographs of the American landscape. In her two years traveling through the South, before she came west, she photographed the poor and the wealthy—she was the only FSA photographer to picture the haves as well as the have-nots. But she took those photos always with a political eye, knowing that photographs of well-fed, well-dressed men and women attending horse races juxtaposed with ill-fed, ragged migrant workers was a powerful statement about the inequalities of wealth and opportunity in America. She pictured bountiful America, with its bounty profoundly maldistributed.

While her working time was absorbed by the FSA in the late 1930s and early 1940s, Wolcott was well aware of political developments in the world. From Montana she wrote to Stryker: "It's sort of awful to be separated from someone you love very much, for a long period, & at a great distance, & keep reading in the paper that we may be getting closer, very rapidly, to the kind of world system that may drastically, & perhaps tragically & seriously, change our whole lives. There seems so little time left to even try to really live relatively normally. I get very frightened at times."[95]

Wolcott was due at the Quarter Circle U Ranch, and as she drove southeast, she stopped in the Judith Basin, looking for threshing scenes. She found men cutting grass with a binder pushed by a four-horse team. Her pictures of this operation were a strong visual contrast to the pictures of mechanized labor on the Schnitzler Corporation farm. One of the interesting themes in the FSA work was the visual collocation of traditional animal labor and the increasing presence of internal combustion

engines. John Vachon photographed boys with their car on the main street of Judith Gap and a man with his horse on the same street in the same afternoon. The file is full of cars and trucks and mules and horses. The FSA's mission was to improve the condition of American farmers, and in many cases that meant loaning money to buy tractors and modernize farms. Yet that impetus toward modernization and cash crop agriculture was always in tension with a sentimental attachment to subsistence farming. A steady bass line in the chorus of criticism of the period was the cry that voracious mechanization was destroying family farms. John Steinbeck brought the tale to dramatic life in *The Grapes of Wrath*, in which unswerving tractors push the Joads and other tenant

Marion Post Wolcott • Cutting clustered wheat grass, Judith Basin, September 1941. Wolcott drove all over looking for horse-drawn equipment in response to Stryker's request for such pictures.

Marion Post Wolcott • Grain elevator and Great Northern freight train, Great Falls, August 1941. FSA photographers pictured all phases of grain production and shipment. A switchman perches above the Great Northern emblem that reads "See America First—Glacier National Park" in this photograph of a train beside the Royal Milling Company flour mill in Great Falls.

families off their farms. Steinbeck studied the FSA file for inspiration and made FSA migrant camps one of the only humane places in the book. The irony was that the tractors that pushed tenants off their land were paid for with loans from the AAA.

Wolcott spent late August and early September on the Quarter Circle U Ranch. In addition to photographing hands working with horses, the visit of hide buyers, and the play of dudes, she accompanied guests on several outings, to a rodeo at Ashland, to a stockmen's barbecue at Wyola, and to the Crow Fair. All three were important community celebrations. The Brewster sons had grown up riding broncs in local rodeos, and

stockmen's barbecues had been widespread in cattle country in times of plenty. A worker on the Montana Federal Writers' Project had gathered an account of one such barbecue in Fergus County, where "juicy meat" anchored a feast that included "loads and loads of boiled and mashed potatoes, steaming hot; . . . bowls and bowls of juicy brown gravy; your choice of brown or white homemade bread; string beans, pickled beets, peas in cream, apple sauce, mustard and horseradish, hot coffee and tea, milk and cold spring water"—all more than enough "to test the appetite of anyone who happened to be around."[96] Wolcott's photographs captured the congenial visiting of neighbors as well as the atmosphere of spectacle and competition at the rodeo.

Marion Post Wolcott • Dudes in a covered-wagon seat, Quarter Circle U Ranch, August 1941. The romance of the West was one of the major selling points of dude ranches in the 1920s and 1930s. As one guest at the Quarter Circle U reported, in addition to attending a rodeo and having a chance to participate in a roundup, "there were pretty girls to be talked with."

Marion Post Wolcott • Dudes and cowboy from the Quarter Circle U at Crow Fair, Crow Agency, September 1941. Wolcott, Vachon, and Rothstein all zeroed in on the clothing and gear of western cowboys and dudes in their portraits of the many sides of Montana's ranching business.

For the Quarter Circle U, the Crow Fair provided another venue for entertaining guests, and the Brewster-Arnold outfit often arranged a camping excursion in concert with it. Indian agent Samuel G. Reynolds inaugurated the Crow Fair in 1904, modeled after the midwestern county fairs of his youth. Originally designed to display the success of Crow farmers, men and women exhibited their prize vegetables, farm animals, baked goods, and sewing. Crow Fair allowed all the Crows to gather together, and over the years the fair became an opportunity for tribal

Marion Post Wolcott •
Sheepherder's wagon,
flock and pen, Rocky
Mountain Front Range,
September 1941.

LC-USF34-058374-D

members to parade in elaborate beaded outfits, to dance, and to demonstrate their prowess in horse races and rodeos. It also became popular with non-native audiences. Painters, such as Joseph Henry Sharp, and photographers, such as Elsa Byron Spear and N. A. Forsyth, often came to Crow Agency to render the fair.[97] Wolcott took only a few pictures of dancing and of tepees set up in the fairgrounds; she focused most often on the spectators, both Indian and non-Indian, perhaps feeling most comfortable taking pictures of people in the same role as she.

Stryker had wanted Wolcott to take photographs of cattle and sheep as well as wheat, but livestock was far more elusive than grain. The weather had been bad at the Quarter Circle U, and fall roundup had not yet begun. She headed south through Wyoming, which was an exercise in frustration. Stopping at the "biggest sheep ranch in Wyoming" because she was tired of hunting for cattle and sheep on her own, she asked for some help locating stock to photograph. "They said sure, delighted, etc., etc., & we started out—on & on & on & on—over tracks, over pastures, over hills, up hill, down hills, on & on & on & on, searching for sheep—'lots of sheep out on the range, lady—don't know exactly where but we'll find some for you.'" No sheep appeared, and in the evening the hands took her down to the sheds to view the prize sheep that they shipped all over the world, not exactly the subjects she had been hunting.[98]

Continuing south to Colorado Wolcott ran into a blizzard and had to have a snowplow pull her back onto the road. She kept her sense of humor, even as cattle proved as camera shy as sheep. "Now—about your cattle in the great BIG West. It's harder to get 'portraits' of bulls, or cattle on the range or calves sucking, than it is to get into United Aircraft for pix! . . . Somebody should photograph me for the records—lying in ambush among the sandburrs, for hours, trying desperately to get pix of the beasts going to a water hole, or around a windmill. They don't like cars, nor people on foot, nor cameras, nor girls with cameras, even with 'jeans' on." Cattle ranchers proved as elusive as cattle. Jack Arnold at the Quarter Circle U had given her a list of stockmen in various western states, but as she worked her way through Wyoming, Colorado, and Nebraska, none of them were at home. They were all in Washington, D.C., testifying for tariffs on South American beef. Wolcott finally "decided to go east & look in our own backyard, where I'm personally

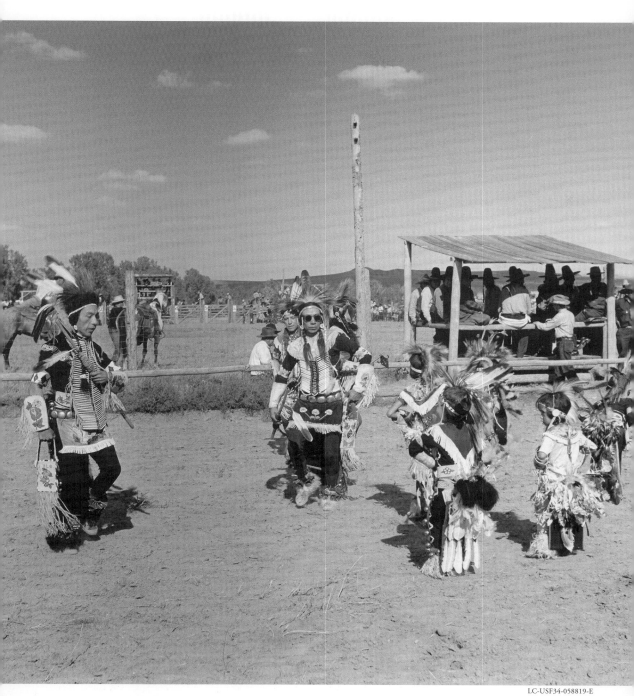

Marion Post Wolcott • Crow Fair, Crow Agency, September 1941. Most of Wolcott's photographs from Crow Fair depict spectators, but here she shows one generation of dancers learning from another, while men gathered under a shelter look on, their tall-crowned hats making a lovely silhouette.

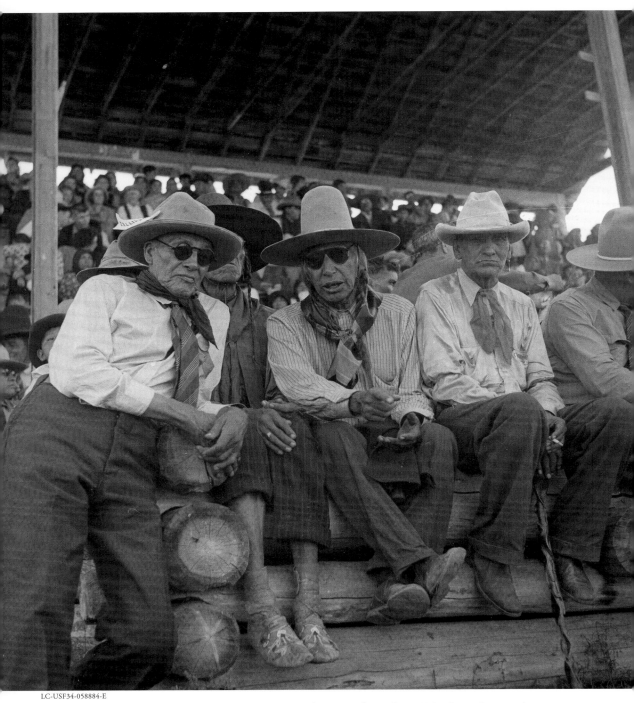

Marion Post Wolcott • Indians watching Crow Fair, Crow Agency, August 1941.
From the shelter of the grandstand Indians wearing moccasins and sunglasses watch
and comment on a performance at the Crow Fair.

acquainted with some mighty pretty head of Hereford cattle being fattened & raised on the grasses of Virginia. Their mother cows probably didn't ever warn them to stay away, or run away from photographers either. I'm sure Eastern livestock is better trained."[99]

This was Wolcott's last long field trip for the FSA. The Wolcotts were newlyweds; Lee wanted a full-time wife and mother, and Marion wanted to take up that new challenge. In February 1942, several months pregnant, Marion Post Wolcott resigned from the FSA.

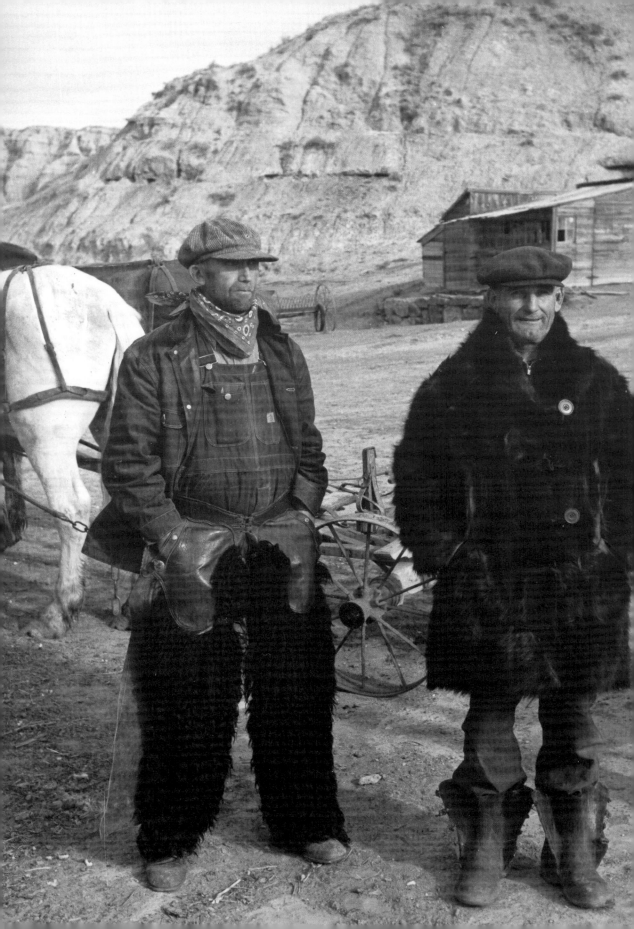

Russell Lee

IN FALL 1937 Russell Lee was working his way across the northern plains documenting "the effects of drought upon the people."[100] Thirty-four years old when he arrived in Montana, Lee had photographed drought in Iowa and the aftermath of flooding in the Ohio and Mississippi valleys before Stryker sent him to the northern plains. Just before coming to Sheridan County, Montana, he had been in North Dakota, where he worked with his typical focus and energy. Arriving in Williston late on a Thursday evening, by Tuesday he had arranged to go out with the county nurse to photograph health conditions (which he later described in great detail in a letter to Washington), to spend a day making a survey of farm laborers who had moved into Williston and were living in a shanty town, and to photograph an evening meeting of the Farmers Holiday Association. He had also talked with enough people to identify where he should go to photograph sugar beet workers in Montana and to get a sense of how the drought had affected local school funding. In between he had dealt with correspondence from the Resettlement Administration offices and developed a quantity of film.[101] A few weeks later Stryker asked him if he felt he would be rushing too much to get to Montana that fall; he did not want Lee to think that "we are hurrying you too much. But I know that you and I share an urge alike, that is, a desire to photograph the whole United States at once. Have a feeling that if we don't do it this year, it may blow away by next year."[102]

Of all the members of the FSA project, Russell Lee and Roy Stryker probably did most closely share the same agenda. Lee did not seem to feel the same tension that sometimes characterized Stryker's relationships with other photographers. Perhaps it was because he was a few years

Russell Lee • Farmers, Sheridan County, November 1937. Martin Olson (left) from Sweden and Fred Lee (right) from Norway were friends, neighbors, and part of a community of immigrants who celebrated the Fourth of July on the Olson place. Fred Lee died a few years after Russell Lee made this photograph. Olson lived alone until his death in 1963 when the house in the photo caught fire and incinerated him and his dog. LC-USF33-011369-M5

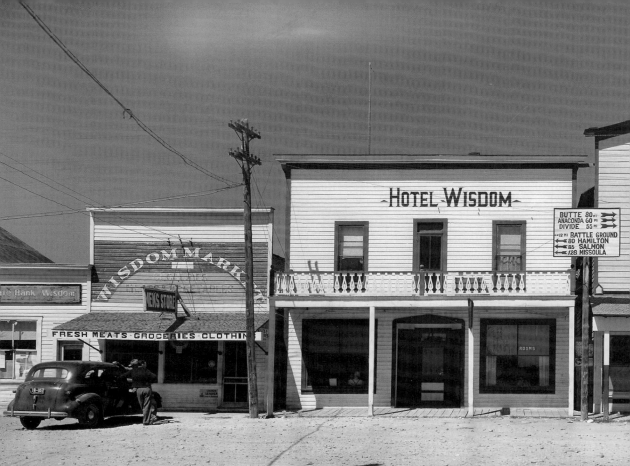

Russell Lee • Main street, Wisdom, Big Hole Valley, August 1942. Wisdom was the market town for the Big Hole Valley, which one resident called "a haven of traditionalism," where "they reduce the hay/cattle relationship to its essentials: one crop—hay—one cash source, cattle." In 1942 when Stryker wanted to show the plentitude of food in America, the Big Hole was a cornucopia of beef.

older and better traveled and seemed less in need of direction, or perhaps because he was rarely in Washington, D.C., and his interactions with Stryker were conducted predominantly through letters. Whatever the reason, Lee and Stryker's relationship was more egalitarian than Stryker's relationship with the others, and over the years the two developed a true friendship. Lee felt perfectly comfortable making suggestions to Stryker about administrative processes and procedures as well as subjects to be photographed.

It is also true that from Stryker's point of view Lee caused him no headaches. Lee was an indefatigable photographer for the FSA, equally fascinated by the technical puzzles of photography and the aesthetic

challenges of conveying stories through that medium. He and Arthur Rothstein were constantly exchanging information about their experiments with film and equipment, always searching for ways to get sharper negatives, better exposures, finer technical quality. Lee was also a voracious researcher, pulling into his orbit novels, magazines, government bulletins, technical journals, anything that would give him a more thorough understanding of the country and people he was photographing. He once informed the Washington office that the Bureau of Labor Statistics's monthly reviews contained "swell studies on wage earners of different cities." In the same letter he reported on an article in *American Forests* and recommended two USDA bulletins.[103] In 1942 he informed Stryker that he planned to subscribe to *Fortune* magazine because he thought it would help him with his industrial photography and asked if it would be okay for it to be sent to the Washington office and then forwarded to him since he was on the road so much.

Lee had tremendous energy and purpose, but he also had a warmth, a sense of humor, and an obvious concern for people that put strangers at ease and allowed him to take intimate photographs of hundreds of American families. A friend, who first met him in Washington, D.C., in 1941 recalled that Lee had "a smile that wrinkled his face around the eyes and mouth with laugh lines that obviously were working most of the time." Minnie Harshbarger, whose family he photographed in Sheridan County in 1937, remembered him as "a nice person, not forceful, considerate and polite," qualities summed up in another friend's description of Lee as "a perfect gentleman."[104]

Jack Delano • Jack Delano Papers, Library of Congress. Jack Delano's cartoon of Russell Lee portrayed him as larger than life, a heroic photographer, leaving a trail of used flashbulbs in his wake.

By the time Lee arrived in Montana in November 1937, he was a veteran of the project. Stryker had hired him after seeing a portfolio of his work in summer 1936, although Lee had been photographing for only a short time. Educated as a chemical engineer, Lee had married artist Doris Emrick in 1927. Two years later he quit his job as a plant manager

in Kansas City, and he and Doris moved to San Francisco, where they both studied painting at the California School of Fine Arts. In 1931 the Lees moved to New York, where Russell took classes from John Sloan at the Art Students' League, where many of America's most important twentieth-century artists studied and painted. Whether through happenstance or plan, Stryker employed several photographers educated in fine arts: Ben Shahn, Russell Lee, Jack Delano, John Collier, Jr., and John Vachon. In a discussion among the photographers at a 1979 reunion, they speculated on the artistic traditions that had influenced them. Lee noted the impact of Daumier, Delano of Brueghel as well as Daumier, Collier of Goya and Bosch. Although Lee always insisted that art had nothing to

LC-USW3-008779-D

Russell Lee • Anaconda Wire and Cable Co., Great Falls, September 1942. Producing goods for the war effort required enormous amounts of electricity. Demand for copper wire and cable for use in electric motors and wiring in ships and factories, as well as transmission lines, skyrocketed. Copper towns, plagued with unemployment in the 1930s, begged for workers in the 1940s.

Russell Lee • Circus wagons made by Mr. George Whitmarsh, Archer, November 1937. George Whitmarsh wanted a circus, so he built his own circus wagons in the town of Archer in Sheridan County. Whitmarsh had a calliope, and while he never managed to acquire a collection of wild animals, he did display a neighbor's Saint Bernard.

do with his FSA work, years of training, painting, and discussion with artists in California and New York undoubtedly shaped the eye with which he composed his photographs.[105]

At the time Stryker hired him, Lee and his wife were living in Woodstock, New York, and Russell had taken up the camera in hopes that photographing people would improve his portrait painting. But within a short time photography seduced him. He recalled, "I found I was intended to work with the camera instead of the canvas."[106] The chemical engineer in him loved the mechanics and chemistry, the artist found himself looking at the world in a new way. It was 1935. Doris was painting scenes of American rural life and starting to win commissions for federally funded post office murals. The New York and Woodstock artists' communities of which they were a part were increasingly politicized. Photographing "auctions where poor people were selling off all their household

Russell Lee • John Herlihy and his wife at home, Butte, October 1942. Lee photographed John Herlihy underground in his capacity as shift boss and then with his wife in their bed-sitting room. A common theme of FSA photographs was how hard people worked to gain a measure of comfort in their homes.

goods" and men digging coal from "bootleg coal mines," Lee's camera work began honing his social conscience.[107] His early photographs from New York City are reminiscent of Dorothea Lange's pre-FSA photographs of San Francisco. Compelled by the devastating suffering that surrounded them, Lee and Lange began photographing the unemployed men and women on the streets of their respective cities, not necessarily knowing what use or venue their photographs might have. Lee's pictures of New York capture the motion of the city, the great visual richness, and a profound sympathy for the unemployed.[108] By 1936 he was devoting all of his time to photography, and magazines were beginning to publish his work. That year he saw an exhibit of FSA photographs and decided it was

exactly the sort of work he wished to do. He had his friend Ben Shahn put him in touch with Stryker.

Stryker liked Lee and liked the portfolio he showed him, but he was not able to hire him until later in the year when Carl Mydans left the project to join the staff of *Life* magazine. Russell Lee officially joined the Historical Section in September 1936, and he remained until January 1943,

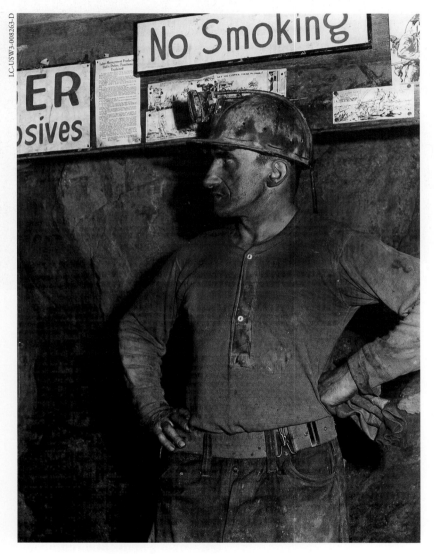

Russell Lee • John Herlihy, shift boss, Butte, September 1942. John Herlihy was a shift boss at the Mountain Con mine. Tacked on the timber behind him are safety posters and cartoons depicting the strategic need for copper during World War II, including one that urges "Get the copper there in time."

Russell Lee • Elmer "Hominy" Thompson in his shack home, Sheridan County, November 1937. A photograph that at first glance seems a classic portrait of "the forgotten man" of the Great Depression conceals a more complicated story. "Hominy" Thompson was a legendary character in Sheridan County, a cowboy who had come up the trail from Texas and the first white settler in the area. He was squatting on public land when Lee photographed him, having lost his land in a dispute with the railroad.

when he joined the Still Photography Section of the Air Transport Command. Lee photographed for the project longer than anyone else and took more pictures than any other photographer: "It was the best job I ever had."[109]

Russell Lee spent only a few days in Montana in 1937, but he took the memorable photographs of the Harshbarger family in Sheridan County, as well as several other portraits. While working in the Midwest photographing tenant farmers, Lee had become frustrated with what he could portray using only available light. As he remembered: "There was a limit to what you could do with the outside of buildings. After having

photographed about ten farmsteads in various ways in the outdoors, with people standing in the doorway and working outside, I decided that perhaps the story was inside the houses. So I began to bring out the flash camera."[110] Lee was the first of the FSA photographers to use flash extensively in order to film the inside of houses, apartments, factories, and, in the case of the West, dugout homes. Lee believed that a home's interior revealed much about a person's or a family's life. As he said, "Here was the way people lived . . . and I wanted to get this."[111] He turned his lens on a cabin's stove, a bedroom dresser, a kitchen table in order to reveal the details of daily life. Decades later, when he taught photography at the University of Texas, he had students choose an area no larger than one-hundred-by-one-hundred feet and "document it extensively and intensively."[112] Yet his approach to documentation was more than simply making a record. He taught that photography was a means to seeing and once said: "You don't need to tell people everything that you do to develop a picture. You take the picture and show it to them and let it speak for itself. You need to leave something to people's imagination."[113] In the 1930s he wanted viewers to be able to imagine what life was like for the people whose homes he photographed. He wanted his photographs to "help the people."[114]

An unremarkable photo that Lee took in Sheridan County illustrates the way he crafted portraits to show the human face of the Depression. "Mr. and Mrs. George Jackson, formerly prosperous farmers, now on relief," shows Mr. Jackson sitting in an oak rocker. Legs crossed, his high lace-up work boot is smack in the middle of the picture and draws the viewer's eye up to the rest of his clothing: cuffed overalls worn under a mud- or paint-spattered canvas jacket and over a couple of shirts. Unshaven, wearing the cap donned by farmers in dozens of other pictures, in one scrupulously clean hand he grips an empty pipe. He is turned in conversation to his wife who sits next to him in her neat, flowered housedress, stockings, and lace-up shoes. She has been reading a magazine. Plank walls and floor, the corner of a stove, a Chase and Sanborn coffee crate, and a small dog form the setting for their conversation. There is a hammer on the floor. The Depression might have brought them great difficulties, but they have each other, and they still have their dog. They keep themselves neat and clean; they read and talk to each other. No

matter how little they might have in the way of material wealth, they are a family.

Lee returned to Montana in 1942, this time to photograph the country in full wartime production. On this trip Lee was accompanied by his second wife, Jean Smith Lee. Russell and Jean had met in 1938 in New Orleans, where she was a stringer for *Time*. As Jean recalled, "It didn't take fifteen seconds for us to know we belonged together," and "without the vaguest idea of what I was getting into," she began traveling with him.[115]

Russell Lee • Mr. and Mrs. George Jackson, Plentywood, November 1937. Lee described the Jacksons as "formerly prosperous farmers, now on relief."

Russell Lee • Benbow chromite mine, Stillwater County, September 1942. A cook who had worked for over twenty years in western work camps opined that "railroad workers are the hardest to please and that miners are the easiest to please. . . . Lots of fried chicken, lots of potatoes, lots of beef, veal, and mutton, and lots of pastry. . . . Give the average Montanan that kind of food and you will win your spurs as being 'one damned good cook.' "

Jean was Russell's "unsung collaborator" from that point on. Russell said, "she could get anyone talking," and that ability, combined with his warmth, forged a wonderfully effective team.[116] Jean's journalism background made her adept at taking notes and writing captions and stories to accompany Lee's photographs, freeing him, as he remembered, to devote practically all his time to photography. She also helped out by carrying "a great big bag of flash bulbs."[117] One letter that she wrote to Stryker from Ontario, Oregon, illustrated her role as full partner—albeit unpaid one—in the project. She reported extensively on the photos that Lee had taken, passed along a request he had for Rothstein to talk to someone about developing 35mm film, filled Stryker in on the adventures of a bunch of FSA men, including Lee, who had gone pheasant hunting,

hinted that she had done the scheduling for shooting at the state Grange conference, and concluded, "I haven't taken over the job of writing Russ' letters—its just when he is rushed he doesn't want you to think that he had forgotten that he is working for you."[118]

During his tenure with the FSA, Lee became known for his skill in producing photo essays, using series of photographs to convey particular tales of American life. In 1941 he and Jean published an article in *US Camera* that contained forty-five photographs of Pie Town, New Mexico, which he presented as "the last frontier." It is his best-known work in this vein.[119] But he was always thinking in terms of stories, and that was true while he was in Montana. He and Jean based themselves in Butte for much of September and early October, traveling from there to Nye in Stillwater County to photograph two new mines where workers extracted chromium ore for producing special alloy steels and other strategic products. They also traveled to the Big Hole Valley to photograph haying and to the Gravelly Range in Madison County to photograph sheep grazing. But the main story he covered during that time was copper production. He took pictures in Butte, Anaconda, and Great Falls and was happy with the cooperation he received from Anaconda Company officials. He reported to Stryker that he was the seventh photographer to come to Butte for a story; *Life*, *Look*, the Associated Press, and "God knows who else" had

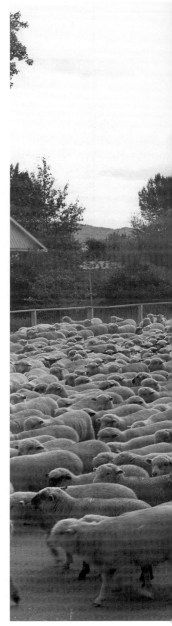

Russell Lee • Sheep, Sheridan, October 1942. Lee simply captioned this photo "sheep." Stryker had exhorted the photographers to get pictures of sheep raising since 1936. By 1942 Lee probably had nothing left to say on the subject.

already been there.[120] While the government had arranged for him to photograph Anaconda Company properties, it was Lee's idea to contact the miners' union and do a photo essay on it as well. He was full of ideas for still more stories. He thought a sequence of photographs about Butte's ethnically diverse population might show America's relationship to

Europe and help solidify wartime unity. He took a set of photographs of a scrap salvage campaign in the mining city. He hoped that when he was en route from Butte to Great Falls he would have time to photograph sheep shipping in the Deer Lodge area and the potato harvest near Great Falls.[121] An article he read in the *Saturday Evening Post* about Nazi research and technology prompted him to query Stryker as to the feasibility of doing a story on American ingenuity.[122] Lee's technical background was particularly useful in his industrial photography, and he was fascinated by the processes as well as the wartime significance of what he was documenting. Above all, his photographs show respect for the workers of whatever industry he recorded.

LC-USW3-009706-D

Russell Lee • Home and car of Victor Rauh, miner, Butte, October 1942. Many people commented on the poor upkeep of housing in Butte in contrast to the good cars, nice clothes, and often healthy savings accounts of miners, not realizing that the boom-and-bust economy encouraged people to improve only what they could take with them if laid off.

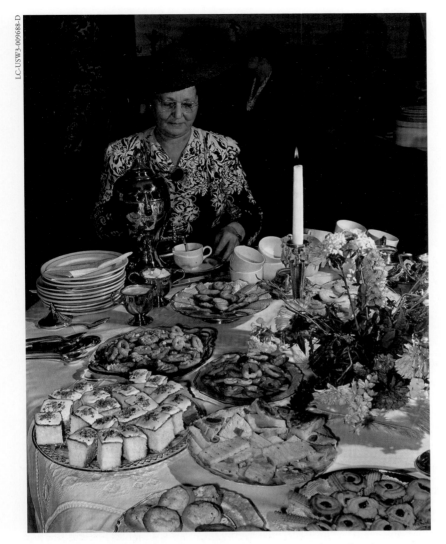

Russell Lee • A laden tea table, Butte, October 1942. Lee planned to do a story on Butte's ethnic groups, but only took pictures of this tea at the Little Norway Knitting Club and a joint meeting of the Young American Serbs Club and the Serbian-American Society. At both meetings the United States flag and the flag of the ethnic group's homeland were prominently displayed.

The Lees did not work all the time. They found a Butte restaurant "serving wonderful 2 inch thick steaks" and tried to lure Stryker into coming out to visit by promising to treat him to one.[123] They also took a vacation once they finished the copper story. After a week fishing and reading at Mack's Inn, southwest of West Yellowstone, they drove through

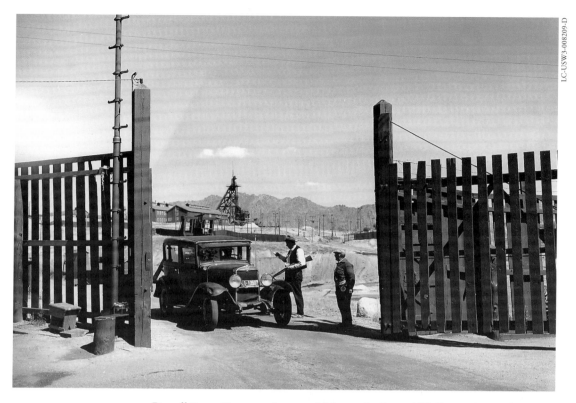

Russell Lee • Copper mine gate high on the Butte hill, Butte, September 1942.
When he was taking pictures of copper production during World War II, Lee was
stopped and questioned by the FBI. He showed them his FSA identification card and
a letter assigning him to photograph the copper industry. They let him proceed with-
out noticing that his identification card had expired.

Grand Teton, Yellowstone, and Glacier national parks en route to Oregon
and more work. Unlike Rothstein, Vachon, and Wolcott, Lee did not get
caught up in the western mystique of Montana, but he did conclude,
"Montana was beautiful at that time of year and it seems like a damned
fine state from the standpoints of country and people."[124]

By fall 1942 the Lees had been in the field for eighteen months.
Russell needed to take care of family business in Illinois, and he wanted
to get back to Washington, "feeling the need of more personal contact for
a short while."[125] He had issued several invitations to Stryker to join them
in the field, but Stryker was absorbed with preserving the Historical
Section and overseeing its transfer to the Office of War Information, a
process that was completed in October 1942. The war had changed the

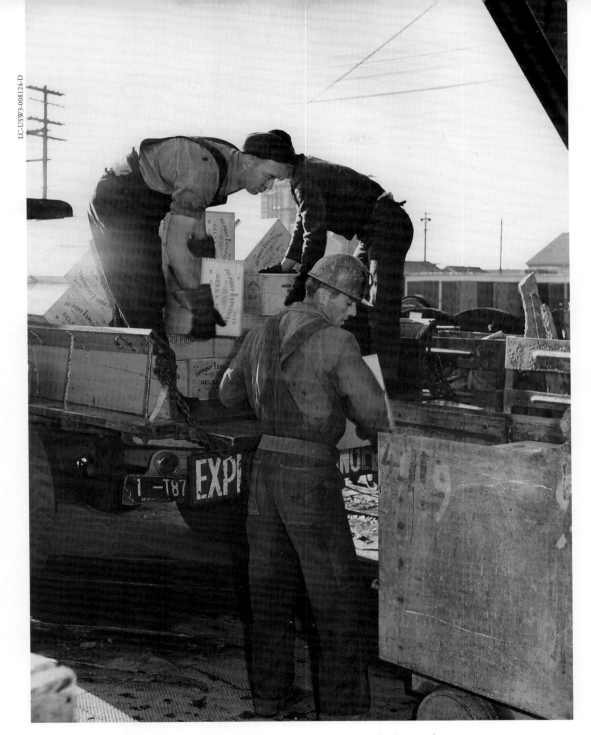

Russell Lee • Men unloading powder, Butte, August 1942. Men transfer boxes of Dupont Gelex No. 2 to a mine car in order to transport it underground where it will be used to blast rock loose. Dynamite boxes were always made of wood and held together with pegs or glue because nails could attract static electricity or spark, potentially causing the dynamite to explode.

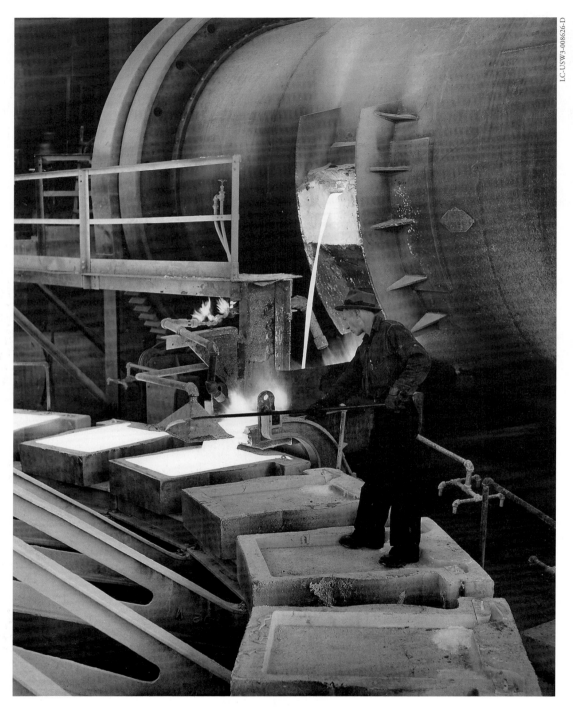

Russell Lee • Anaconda Copper Mining Co. smelter, Anaconda, September 1942.
Molten copper is cast into anodes, which will be shipped, suspended by their "ears,"
in rail cars to Great Falls for electrolytic refining.

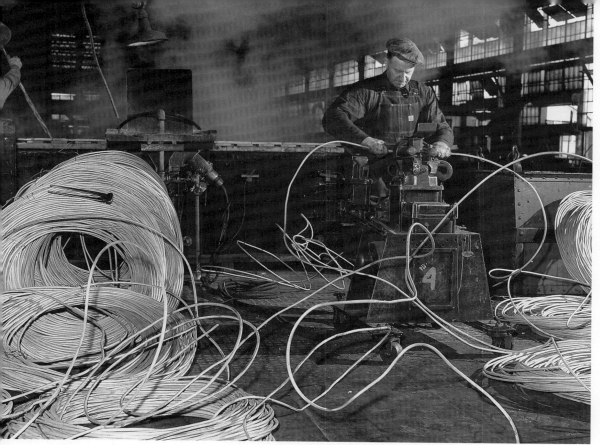

Russell Lee • Anaconda Wire and Cable Co., Great Falls, September 1942. A worker at the Anaconda Wire and Cable Company makes an electro-weld in order to join two pieces of copper wire.

purpose of the Historical Section and was changing the photographers' working conditions. Lee reported from Anaconda that he had been stopped and questioned by the FBI, and he hoped that the photographers would soon get better identification cards. He did not anticipate problems with law enforcement in the big cities, but thought his legitimacy might be hard to prove to "the two bit constable in the smaller town."[126] Lee's brother-in-law had just been drafted, and he had been expecting to hear that some of the photographers had also been called up. That December, while back in Washington, Pare Lorentz, who had been commissioned to put together a photography team to shoot briefing pictures for the Air Transport Command, recruited Lee to join the crew. In January 1943, at age thirty-nine, Lee left the FSA and joined the service.

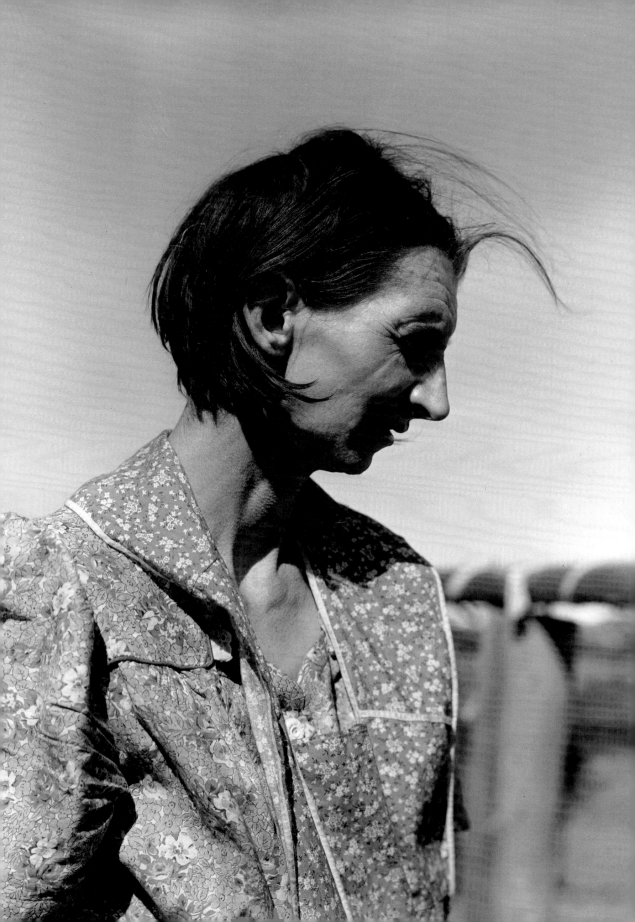

John Vachon

LIKE ARTHUR ROTHSTEIN, John Vachon came of age on the FSA project, and like Rothstein, he fell in love with the West. Just twenty-two when he began working for the Historical Section, in the seven years he was with the FSA-OWI project, he married, fathered two children, and found his calling—he would be a photographer until his death. Two trips to the West for the project instilled in him a deep affection for "that land of vast space and wild blowing snow." The Dakotas, in particular, became one of his "favorite places in the world, like Paris, or the Italian Riviera, only different."[127] Montana in 1942 also captured his imagination, especially the Big Hole Valley. Montana was part of John Vachon's last trip for the Historical Section, a marathon six-month sojourn which began in Maryland, reached as far as Idaho, and wended its way back to Nebraska. There his sorely tried tires finally gave out, and unable to acquire replacements, he took a train back to Washington, D.C., to discover he was the only photographer left on the staff. All the others had gone to war.[128]

Vachon inherited his wandering feet from his father, a traveling stationery salesman. Growing up in an Irish Catholic family in St. Paul, Minnesota, where he attended school and college, he wanted to be a writer and started keeping a journal when he was nineteen. He wrote short stories and a novel, which never found a publisher, and he composed scads of letters when he was on the road. In pursuit of a graduate degree in English, he arrived in Washington, D.C., in 1935 to attend Catholic University. Drinking got him expelled, and the need for a job led him to the position as assistant messenger in the Historical Section. There Stryker encouraged him to study the photographs, Walker Evans and Ben Shahn taught him how to use a camera, and a new FSA photographer emerged.[129]

John Vachon • Mrs. Ballinger, wife of an FSA borrower, Flathead Valley, March 1942. The photographers often traveled to "FSA farms" to document the hardworking men and women who had borrowed from the program to buy land and equipment. This portrait of a gaunt woman in her print dress and calico apron was typical of FSA photos of farm women, but not what Stryker wanted in 1942.

LC-USF34-065186-D

Jack Delano • Jack Delano Papers, Library of Congress. Vachon appears unflappable in Jack Delano's cartoon set in the mountain passes Vachon found so appealing.

Stryker had sent Vachon to the West to photograph plentitude. The country was at war, and Stryker was gathering ammunition, photographs that would depict a nation with the resources to fight a war and a society worth defending. He instructed Vachon to get pictures that showed "lots and lots of sheep and cattle," that portrayed "women in the kitchen, women gardening, women working," and more photographs of middle-class Americans and white-collar workers.[130] When Stryker sent Vachon a batch of his photographs, having "killed"—marked unworthy of putting in the file—a portrait of a couple on an FSA project in Kalispell who, as Vachon described, "don't look healthy wealthy or wise," Vachon responded that he wanted Stryker to reconsider. "I recognize your motive," he told him, "that we want good looking people and to hell with you have seen their faces." (He was referring to Margaret Bourke-White and Erskine Caldwell's 1937 photo book on southern sharecroppers titled *You Have Seen Their Faces*). But Vachon liked the photo and thought it was important to the FSA story, even if the thrust of the project had changed with the war.[131] Unfortunately, we do not know whose judgment prevailed since Vachon did not describe the picture in enough detail to determine if it is in the collection.

As had Rothstein, Lee, and Wolcott, Vachon approached Montana from the Dakotas. He was pleased with the work he had done there, especially the snow scenes he captured in North Dakota, and his joy in driving across the plains is clear in his letters to Stryker and to his wife, Penny. From Dickinson, North Dakota, he reported: "Every time I leave one town for the next one I get pretty damn exhilerated about the miles of nothing rolling around me. . . . I like this country plenty, especially the no trees."[132] He had plenty of time for absorbing the landscape, since the wartime speed limit was thirty-five miles per hour, and he nursed bald tires for virtually the entire trip. As always, Stryker had sent him west with reading material, including the 1939 Federal Writers' Project's *Montana:*

A State Guide Book, which enticed him with descriptions of "precipitous mountain pass roads" and "roaring gulch mining town stuff."[133]

During Vachon's time in Montana, from early March through April 1942, he reveled in all things western. He made no pretense that he was anything but a greenhorn, and people took him in, fed him, entertained him, educated him, and let him take their pictures. He loved the cowboys, the hospitality, the drinking. He made clear his fervent embrace of the

LC-USF34-065562-D

John Vachon • Son of Ted Barkhoefer, Hamilton, April 1942. A lighthearted moment in the FSA file, this photo also illustrates a modern, up-to-date kitchen of the 1940s with refrigerator, electric mixer, toaster, new linoleum, central heating, and a brand new stroller for the baby. It was in keeping with Stryker's request that the photographers get more pictures of the middle class.

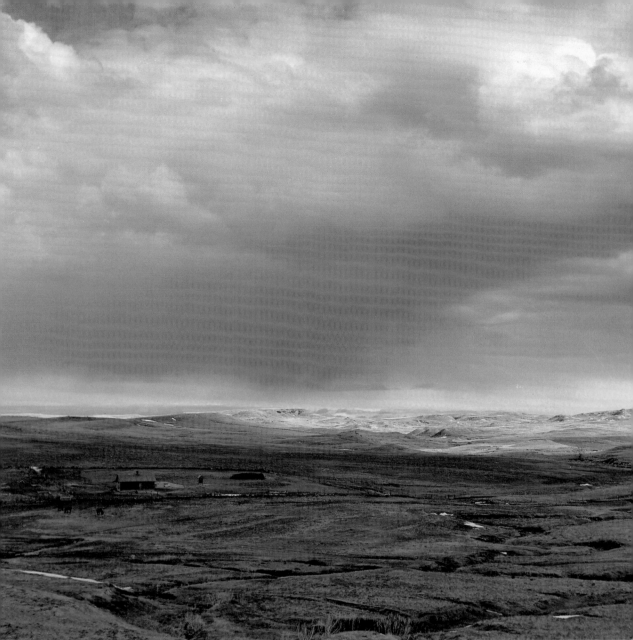

LC-USF34-064963-D

West and all that he "knew" as western and proclaimed his belief that "this is the most wonderful country ever."[134] Delighted to receive silver dollars in change, he planned to save them all but ended up needing to spend them. He got "a haircut, good and short, Montana style," and he wished he had enough money to buy a jacket of some sort and a broad-brimmed hat since "city overcoats are extremely conspicuous" and his was worn out to boot.[135] Vachon was making about $150 a month and had left behind

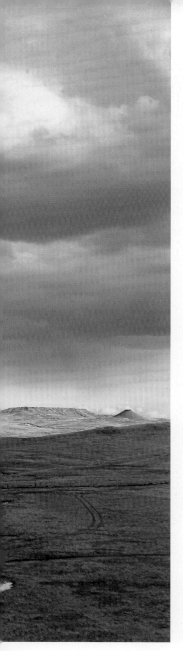

John Vachon • Sheep grazing land, Garfield County, March 1942. Outside of Jordan, Vachon climbed a butte to investigate one of the stone cairns he had seen throughout the country and met a sheepherder who told him they were "built by sheepherders when they've got nothing to do, which is mostly, I guess." Here he captured the vast expanse of grazing land in eastern Montana.

in Maryland not only his wife, Penny, but his daughter, Ann, and infant son, Brian. Money was tight, and his letters reveal careful juggling of funds in order to send home enough for them and keep enough to enable him to do his work until he received reimbursements for his expenses.

Despite his enjoyment of Montana's landscape and people, his time in the state was also fraught with self-doubt. He wrote to John Collier, Jr.: "Yep, it's wonderful the West . . . but photographically I seem to be moving pretty clumsily through it. . . . I'm not very happy about anything I've done yet. I spend most of my time driving the car and singing Home on the Range."[136] He received little communication from Stryker during these two months, and he worried that his photographs were not any good; he wondered about the meaning of his work, and increasingly he encountered people who thought the government paying a young man to take pictures while the country was at war was a foolhardy and wasteful enterprise. He foresaw the end of the project and pondered what the future held for him. He spent many evenings in movie theaters or in his hotel room, often discouraged. From Lewistown he wrote Penny that he spent the night happily drinking whiskey, reading Walt Whitman, and looking out the window of his cozy hotel room.[137] But there were many other nights when he was not so content. Missing Penny and his

children, worried that Ann would forget him, he asked Penny to write often, which she did. His letters to her convey his struggle to keep on taking pictures when he was unsure of his purpose or his ability, the pleasure he found in Montana small towns, and the particularities of his days. From Bozeman, for instance, he recorded a day when he took pictures of sheep, snow, telephone poles, met a bellboy who was a photographer, had roast pork and applesauce for dinner, and bought a *Life* magazine.[138] Although Penny's letters do not survive, it is clear from his that she responded in kind, detailing the children's activities, her reading, what she thought of movies he recommended. Their nearly daily correspondence forged a link across the continent, a lifeline for him in his loneliness.

LC-USF34-065085-D

John Vachon • Used car lot, Lewistown, March 1942. Vachon kept hoping for more snow in his travels through Montana. Getting through it was daunting, but both he and Stryker liked its effect in photographs and wanted more winter pictures for the file.

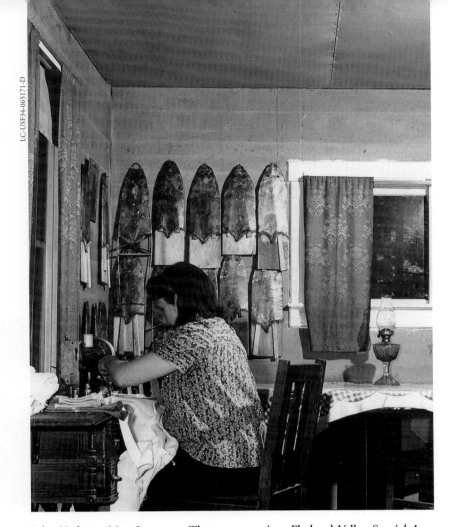

John Vachon • Mrs. Lawrence Thompson sewing, Flathead Valley Special Area Project, March 1942. Stryker had instructed his staff to get "good pictures of any special home craft" when they visited FSA projects. This photo of Mrs. Thompson at her Singer sewing machine surrounded by the skins of muskrats her husband had trapped certainly qualified.

As Vachon headed west, he encountered the mountains and found them "stupendous." He did not like Anaconda, "a stink of a town dominated and owned by the big copper smelter," but he did like Butte, an "amazing city" with fancy night clubs, good-looking restaurants, and "streets full of old whores, old miners, old cowboys, old cattlemen." He told Penny he thought it would be "a swell place" for them to spend a vacation.[139] He spent another day in April exploring Butte, driving up the hills "with all the slums, ugliness and strange architecture of any West Virginia town. But not the weird brooding quality, not the thin smiles and

crooked breasts and dirty ancient children of West Virginia. . . . This is still more like a Bret Harte story."[140] While he took a few photographs there, he was restrained with his film since "Stryker wants lots of pictures of how much we got in America, what a great country to live in, etc., not faded miners."[141]

Vachon was on his way to Kalispell, where he spent several days photographing an FSA project and reviewing a batch of photographs that dismayed him. He had abandoned using a tripod in the windy, cold weather and now discovered that his prints were "fuzzy, out of focus, and unsharp, totally lacking in the real photographic quality, depth, crispness, sharpness."[142] They shook his confidence, and, unfortunately, he had too much time to dwell on his perceived shortcomings. While in Kalispell Vachon began preparing for a special assignment, to shoot the Rocky Mountain Lab in Hamilton. He got vaccinated against Rocky Mountain spotted fever but then had to wait for film and credentials to permit him entry into the laboratory. Short on film, he could not work much, and he was frustrated waiting for news from the office. On three consecutive days he wrote long letters home, confessing: "I can't take good pictures any more. I sit in my room and think, look at *US Camera*, and my prints. I figure out all the rules and right approaches. I know good pictures from bad. I have ideas of what to do. When I'm out without my camera I sense wonderful pictures and know just how to make them. But every damn time I get into action I seem to fall way short and hurry out of my situations."[143] He fretted about what would happen when he finished this field trip, dreading the thought of being home for two weeks and then hurrying off again, missing seeing his children grow, missing making love to his wife. Finally, after over a week in Kalispell, going to movies and "getting bedsores from so much idle lying about my room," he received a wire from Stryker telling him he had permission to proceed to Hamilton.[144]

John Vachon • FSA cooperative sawmill, Kalispell, March 1942. This steam traction engine with an extended smokestack and spark arrester powered the sawmill. The mill operation was an FSA cooperative, and in lieu of wages workers received lumber, which they could use to build or improve their homes, and scraps, which they could use for fuel.

Once he arrived in the Bitterroot Valley town, he still had to wait for clearance to enter the laboratory, so he tried to get some of the sheep and cattle photographs that Stryker wanted. Driving around southwestern Montana, he became entranced with the huge rock formations and at one point stopped simply to stare at them: "The faces I could see in these rock hunks were startling. Supernatural. For a few minutes it was a new idea in photography, just shooting straight into hunks of rock. Something creative, like sculpturing."[145] But he did not actually take any pictures and went on to a sheep ranch to photograph lambing. He won over a worker who initially snarled at him and called agriculture pictures "goddam horseshit." Vachon decided to be amenable and soon the man told him something about his life and why he was so disagreeable. He had been born in Russia, served in the army there, had six brothers killed in war, and now his two sons had been drafted into the United States Army. He told Vachon that God had made enough "for everyone to live happy and we don't need wars." He woke up in the middle of the night with tears in his eyes, "not for his sons but for all the young men."[146] He was not interested in photographs that promoted the war.

Working on the ranch Vachon experienced a lighter moment as well. Waiting for the hands to come back from their lunch, Vachon saw a ewe giving birth to a "thing coming out, look[ing] like bananas encased in lemon jello." After dropping the lamb the ewe walked off, and Vachon closed in to get a photo, only to find the lamb rubbing against his pant leg and licking him. When he tried to leave, the bleating lamb followed, so he picked him up and brought him over to the ewe, who after some hesitation accepted him. As Vachon told Penny, "I got lemon jello all over my hands."[147] A couple of days later he photographed men castrating lambs and docking their tails. Although he may have done some research on the livestock industry before he headed west, the method of lamb castration "was an amazing revelation to me," he confessed to Stryker. "I suppose you know how it's done—orally. Unless that guy was playing a grisly joke on me." But he was not. Vachon observed and recorded the process and then reported on it to Penny: "A guy slits off the end of the scrotum with a razor, then he gets right down there with his mouth and sucks in the testes which he comes up with a mouth full of and spits out, then spits again and proceeds with the routine. He's bloody all over the face. The

owner says there's a machine to do the job, but most people do it this way, as the machine kills too many lambs." Vachon concluded, "I now remember the expression, 'anyone who would do that would suck sheep,' to which I never attached any meaning." After finishing this job, he pronounced, "I am definitely through with sheep."[148] He might have been through with sheep, but he was not yet through with castration. After photographing calves branded, dehorned, and castrated, he reflected, "To see the great globes of a fine young bull drop off and roll in the dust is a profound lesson in humility."[149]

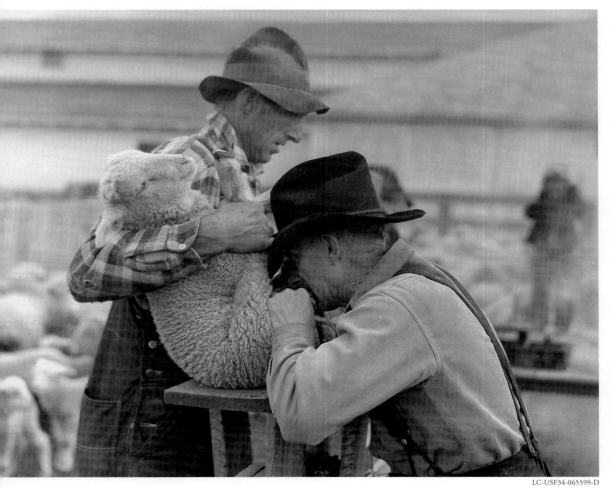

John Vachon • Castrating young lambs, Ravalli County, April 1942. Vachon wrote to his wife, Penny, that he had seen everything on a visit to a sheep ranch: "little lambs being castrated, ears slit, tails cut off, paint brand put on." But the method of castration was what made the greatest impact upon him.

At last Vachon had all the necessary paperwork and vaccinations to enter the Public Health Service's laboratory in Hamilton where research had been ongoing since 1902 into the origins of and vaccine to prevent Rocky Mountain spotted fever and related diseases. When the Montana State Board of Health was created in 1901, spotted fever in the Bitterroot Valley was one of its first concerns. No one knew exactly how the disease

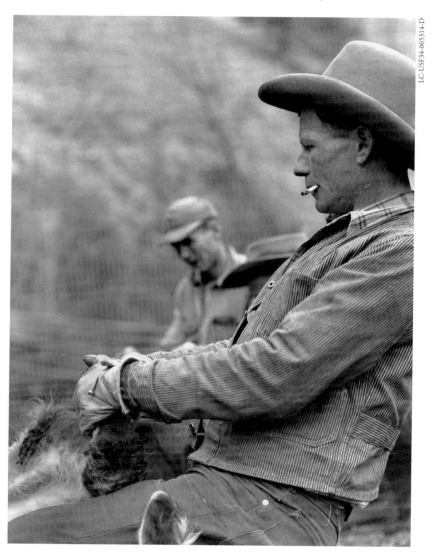

LC-USF34-065314-D

John Vachon • Cowboy holding a calf being branded, Bitterroot Valley, April 1942. Vachon spent a day on a ranch in the Bitterroot Valley photographing branding and castration. Here Vachon closed in on a cowboy, with his requisite hand-rolled cigarette.

was contracted, although residents suspected it had something to do with drinking melted snow water. The people who seemed to contract the disease were ranchers, sheepherders, and timber cruisers working in the mountains west of the Bitterroot River. Spotted fever was not common, but it was deadly. Around the turn of the century, 80 percent of those identified as contracting the fever died. Two researchers suspected as early as 1902 that ticks carried the disease, an explanation local developers in particular resisted, as they feared that this theory would discourage settlers. Prospective land buyers could avoid drinking mountain run-off by digging wells but could hardly avoid ubiquitous ticks.[150]

Dr. Howard Taylor Ricketts proved that ticks did indeed carry the disease and discovered that the microorganism that caused spotted fever was related to that which caused epidemic typhus. Subsequent research unveiled more diseases caused by this group of organisms, which because of Ricketts's work, was named *rickettsia*. In 1927 the Montana legislature appropriated sixty thousand dollars for a new lab to replace the series of structures that had housed research into spotted fever since 1902. The Hamilton lab had been a state operation in which scientists from Montana had worked with researchers from the Mayo Clinic, various universities, and such federal agencies as the Bureau of Entomology, the Biological Survey, and the Public Health Service, sometimes in uneasy political alliance. By 1930, as more was known about the disease, it became clear that investigation could not be limited to Montana, and in 1931 the state legislature approved sale of the laboratory to the Public Health Service; the transfer took place in 1932. What had been popularly known as the Spotted Fever Laboratory became the Hamilton Station of the Public Health Service. The New Deal also was to have an important effect on the lab. A provision of the new Social Security Act, signed into law in August 1935, authorized a large sum of money for public health work, including $2 million annually for research conducted by the Public Health Service. Dr. Ralph R. Parker, director of the Hamilton lab, submitted a long list of research projects, including a comparative study of typhus-like diseases and studies to improve the spotted fever vaccine, which had been first developed in 1924, as well as to investigate a simpler method for its production. In February 1936 the Hamilton lab's name was once again changed to the Rocky Mountain Laboratory, and in May

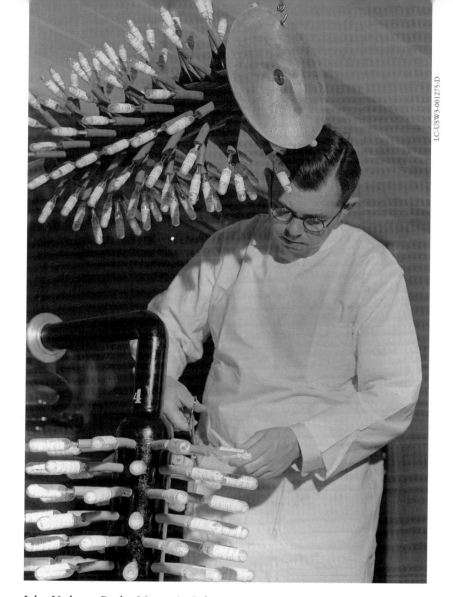

John Vachon • Rocky Mountain Laboratory, Hamilton, April 1942. A scientist works with an ampoule of yellow fever vaccine. During World War II the Rocky Mountain Laboratory became a "national vaccine factory."

Dr. Herald R. Cox, a microbiologist, was hired to "search for a less dangerous, more efficient means" to produce the vaccine than the current method, which required raising millions of ticks in the lab in order to produce the rickettsiae necessary for vaccine production. In 1938 Cox solved the problem; he discovered that rickettsiae grew prolifically in the yolk sac tissue of fertile hen's eggs. Cox's discovery meant that vaccine production no longer had to be limited to the geography of where ticks were present;

it reduced the danger inherent in working with large tick populations; and it made vaccine production significantly cheaper.

By the time John Vachon arrived at the Rocky Mountain Laboratory, researchers had shifted their focus from spotted fever to "the international wartime threat of epidemic, louse-borne typhus."[151] Cox had developed an experimental vaccine against typhus, which scientists worked to improve throughout the decade. During the war the Rocky Mountain Laboratory became a factory producing typhus, spotted fever, and yellow fever vaccines, primarily for the military. Immediately after the attack on Pearl Harbor, security tightened at the lab, hence Stryker's need to get clearance for Vachon to visit and photograph.

Vachon enjoyed working in the Rocky Mountain Laboratory, where he "learned a lot about ticks lice guinea pigs and diseases."[152] As in many

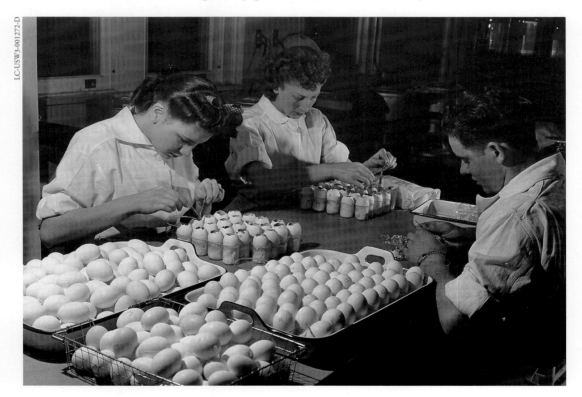

LC-USW3-001272-D

John Vachon • Rocky Mountain Laboratory, Hamilton, April 1942. Technicians are harvesting yolk sacs from eggs infected with louse-borne typhus. Dr. Herald R. Cox developed a method for growing rickettsiae in egg yolk sacs, which revolutionized rickettsial diseases research and permitted the more efficient production of vaccines against them.

times past, a lack of communication between Washington and local sites made work more difficult. All Dr. Parker knew was that Vachon had legal permission to come to the lab; he really had no idea of what Vachon was supposed to do there. So Vachon simply "tried to get something on all aspects" of the operation, while concentrating on Dr. Cox's work with the typhus vaccine. While most of his photos document the various stages of experimentation and vaccine production, his portrait of serious faced, lab-coated staff members, their looming shadows cast on the wall behind

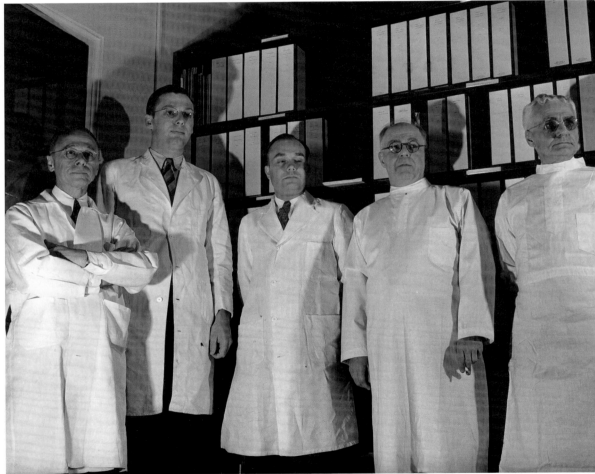

LC-USW3-001292-D

John Vachon • Rocky Mountain Laboratory, Hamilton, April 1942. Vachon found the Rocky Mountain Laboratory fascinating but photogenically disappointing. Instead of "fancy lighted earnest young men in white with 10000 test tubes and intricate machinery buzzing around them," he met scientists who showed him "tick after tick, with gleam in the eye."

them and light glinting off their spectacles, has a Dr. Frankenstein quality. Vachon confessed that working in the lab gave him "tickphobia" and that he got a stiff neck from spending so much time looking in the mirror at the freckles on his back, which "looked exactly like ticks under the skin."[153]

When Vachon finished at Hamilton, he had no particular destination; he planned to follow Stryker's instructions to pursue "sheep and cows, spring gardens, snow melting down mountains," and having found a tick on his wrist two days after he had last searched his clothes and body, he vowed he would "be an every night body inspector."[154] Driving through Dillon and Bannack he set his course for the Big Hole Valley. Not long after he arrived in Montana, when he was asking about places to photograph cattle, he heard about the Big Hole: "Cowpunchers would get dreamy looks on their mugs and tell me I should go to the Big Hole Basin if I really wanted to get pictures of cow outfits."[155] He had tried to get into the valley in March, only to be turned back by a road "icy and full of bumpy holes," "wet slushy and muddy," "cliff hanging, unguarded and narrow."[156] But now the road was open.

Vachon checked into Wisdom's hotel, which had a pump in the backyard for water and an outhouse equipped with a "genuine Montgomery Ward catalog." His room came with a wood stove he did not know how to use. Main Street boasted a barber shop, a café, two general stores, and four bars. His every move was watched since "this is . . . the sort of place where a strange guy in a suit coat, and especially carrying a camera, and a Maryland license, is about as conspicuous as Mrs. Roosevelt in the Gayety chorus."[157] He chatted with as many people as he could and took lots of pictures to get the community used to his camera. In a few hours everyone knew him: "Guys I hadn't seen before would come around to discuss my business with me, willing to do anything to help me get pix." After five days in the Big Hole, Vachon decided "it is impossible to ever really love any other part of the country. It is the purest most undiluted West I've ever seen, and the people there are the best damn people in the world." He played poker with ranchers, cowhands, and "the veterinarian who is passing through," got called "Slim" again, and lost six dollars, but did not mind because "it was worth it for the experience of sitting around the table with all those guys."[158]

LC-USF34-065379-D

John Vachon • Singing hymns at Sunday school, Wisdom, April 1942. "This morning I went to Sunday school. The teacher is a young man misfit who has been here about three months. He most piously refused my proffered cigarette, he talked confidently with me about how small the people are around here, and most true to type he steered the conversation experimentally and smirking into sexy. The boys around town say he is sure as hell leaving town after the school term is up," wrote John Vachon.

Vachon, who drank a lot himself, appreciated the drinking habits of the locals: "I never knew before what drinks on the house meant. About one in three comes that way. If you're walking by a bar in the morning they call you in for one on the house. During the haying season, I'm told, before they open up the place in the morning, they line glasses of whiskey all the way down the bar. Then they open the doors and let you in for free eye openers."[159] Vachon was charmed by a five-year-old boy who came into the bar one afternoon and protested to the bartender who shooed him out, "Jesus Christ, Mac, ain't we partners?" One night two drunken cowpunchers got into a fight, "a real slugging knocking down rolling on the floor fight." Vachon went to get his camera, but by the time he came

back they were buying each other drinks and "didn't want to do it again for pictures."[160]

The longer he stayed, the more he liked the place. Unfortunately for his work, little of photographic interest was going on at the valley's ranches. He took photographs in town and went to two or three outfits where he got some pictures of feeding "and some little rounding up of stuff which a guy put on for me." But he concluded there was not much he could do photographically, "even the poker games I can do better after I've shown them some pix and come back a second time."[161] He hoped he could return during haying season in July, which someone told him drew two thousand hired hands to the valley. So Vachon reluctantly

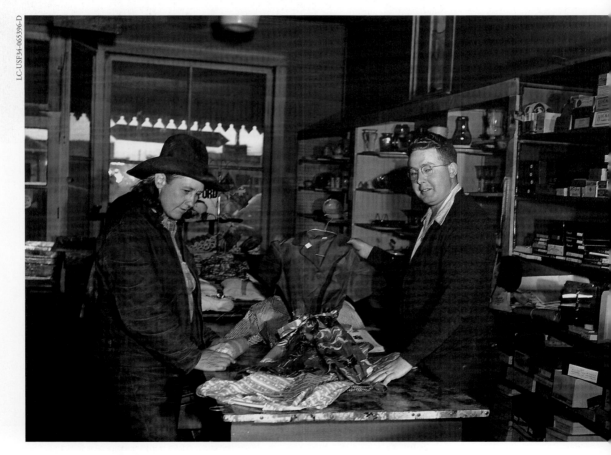

John Vachon • Basin Mercantile Company, Wisdom, April 1942. In communities as isolated as Wisdom, the mercantile store had to carry a little bit of everything. Here the storekeeper displays a party dress to a ranch woman, a purchase that would have been unlikely in the financially tighter days of the Depression.

departed from the Big Hole. To Stryker he wrote: "I saw while there every-thing I ever got in a western movie except the guy who rides down the middle of the street shooting in all directions. They didn't do that for me, though I saw several guys who packed guns."[162] Driving on to Dillon he found mail waiting and then he headed south to Idaho Falls, where he concluded, "Idahos got to go some to endear itself to me like Montana, my favorite state."[163]

When John Vachon arrived in Montana in 1942, drought and depres-sion were already parts of the past. War had boosted the economy and changed the tenor of the country and the agenda of the Historical Section's

LC-USF34-065332-D

John Vachon • Air raid shelter, Stevensville, April 1942. By 1942 the camera-wielding photographers were often treated as suspicious characters, possibly spies, and certainly lollygaggers. Vachon recalled a rancher looking at him with "incredulity" and exclaiming, "There's a war going on, and the government's sending you around *taking pictures?*"

John Vachon • Negro soldiers stationed at Fort Harrison, Helena, March 1942.
Five thousand troops were stationed at Fort Harrison outside Helena in 1942, including an African American company that was part of the United States Army's 474th Quartermasters. Vachon also photographed African American troops and defense workers in Michigan, Georgia, Virginia, and North Carolina.

project. Increasingly, Vachon was uncomfortable meeting people, whom he suspected thought that he should be in the army, not driving around taking pictures.

Vachon's letters reveal his pleasure in the movie-set quality of the West, the open-handed hospitality he contrasted with some of his experiences in the Midwest, and the panoramic quality of the land. He had begun his Montana sojourn in the northeastern part of the state and traversed it to the southwest, looped north to the Flathead Valley and south again to the Big Hole. When you arrange his photographs according to

John Vachon • Clothing store advertisement, Dillon, March 1942. FSA photographers took hundreds of pictures of billboards and signs in order to capture the sensibility of American culture in the 1930s and 1940s. This whimsical painting portrays a man in town and country style. Interestingly, the cowboy's jeans are more densely covered with graffiti than are the gentleman's trousers.

the route he took, his struggle with how to deal with Montana is obvious. In McCone County he shot long views of dryland farms, rutted roads, and rows of grain elevators, but he never managed to capture the grace of the landscape or its architectural forms the way that Marion Post Wolcott had the previous year. As he moved west he closed in on his subjects, photographing more people, filling the frame with ranch buildings,

John Vachon • Two old-timers, Bannack, April 1942. Vachon met these two men, partners in a small mine near the first territorial capital, reminiscing about good times they once had in Skinner's Saloon.

automobiles, men, cattle, and sheep. By the time Vachon arrived in Beaverhead and Ravalli counties, he got so close to his subjects that his frames were filled with the heads of cowhands and sheep workers and the bodies of sheep and cattle, usually undergoing the indignities of castration and branding.

Vachon's most effective photographs are those he took from a middle distance. Many of his tight portraits abstract the subjects from any context

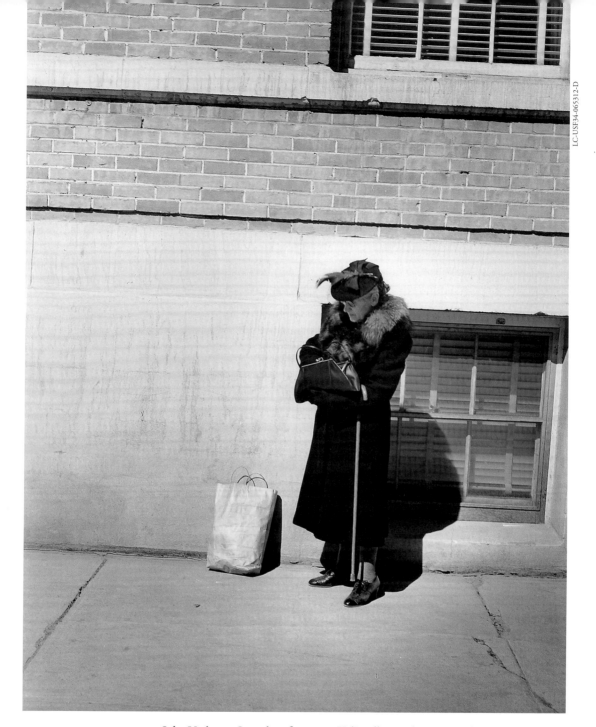

John Vachon • Saturday afternoon, Kalispell, March 1942. Vachon spent a week in Kalispell photographing an FSA project, then waiting for film and clearance to proceed to Hamilton to photograph the Rocky Mountain Laboratory. He was discouraged by receipt of a set of his prints that were out of focus, frustrated with waiting for credentials, lonely for his family, and "worried and uncertain, sometimes, about what is happening to my life," sentiments perhaps echoed in this photograph.

of what inscribed those lines on their faces and shaped the grizzled countenances that so appealed to him. His photographs of ear-slitting, castration, branding, or the scientific procedures in the Rocky Mountain Lab in Hamilton are excellent illustrations of these processes. But those photos in which he stepped back are the ones that linger: The elderly woman on a Kalispell street, her shopping bag resting on the sidewalk, as she looks into her purse. The store owner and ranch woman in Wisdom considering the purchase of a dress. Men sitting or standing in front of cafés and bars, talking. Here are pictures of small-town American life, but here, too, is a sense of mystery. What is the woman looking for, checking her change from her purchases, looking anxiously for a misplaced key? What does the examination of this dress mean, a special occasion, a luxury long desired, a future trip? The men talk, but about what? Perhaps the weather, cattle prices, war news, local gossip, perhaps about the young government photographer in town.

Vachon liked the Montanans he met, and he did the best he could to understand their work, to appreciate their communities. But he, like all field workers, was a stranger. His best work was not that which suggested a false sense of intimacy, but that which revealed his curiosity and delight in his role as spectator in the movie set of the West. Looking back on his 1942 western sojourn, he mused, "For ten weeks I traveled this exalted rolling land and photographed what pleased or astonished my eye, what I saw and wanted others to see: winter sheep camps, creased faces of cattlemen, a poker game in the back room of a bar, buttes, and wild black horses on the Bad Lands, silver jukeboxes and waxen bowling alleys, a snowman holding a flag, and a Flexible Flyer leaning against the back door."[164] His photos of the western plains and mountains reflect a deeply felt experience, one that depicted not only the weather-worn faces of western stockmen and the icons of small-town life, but the struggle with loneliness and self-doubt that marked the honing of his own photographic vision.

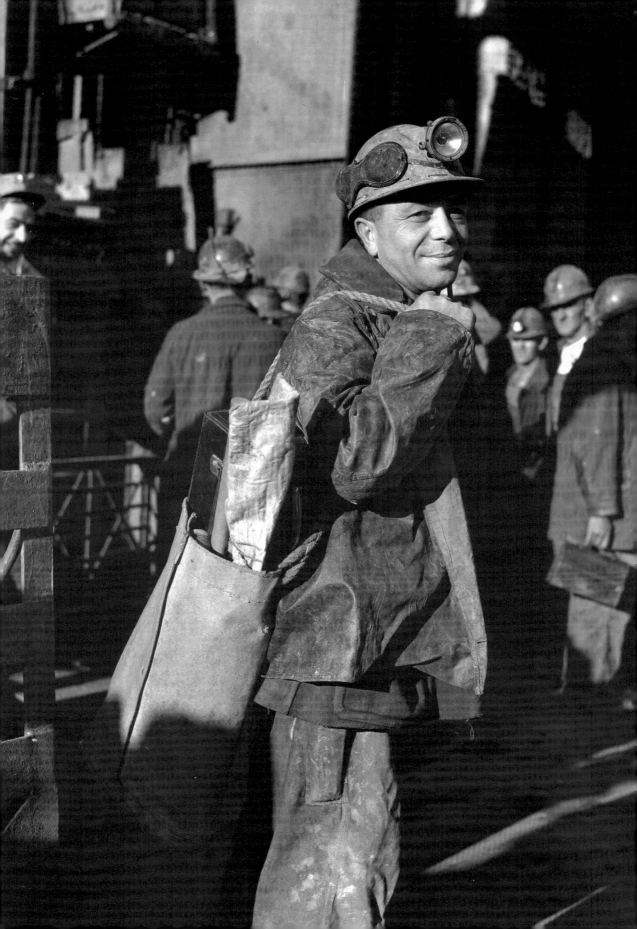

Afterword

IN 1943 Roy Stryker arranged the transfer of the FSA-OWI photographs to the Library of Congress, and then he resigned from the FSA. Much to the surprise of many of his friends and colleagues, he took a job with Standard Oil of New Jersey, coordinating a photography project to document the role and impact of oil in daily life. In reality the project allowed him to continue his vision of documenting America and to expand that mission worldwide, since Standard Oil's operations were far flung. He drew upon the cadre of FSA photographers for part of his staff. The FSA itself was abolished in 1946 and replaced by the far more conservative Farmers Home Administration.

The four photographers who had worked in Montana embarked on new adventures. Rothstein, Lee, and Vachon all served in World War II. After the war Arthur Rothstein and John Vachon accepted photographic assignments for the United Nations Relief and Rehabilitation Administration, Rothstein in China and Vachon in Poland. Rothstein then returned to *Look* magazine, where he had worked briefly before the war and eventually became director of photography. In 1948 he hired Vachon as a staff photographer and they both worked there until the magazine ceased publication in 1971. Lee spent some time on the Standard Oil project with Stryker, and then he moved to Austin, where he worked as a free-

(facing page)
Russell Lee •
Waiting to go down,
Butte, September 1942.
A miner waits his turn
to take the cage down
into the mine.
LC-USW3-008150-D

lance photographer and taught at the University of Texas. Marion Post Wolcott became a full-time wife and mother and did not pick up her camera in a professional way for over thirty years.

In the 1960s America took another look at the FSA photographs when the War on Poverty rekindled an interest in the history of the rural poor. Since then historians and photographers have studied and analyzed the photographs and the project; museums have mounted many exhibitions; and scholars, students, journalists, and archivists have interviewed the photographers formally and informally. The FSA-OWI collection has gained recognition as the historical treasure Stryker envisioned, and the photographs, made as propaganda, have become art.

The passage of time provided the photographers a chance to reflect on their experiences and to assess their meaning. Speaking in 1965 of the FSA and the Historical Section, Marion Post Wolcott mused, "It was the beginning of the recognition and assumption of responsibility, government assumption of responsibility for the welfare of the individual, and I think that that was one of its most important contributions, and we were the photographic end of it."[1] All of the photographers had been imbued with the idea that their work could foster positive social change. That belief had fueled their vision and their persistence even when they were tired, lonely, and discouraged. Although they rarely saw each other and few knew each other well, they shared "a great social responsibility," according to Arthur Rothstein. "This is one thing that we all had in common. We were dedicated to the idea that our lives can be improved, that man is the master of his environment and that it's possible for us to live a better life, not only materially, but spiritually as well. We were all tremendously socially conscious."[2]

That sense of possibility took some battering when their cameras bore witness to the horrors of World War II and the persistent poverty and racial discrimination of the postwar decades. Nonetheless, the work of the former FSA photographers remained infused by an utter confidence in the dignity of human beings. The politics and passion that had led each of them to Roy Stryker, that had kept them working in the field, and that had shaped each one's photographic eye grew into a sixth sense. During the FSA years the photographers' mission was repeatedly retuned by the shifting politics of the decade. However, the constants they portrayed

throughout the mid-1930s and early 1940s were people's determination and resilience. Individual portraits may have revealed despair or hopelessness, but in the FSA file the people of the Dust Bowl, of Appalachia, of small-town New England, of California's migrant camps, of Montana's ranches, farms, and mines appear resolved to weather unemployment and exile, to preserve the rituals of small-town America, to support a nation at war. The FSA photographs have shaped the visual memory of America, but they also shaped the continued work of each individual photographer.

During the years they worked for the FSA, Lee, Rothstein, Wolcott, and Vachon shared a social consciousness, but they did not share a sense that what they were doing was art, and they could little comprehend the scrutiny and admiration that would follow their work. Indeed, they had much in common with Montana rancher, Wallace Lockie. Recalling the Great Depression, Lockie resisted any romanticization of the past, and he spoke for the FSA photographers, as much as he spoke for his fellow Montanans, when he said: "People did what they had to in those days. It wasn't a matter of glamor or anything else. It was a matter of survival. . . . It was just a lot of hard work and grit. . . . If you'd talked to those people that was knee deep in dust them days and sweat, it wasn't glamorous. It was their job. That's what it was."[3]

And their work made life sweet.

Notes

Photographing History

1. See, for further discussion, Mary Murphy, "Picture/Story: Representing Gender in Montana Farm Security Administration Photographs," *Frontiers: A Journal of Women Studies* 22, no. 3 (2001): 93–116.

2. Erick Olson, interview by Laurie Mercier, Fort Peck, Mont., July 28, 1987, Oral History 1068, New Deal in Montana/Fort Peck Dam Oral History Project (hereafter New Deal OH), Montana Historical Society Archives, Helena (hereafter MHSA).

3. Minnie Richardson, interview by author, Antelope, Mont., August 17, 2000, in possession of author; Magnus Aasheim, comp., *Sheridan's Daybreak II* (Aberdeen, S.Dak., 1984), 44–45.

4. Roy Emerson Stryker and Nancy Wood, comps., *In This Proud Land: America 1935–1943 As Seen in the FSA Photographs* (Greenwich, Conn., 1973), 17.

5. For Stryker's biography, see F. Jack Hurley, *Portrait of a Decade: Roy Stryker and the Development of Documentary Photography in the Thirties* (Baton Rouge, La., 1972); Roy E. Stryker, interview by Richard K. Doud, Montrose, Colo., June 13, 14, 1964, Archives of American Art, Washington, D.C. (hereafter AAA).

6. Hurley, *Portrait of a Decade*, 6.

7. Jhan Robbins and June Robbins, "The Man behind the Man behind the Lens: Roy Stryker," *Minicam Photography* 11 (November 1947): 52.

8. David M. Kennedy, *Freedom from Fear: The American People in Depression and War, 1929–1945* (New York, 1999), 203–4; William D. Rowley, *M. L. Wilson and the Campaign for the Domestic Allotment* (Lincoln, Nebr., 1970), 195–96.

9. In 1942 the Historical Section became part of the Office of War Information, and the file of photographs that encompassed the work of the section under the RA, FSA, and OWI is formally known as the FSA-OWI collection. It is housed in the Library of Congress.

10. James C. Anderson, ed., *Roy Stryker: The Humane Propagandist* (Louisville, Ky., 1977), 4.

11. Leah Bendavid-Val, *Propaganda and Dreams: Photographing the 1930s in the USSR and the US* (Zurich, 1999), 71.

12. In his study of rural youth in Teton County, Glen Vergeront found that the newly created picture magazines, such as *Look* and *Life*, were read by large numbers of young men and women. Glen V. Vergeront, "Rural Youth Adjustment in Selected Areas of Teton County, 1925–1940" (master's thesis, Montana State College, 1940), 66.

13. FSA photos were exhibited in a show sponsored by *US Camera* in 1936, in exhibits for the College Art Association and Carl Zeiss Co., and at the International Photography Exhibition at New York's Grand Central Palace in 1938. Bendavid-Val, *Propaganda and Dreams*, 71.

14. Rosa Reilly, "Photographing the America of Today," *Popular Photography* 3 (November 1938): 11.

15. Stryker and Wood, *In This Proud Land*, 9.

16. Edwin Rosskam, "Not Intended for Framing: The FSA Archive," *Afterimage*, March 1981, 10.

17. Hurley, *Portrait of a Decade*, 86–92.

18. Ibid., 96–98.

19. Quoted in Carl Fleischhauer and Beverly W. Brannan, eds., *Documenting America, 1935–1943* (Berkeley, Calif., 1988), 5.

20. Ibid., 330.

21. Romana Javitz, interview by Richard K. Doud, New York, February 23, 1965, AAA.

22. Roy Stryker to John Vachon, March 18, 1942, Roy E. Stryker Papers, 1912–1972, microfilm, Special Collections, University of Louisville, Louisville, Kentucky (hereafter Stryker Papers, ULSC).

Part I: Hard Times

1. James Womble, Jordan, Mont., to James E. Murray, May 31, 1937, folder 7, box 194, series 1, Manuscript Collection 91, James E. Murray Papers (hereafter Murray Papers), K. Ross Toole Archives, University of Montana, Missoula (hereafter UM).

2. Orville M. Quick, comp., *The Depression Years, 1930–1939: As Reported in "The Circle Banner"* (Circle, Mont, 1987), entry for July 27, 1934. This book is organized chronologically by the date of an item's appearance in the newspaper.

3. Bertha Josephson Anderson, "Excerpted Material from the Handwritten Autobiography of Mrs. Peter Anderson, Sr.," TS, pp. 15–17, Small Collection 360, Bertha Josephson Anderson Reminiscence, MHSA.

4. Elliott West, *The Way to the West: Essays on the Central Plains* (Albuquerque, N.Mex., 1995); Elliott West, *The Contested Plains: Indians, Goldseekers, and the Rush to Colorado* (Lawrence, Kans., 1998).

5. Kermit Baecker, interview by author, Fort Peck, Mont., July 31, 1987, Oral History 1074, New Deal OH, MHSA.

6. Emil Ferdinand Madsen, "On the Pioneer Trails of the Northwest: The Dagmar Colony in Eastern Montana" 1939, TS, folder 11, box 110, Collection 2336, Works Progress Administration Records (hereafter WPA Records), Merrill G. Burlingame Special Collections, Montana State University, Bozeman (hereafter MSU);

Emil Ferdinand Madsen, "Dagmar: A New Danish Colony Established in Valley County, Montana," 1939, TS, ibid.

7. Donald and Agnes Morrow, interview by Laurie Mercier, Helena, Mont., August 15, 1988, Oral History 1135, New Deal OH, MHSA.

8. Daniel N. Vichorek, *Montana's Homestead Era* (Helena, Mont., 1987), 9.

9. Mary Wilma M. Hargreaves, *Dry Farming in the Northern Great Plains, 1900–1925* (Cambridge, Mass., 1957), 3.

10. Ibid., 14.

11. Conrad Taeuber and Carl C. Taylor, *The People of the Drought States*, WPA research bulletin (Washington, D.C., 1937), 29.

12. Vichorek, *Montana's Homestead Era*, 18; Michael P. Malone, Richard B. Roeder, and William L. Lang, *Montana: A History of Two Centuries*, rev. ed. (Seattle, 1991), 253.

13. M. L. Wilson, *Dry Farming in the North Central Montana "Triangle,"* Montana State College Extension Service bulletin no. 66 (Bozeman, Mont, 1923), 124–25.

14. Taeuber and Taylor, *People of the Drought States*, 50. On the expansion of wheat lands, see E. A. Starch, *Economic Changes in Montana's Wheat Area*, Montana State College Agricultural Experiment Station bulletin no. 295 (Bozeman, Mont., 1935).

15. Vichorek, *Montana's Homestead Era*, 89.

16. Edith McKamey, interview by Laverne Kohl, Great Falls, Mont., January 25, 1970, "Great Falls–history–oral" vertical file, Great Falls Public Library, Great Falls, Montana.

17. Kaia Cosgriff, interview by Rom Bushnell, Big Timber, Mont., December 7, 1993, Real West Oral History Project, Western Heritage Center, Billings, Mont. (hereafter Real West OH, WHC).

18. Rose Maltese, interview by Rom Bushnell, Sidney, Mont., August 27, 1993, Real West OH, WHC.

19. McKamey, interview.

20. Ethel E. George, interview by John Terreo, Kinsey, Mont., November 18, 1988, Oral History 1137, New Deal OH, MHSA.

21. Blanche Metheney Kuschke, "A Study of the Factors That May Affect the Leisure Time of Rural Homemakers in Montana" (master's thesis, Montana State College, 1930), 24, 28, 46, 53–54. Within Kuschke's sample were some large variations: one woman reported a work week of forty hours and another of eighty-seven.

22. Scott C. Loken, "Montana during World War Two" (master's thesis, University of Montana, 1993), 15.

23. Olson, interview.

24. Loken, "Montana during World War Two," 15. While the total investment in agricultural equipment for the decade of the 1920s increased 12.8 percent for the state, in the wheat-growing area the increase was 32.4 percent. At the same time the number of horses and mules declined dramatically. Starch, *Economic Changes in Montana's Wheat Area*, 21, 23.

25. Birdie Streets, interview by Rom Bushnell, Billings, Mont., July 20, 1993, Real West OH, WHC.

26. John C. Harrison, interview by Marie Deegan, Helena, Mont., February 19, 1990, Oral History 1208, Twentieth-Century Military Veterans Oral History Project, MHSA (hereafter Veterans OH).

27. Lillian Stephenson, interview by Rom Bushnell, Wilsall, Mont., August 6, 1993, Real West OH, WHC.

28. Taeuber and Taylor, *People of the Drought States*, 29.

29. Wallace Lockie, interview by Rom Bushnell, Sunday Creek, Mont., July 25, 1993, Real West OH, WHC.

30. Taeuber and Taylor, *People of the Drought States*, 51; Bradley H. Baltensperger, "Farm Consolidation in the Northern and Central States of the Great Plains," *Great Plains Quarterly* 7 (fall 1987): 259.

31. Ruth B. McIntosh, "Social Problems of the Rural Relief Population Prairie County, Montana" (master's thesis, Montana State College, 1937), 84–85.

32. Cosgriff, interview.

33. Lockie, interview. The distance between Miles City and Forsyth is forty-five miles.

34. August Sobotka, interview by Rom Bushnell, Intake, Mont., August 26, 1993, Real West OH, WHC.

35. On drought years, see Francis D. Cronin and Howard W. Beers, *Areas of Intense Drought Distress, 1930–1936*, WPA research bulletin (Washington, D.C., 1937), 4. The drought years were 1889, 1890, 1894, 1901, 1910, 1917, 1930, 1931, 1933, 1934, and 1936.

36. Alfred R. Anderson, Sioux Pass, Mont., to James E. Murray, July 17, 1937, folder 10, box 194, series 1, Murray Papers, UM.

37. Mary Frances Alexander McDorney, interview by Gladys Peterson, Missoula, Mont., October 8, 1985, Oral History 131-034, UM.

38. Cronin and Beers, *Areas of Intense Drought Distress*, 4.

39. Taeuber and Taylor, *People of the Drought States*, 5–6.

40. *Circle (Mont.) Banner*, January 8, 1932; James V. Bennett diary, June 19, 1931, Manuscript Collection 236, James V. Bennett Diaries, 1929–1951, MHSA.

41. *Circle (Mont.) Banner*, January 15, 1932.

42. Loken, "Montana during World War Two," 9.

43. Griffith A. Williams, "America Eats," 1941, folder 17, box 2, WPA Records, MSU.

44. Charles Vindex, "Survival on the High Plains, 1929–1934," *Montana The Magazine of Western History* 28 (autumn 1978): 7.

45. J. Calvin Funk, Santa Maria, Calif., to John E. Erickson, August 1, 1931, folder 9, box 40, Manuscript Collection 35, Montana Governors' Papers, MHSA (hereafter Governors' Papers).

46. Mrs. H. Fredrickson, Opheim, Mont., to John E. Erickson, August 2, 1930, folder 8, box 40, Governors' Papers, MHSA.

47. Steve and Louise Watts to John E. Erickson, October 14, 1932, folder 7, box 54, Governors' Papers, MHSA.

48. Irene Link, *Relief and Rehabilitation in the Drought Area*, WPA research bulletin (Washington, D.C., 1937), 38.

49. McIntosh, "Social Problems of the Rural Relief Population," 49.

50. Taeuber and Taylor, *People of the Drought States*, 11.

51. McIntosh, "Social Problems of the Rural Relief Population," 92.

52. Ibid., 49, 88.

53. Carl F. Kraenzel, with Ruth B. McIntosh, *The Relief Problem in Montana: A Study of the Change in the Character of the Relief Population*, Montana State College Agricultural Experiment Station bulletin no. 343 (Bozeman, Mont., 1937), 49.

54. Vindex, "Survival on the High Plains," 9–10.

55. Jim Kelsey, Kirby, Mont., to John E. Erickson, September 2, 1931, folder 10, box 40, Governors' Papers, MHSA.

56. Mrs. L. R. Lang, Wolf Point, Mont., to John E. Erickson, August 18, 1931, folder 9, box 40, Governors' Papers, MHSA.

57. A. W. Ricker, St. Paul, Minn., to John E. Erickson, August 8, 1931, folder 9, box 40, Governors' Papers, MHSA.

58. *Circle (Mont.) Banner*, September 11, October 30, 1931.

59. Wencil Vanek, Brooks, Mont., to John E. Erickson, September 24, 1931, folder 10, box 40, Governors' Papers, MHSA. On the park's policy, see Roger W. Toll to John E. Erickson, October 3, 1932, folder 7, box 54, ibid.; Guy D. Edwards to John E. Erickson, October 28, 1932, folder 7, box 54, ibid.; Guy D. Edwards to John E. Erickson, November 23, 1932, folder 7, box 54, ibid.

60. W. H. Hoover to John E. Erickson, August 2, 1932, folder 2, box 54, Governors' Papers, MHSA; John Glancy, Roundup, Mont., to John E. Erickson, August 3, 1932, folder 7, box 54, ibid.; D. G. Stivers, Butte, Mont., to John E. Erickson, August 13, 1932, folder 7, box 54, ibid.

61. M. L. Wilson, Bozeman, Mont., to John E. Erickson, August 25, 1932, folder 7, box 54, Governors' Papers, MHSA.

62. John F. Hauge, Paradise, Mont., to John E. Erickson, November 18, 19, 1931, folder 10, box 40, Governors' Papers, MHSA.

63. Bennett diary, November 11, 1932.

64. Ellis Waldron and Paul B. Wilson, *Atlas of Montana Elections, 1889–1976* (Missoula, Mont., 1978), 128–29, 134.

65. Harrison, interview.

66. Herbert Jacobson, interview by Doni Phillips, Dillon, Mont., July 9, 1988, Oral History 1107, New Deal OH, MHSA; Doris Gribble, interview by John Terreo, Helena, Mont., February 28, 1989, Oral History 1157, ibid.; Morrow, interview.

67. Lawrence W. Levine and Cornelia R. Levine, *The People and the President: America's Conversation with FDR* (Boston, 2002), 89.

68. Amy Lynn McKinney, "From the 'Lost' to the 'Greatest' Generation: Eastern Montana Youth in the 1930s" (master's thesis, Montana State University, 2000), 149–50.

69. David Gregg, William Whisenhand, and Lyle Nelson, interview by author, Fort Peck, Mont., August 1, 1987, Oral History 1075, New Deal OH, MHSA.

70. Montana State Appraisal Committee, "An Evaluation and Appraisal of the Federal Work Program in Montana," (hereafter MSAC, "Evaluation . . . of the Federal Work Program") 1938, TS, p. 3, Montana Historical Society Library, Helena.

71. Ibid.

72. "Employment and Labor Conditions: Five Years' Operation of the WPA," *Monthly Labor Review* 52 (March 1941): 601–8. For an overview of work relief programs, see William W. Bremer, "Along the 'American Way': The New Deal's Work Relief Programs for the Unemployed," *Journal of American History* 62 (December 1975): 636–52.

73. MSAC, "Evaluation . . . of the Federal Work Program," 4.

74. Ibid., 5.

75. Eva MacLean, "The W.P.A. and I," n.d., TS, pp. 8, 24, Small Collection 1238, Eva MacLean Papers, MHSA (hereafter MacLean Papers).

76. Joe Medicine Crow, interview by Rom Bushnell, Billings, Mont., March 25, 1993, Real West OH, WHC. For an assessment of the New Deal programs on Montana's reservations, see MSAC, "Evaluation . . . of the Federal Work Program," 28–29.

77. MSAC, "Evaluation . . . of the Federal Work Program," 6, 10. Nationwide the WPA built over 2,309,000 sanitary privies. *Final Report on the WPA Program, 1935–1943* (Washington, D.C., 1946), 51.

78. *Final Report on the WPA,* 7.

79. Joseph A. Conway, Brooklyn, N.Y., to John E. Erickson, August 1925, folder 2, box 40, Governors' Papers, MHSA.

80. Malone, Roeder, and Lang, *Montana,* 300.

81. MSAC, "Evaluation . . . of the Federal Work Program," 10, 14, 17, 19, 20.

82. Leonard J. Arrington and Don C. Reading, "New Deal Economic Programs in the Northern Tier States, 1933–1939," in *Centennial West: Essays on the Northern Tier States,* ed. William L. Lang (Seattle, 1991), 233, 236.

83. MSAC, "Evaluation . . . of the Federal Work Program," 4; Louis W. Fenske, Savage, Mont., to James E. Murray, February 19, September 13, 1939, folder 11, box 797, series 1, Murray Papers, UM.

84. MacLean, "W.P.A. and I," 3.

85. Ernest Morgan, Ovando, Mont., to John E. Erickson, November 15, 1932, folder 3, box 54, Governors' Papers, MHSA.

86. Kennedy, *Freedom from Fear,* 253, 285. Also see James T. Patterson, *The New Deal and the States: Federalism in Transition* (Princeton, N.J., 1969).

87. James E. Murray to Louis W. Fenske, March 2, 1939, folder 11, box 797, series 1, Murray Papers, UM.

88. Fenske to Murray, February 19, September 13, 1939.

89. James E. Murray to Col. F. C. Harrington, Washington, D.C., March 1, 1939, folder 11, box 797, series 1, Murray Papers, UM.

90. Ibid.

91. Edna Mae St. Claire, interview by Betty Jones, Seattle, Wash., August 10, 1990, Oral History 1215, General Montana Oral History Collection, MHSA.

92. Lucille J. Donovan and J. J. Fitzpatrick, Miles City, Mont., to Elmer C. Linebarger, December 22, 1936, folder 14, box 1, Small Collection 104, David Linebarger Papers, UM (hereafter Linebarger Papers).

93. Joseph E. Parker, Butte, Mont., to J. O. Roberts, Washington, D.C., August 4, 1939, "Montana: movement from farm to city" folder, box 41, Record Group 233, Records of the United States House of Representatives, 1789–1990, National Archives, Washington, D.C.

94. Waldo E. Northcut to Elmer C. Linebarger, March 9, 1937, folder 15, box 1, Linebarger Papers, UM; Ellis Blumenthal, Helena, Mont., to Albert L. Stuart, Brusett, Mont., April 5, 1937, folder 15, box 1, ibid.

95. Judith Basin County Commissioners to James E. Murray, September 4, 1936, folder 6, box 194, series 1, Murray Papers, UM; James E. Murray to Aubrey Williams, September 4, 1936, folder 6, box 194, series 1, ibid.

96. Ralph J. Flynn, Butte, Mont., to James E. Murray, November 1, 1935, folder 5, box 649, series 1, Murray Papers, UM.

97. Morrow, interview; Jean Stanley, interview by Doni Phillips, Miles City, Mont., July 20, 1988, Oral History 1127, New Deal OH, MHSA. For an excellent analysis

of other plains dwellers' attitudes toward federal relief in the 1930s, see Paula M. Nelson, *The Prairie Winnows out Its Own: The West River Country of South Dakota in the Years of Depression and Dust* (Iowa City, Iowa, 1996).

98. Julia June Chitwood Trees, interview by John Terreo, Fishtail, Mont., December 13, 1988, Oral History 1152, New Deal OH, MHSA.

99. Ibid.

100. Claribel Bonine, interview by Rom Bushnell, Hysham, Mont., August 3, 1993, Real West OH, WHC.

101. Elizabeth Phelps, interview by John Terreo, Sidney, Mont., November 16, 1988, Oral History 1140, New Deal OH, MHSA.

102. "Ranch House Blues," n.d., TS, MacLean Papers, MHSA.

103. Eva MacLean to Gwendolyn, Newport, Wash., n.d., MacLean Papers, MHSA.

104. MSAC, "Evaluation . . . of the Federal Work Program," 22.

105. Northern Valley County Drouth Committee, Glasgow, Mont., to James E. Murray, June 8, 1937, folder 8, box 195, series 1, Murray Papers, UM.

106. S. M. Soennichsen, Forks, Mont., to James E. Murray, January 13, 1938, folder 11, box 194, series 1, Murray Papers, UM; Alfred R. Anderson, Sioux Pass, Mont., to James E. Murray, July 17, 1937, folder 10, box 194, series 1, ibid.

107. Many such letters appear in folder 7, box 194, series 1, Murray Papers, UM.

108. MSAC, "Evaluation . . . of the Federal Work Program," 27.

109. Brian Q. Cannon, "Keeping Their Instructions Straight: Implementing the Rural Resettlement Program in the West," *Agricultural History* 70 (spring 1996): 251; Brian Q. Cannon, *Remaking the Agrarian Dream: New Deal Resettlement in the Mountain West* (Albuquerque, N.Mex., 1996), ix.

110. Warner Just to James E. Murray, Phon, Mont., August 10, 1936, folder 6, box 194, series 1, Murray Papers, UM.

111. Cannon, *Remaking the Agrarian Dream*, 11.

112. Carl B. Peters and H. E. Furgeson, eds., *New Life in the Sun River Valley and in the Greenfields Cooperative Sire and Marketing Association* (Great Falls, Mont., n.d.), 22; FSA Division of Information, "Facts about Fairfield Bench Farms," 1939, FSA-OWI supplementary reference file, microfilm, reel 15, Library of Congress, Washington, D.C.; Cannon, *Remaking the Agrarian Dream*, 2–3.

113. *Choteau (Mont.) Acantha*, May 31, 1916.

114. See the *Fairfield (Mont.) Times* from 1934 to 1940.

115. Peters and Furgeson, eds., *New Life in the Sun River Valley*, 18.

116. For a critique of the resettlement program, including Fairfield Bench Farms, see Marion Clawson, "Resettlement Experience on Nine Selected Resettlement Projects," *Agricultural History* 52 (January 1978): 1–92. This report was written in 1943, but it was not published until 1978.

117. Cannon, *Remaking the Agrarian Dream*, 62, 138.

118. Ibid., 135.

119. On the construction of the Fort Peck Dam, see Bob Saindon and Bunky Sullivan, "Taming the Missouri and Treating the Depression: Fort Peck Dam," *Montana The Magazine of Western History* 27 (summer 1977): 34–57.

120. Melvin L. Hanson, interview by Laurie Mercier, Fort Peck, Mont., July 28, 1987, Oral History 1068, New Deal OH, MHSA; William Fly, interview by author, Glasgow, Mont., July 31, 1987, Oral History 1082, ibid.; Owen Williams, interview by Rick Duncan, Fort Peck, Mont., August 1, 1987, Oral History 1085,

ibid.; James and Florence Wiseman, interview by author, Fort Peck, Mont., August 1, 1987, Oral History 1079, ibid.; Gregg, Whisenhand, and Nelson, interview.

121. Red Killen, interview by Rom Bushnell, Miles City, Mont., July 23, 1993, Real West OH, WHC.

122. Lockie, interview.

123. David Rivenes, interview by Doni Phillips, Miles City, Mont., July 20, 1988, Oral History 1129, New Deal OH, MHSA. The center was dismantled and moved to the town of Brockway in the 1950s where it was used as a city center and grade school gymnasium.

124. Donald Worster, *Dust Bowl: The Southern Plains in the 1930s* (New York, 1979), 13–15.

125. *Circle (Mont.) Banner*, June 4, 1937.

126. Maltese, interview.

127. Ernie Pyle, *Home Country* (New York, 1947), 52.

128. Annette Atkins, *Harvest of Grief: Grasshopper Plagues and Public Assistance in Minnesota, 1873–78* (St. Paul, Minn., 1984), 13, 15.

129. Ely W. Swisher, "Controlling Mormon Crickets in Montana, 1936–1941," *Montana The Magazine of Western History* 35 (winter 1985): 60.

130. *Circle (Mont.) Banner*, June 5, 1936.

131. Russell Evans, interview by Rom Bushnell, Seven Mile Creek, Mont., August 26, 1993, Real West OH, WHC; George, interview; Stephenson, interview.

132. *Sidney (Mont.) Herald*, July 21, 1938.

133. Deut. 28:38, 28:42.

134. Rev. 9:3–9.

135. Swisher, "Controlling Mormon Crickets," 61.

136. Ibid., 62.

137. Medicine Crow, interview.

138. Swisher, "Controlling Mormon Crickets," 63.

139. *Circle (Mont.) Banner*, July 8, 15, 22, 1938.

140. Anna M. Schultz, Glendive, Mont., to James E. Murray, August 28, 1937, folder 10, box 194, series 1, Murray Papers, UM.

141. William H. Bartley, Great Falls, Mont., to James E. Murray, May 17, 1937, folder 7, box 194, series 1, Murray Papers, UM.

142. T. H. Watkins, *The Hungry Years: A Narrative History of the Great Depression in America* (New York, 1999), 443.

143. John Vukonich, interview by Rom Bushnell, Joliet, Mont., August 17, 1993, Real West OH, WHC; Lockie, interview.

144. *Circle (Mont.) Banner*, September 21, 28, December 21, 1934.

145. Watkins, *Hungry Years*, 444.

146. Charlotte Edwards, interview by John Terreo, Helena, Mont., November 14, 1988, Oral History 1139, New Deal OH, MHSA.

147. Kraenzel, *Relief Problem in Montana*, 8, 39.

148. "Employment, 1929–32," memo, folder 3, box 51, Governors' Papers, MHSA.

149. On the Depression in Butte and Anaconda, see Mary Murphy, *Mining Cultures: Men, Women, and Leisure in Butte, 1914–41* (Urbana, Ill., 1997); and Laurie Mercier, *Anaconda: Labor, Community, and Culture in Montana's Smelter City* (Urbana, Ill., 2001).

150. Cronin and Beers, *Areas of Intense Drought Distress*, 21; Baltensperger, "Farm Consolidation," 260.

151. United States Department of Commerce, *U.S. Census of Agriculture: 1935, Reports for States with Statistics for Counties and a Summary for the United States*, vol. 1 (Washington, D.C., 1936), 811.

152. "Employment, 1929–1932."

153. McDorney, interview.

154. Edward Bell, "Helena and the Great Depression, 1929–1935" (honors thesis, Carroll College, 1975), 36, 46.

155. Arrrington and Reading, "New Deal Economic Programs," 228.

156. Leverne Hamilton, Musselshell, Mont., to John E. Erickson, July 30, 1931, folder 9, box 40, Governors' Papers, MHSA.

157. *Circle (Mont.) Banner*, November 4, 1932.

158. Mercier, *Anaconda*, 51–56.

159. Clipping, "Great Falls WPA" vertical file, Cascade County Historical Society, Great Falls, Montana.

160. Bennett diary, January 1, 1939.

Part II: On the Road

1. John Vachon to Penny Vachon, March 14, 1942, in the possession of Ann Vachon (hereafter Vachon Collection). My thanks to Ann Vachon for allowing me to use these letters.

2. John Vachon to Penny Vachon, March 1942, Vachon Collection.

3. Vachon to Vachon, March 14, 1942; John Vachon to Roy Stryker, March 1942, Stryker Papers, ULSC.

4. Arthur Rothstein to Roy Stryker, May 30, 1939, Stryker Papers, ULSC.

5. John Vachon to Roy Stryker, April 1942, Stryker Papers, ULSC.

6. *Dude Rancher*, April 1940, 21; ibid., April 1941, 19.

7. Arthur Rothstein to Roy Stryker, May 20, 1939, Stryker Papers, ULSC.

8. T. J. Maloney, ed., *US Camera 1939* (New York, 1938), 46.

9. John Collier, Jr., "By John Collier for Roy Stryker," 1959, AAA.

10. Catherine Aiken and Helen Wool, interview by Richard K. Doud, Washington, D.C., April 17, 1964, AAA.

11. Collier, "By John Collier for Roy Stryker."

12. Stryker to Vachon, March 18, 1942.

13. Roy Stryker to Arthur Rothstein, July 31, 1936, Stryker Papers, ULSC.

14. Marion Post Wolcott to Roy Stryker, September 1941, Stryker Papers, ULSC.

15. Stryker's collection of photos is reproduced on reel 12, Stryker Papers, ULSC.

16. Fleischhauer and Brannan, eds., *Documenting America*, 337.

17. Arthur Rothstein, interview by Richard K. Doud, New York, May 5, 1964, AAA.

18. Paul Raedeke, "Interview with Marion Post Wolcott," *Photo Metro*, February 1986, 17.

19. Rick Sammon, "'The World is My Studio': An Interview with Arthur Rothstein," *Studio Photography*, January 1979, 34.

20. John Vachon, "Commentary: Tribute to a Man, an Era, an Art," *Harper's* 247 (September 1973): 96–99.

21. Ibid., 98.

22. Arthur Rothstein to Roy Stryker, June 27, 1936, Stryker Papers, ULSC.

23. John Vachon to Penny Vachon, April 1942, Vachon Collection.

24. Roy Stryker, interview by Richard K. Doud, June 14, 1964, AAA.

25. See the interviews with the FSA photographers conducted by Richard K. Doud in the Archives of American Art.

26. Arthur Rothstein to Roy Stryker, January 27, 1939, Stryker Papers, ULSC.

27. John Vachon to Penny Vachon, April 7, 1942, Vachon Collection.

28. Hank O'Neal, *A Vision Shared: A Classic Portrait of America and Its People, 1935–1943* (New York, 1976), 77.

29. Ibid., 175.

30. Raedeke, "Marion Post Wolcott," 10.

31. Ibid., 11.

32. Ibid., 14.

33. "Notes from the Road: The Way America Was—As Told in the Letters and Photos of Famed Photographer John Vachon," *American Photo* 2 (May / June 1991): 50.

34. Ibid., 48.

35. John Vachon to Penny Vachon, March 11, 1942, Vachon Collection.

36. Norman Schreiber, "Inside Photojournalism," *Camera Arts* 2 (November 1982): 18.

37. John Vachon to John Collier, Jr., [March] 1942, Stryker Papers, ULSC.

38. O'Neal, *A Vision Shared*, 136.

39. Raedeke, "Marion Post Wolcott," 12.

40. Doris and Russell Lee divorce papers, "divorce papers from Doris Emrick to Russell Lee" folder, box 97-129, Russell Lee Papers, Southwest Writers Collection, Albert B. Alkek Library Special Collections, Southwest Texas State University, San Marcos; Jean Smith and Russell Lee marriage papers, "divorce papers from Doris Emrick to Russell Lee" folder, box 97-129, ibid.

41. F. Jack Hurley, *Marion Post Wolcott: A Photographic Journey* (Albuquerque, N.Mex., 1989), 57–58; Jack Delano, *Photographic Memories: The Autobiography of Jack Delano* (Washington, D.C., 1997).

42. Marion Post Wolcott to Roy Stryker, August 1941, Stryker Papers, ULSC.

43. Wolcott to Stryker, September 1941.

44. Selected shooting scripts are reprinted in Stryker and Wood, *In This Proud Land*.

45. Jack Delano, interview by Richard K. Doud, June 12, 1965, AAA.

46. John Vachon, interview by Richard K. Doud, April 28, 1964, AAA.

47. Robert L. Reid, *Picturing Minnesota, 1936–1943: Photographs from the Farm Security Administration* (St. Paul, Minn., 1989), 116–19.

48. Raedeke, "Marion Post Wolcott," 10.

49. "Notes from the Road," 44.

50. Wolcott to Stryker, August 1941.

51. Arthur Rothstein to Roy Stryker, March 17, 1940, Stryker Papers, ULSC.

52. O'Neal, *A Vision Shared*, 22.

53. Arthur Rothstein to Roy Stryker, March 7, 26, 1940, Stryker Papers, ULSC.

54. Arthur Rothstein to Roy Stryker, April 1, 1940, Stryker Papers, ULSC.

55. Bill Ganzel, "Arthur Rothstein: An Interview," *Exposure* 16 (fall 1978): 2; Arthur Rothstein, *The American West in the Thirties* (New York, 1981); Arthur Rothstein, *The Depression Years* (New York, 1978).

56. *Parade Magazine* press release, copy in "biographical material, 1940–1984" folder, box 1, Arthur Rothstein Papers, AAA.

57. Schreiber, "Inside Photojournalism," 18.

58. Ganzel, "Arthur Rothstein," 2.

59. Schreiber, "Inside Photojournalism," 18.

60. On the Great Plains Committee, see Donald Worster, *Dust Bowl: The Southern Plains in the 1930s* (New York, 1979), 192–97. On Rothstein's assignment with it, see Stryker to Rothstein, July 31, 1936.

61. Ed Locke to Arthur Rothstein, August 14, 1936, Stryker Papers, ULSC.

62. Stryker to Rothstein, July 31, 1936.

63. Marie Braught to Arthur Rothstein, November 2, 1936, Stryker Papers, ULSC; Bill Ganzel, *Dust Bowl Descent* (Lincoln, Nebr., 1984), 24–27.

64. Archie Robertson, untitled draft article, Stryker Papers, ULSC.

65. Arthur Rothstein to Roy Stryker, May 16, 1939, Stryker Papers, ULSC.

66. "Suggestions for Shooting Script on Cattle Industry, 1939," reel 6, Stryker Papers, ULSC.

67. Rothstein to Stryker, May 20, 1939.

68. Roy Stryker to Arthur Rothstein, May 26, 1939, Stryker Papers, ULSC.

69. Rothstein to Stryker, May 30, 1939.

70. Roy Stryker to Arthur Rothstein, May 31, 1939, Stryker Papers, ULSC.

71. Roy Stryker to Arthur Rothstein, April 29, 1936, Stryker Papers, ULSC.

72. John Vachon to Penny Vachon, March 26, 1942, Vachon Collection.

73. Arthur Rothstein to Roy Stryker, June 1, 1939, Stryker Papers, ULSC.

74. Roy Stryker, interview by Richard K. Doud, Montrose, Colo., October 17, 1963, AAA.

75. On the Brewster-Arnold ranch, see *They Came and Stayed, Rosebud County History* (Forsyth, Mont., 1977).

76. Lawrence R. Borne, *Dude Ranching: A Complete History* (Albuquerque, N.Mex., 1983), 217.

77. Joseph Parker Sullivan, "A Description and Analysis of the Dude Ranching Industry in Montana" (master's thesis, University of Montana, 1971), 18; *Sheridan (Wyo.) Press*, July 6, 1982.

78. Sullivan, "Dude Ranching Industry," 17; "Brewster-Arnold Ranch Co. Audit Report as of December 31st, 1932," Collection 331, Brewster Family Papers, 1907–1964, MSU.

79. Arthur Rothstein to Roy Stryker, June 21, 1939, Stryker Papers, ULSC.

80. Arthur Rothstein to Roy Stryker, September 23, 1939, Stryker Papers, ULSC.

81. William MacLeod Raine, "The Dude Rides Circle," *Sunset Magazine* 60 (April 1928): 16–17, 56, 58, 60.

82. "Dressing the Dude," *Vogue* 87 (May 1, 1936): 140–41.

83. *Dude Ranches in the Big Horn Mountains*, pamphlet, p. 35, "dude ranches" vertical file, Sheridan County Fulmer Public Library, Sheridan, Wyoming.

84. Raine, "Dude Rides Circle," 17, 58, 60.

85. Schreiber, "Inside Photojournalism," 18.

86. Collier, "By John Collier for Roy Stryker." Collier was born in New York, but his family moved west when he was six. His son, Malcolm Collier, stated that "he defined his childhood in terms of Taos and California, seeing New York as almost irrelevant." Russell Lee et al., *Far from Main Street: Three Photographers*

in *Depression-Era New Mexico, Russell Lee, John Collier, Jr., Jack Delano* (Santa Fe, 1994).

87. Paul Raedeke, "Marion Post Wolcott: Photographs for the Farm Security Administration—Documenting Rural American Life in the 1930s and 1940s," *Arrival*, summer 1987, 18.

88. On Wolcott's biography, see Julie M. Boddy, "The Farm Security Administration Photographs of Marion Post Wolcott: A Cultural History" (Ph.D. diss., State University of New York, 1982); Paul Hendrickson, *Looking for the Light: The Hidden Life and Art of Marion Post Wolcott* (New York, 1992); Hurley, *Marion Post Wolcott*; and Raedeke, "Marion Post Wolcott," 2–17.

89. Hurley, *Marion Post Wolcott*, 101.

90. Ganzel, *Dust Bowl Descent*, 8.

91. Wolcott to Stryker, August 1941; Hurley, *Marion Post Wolcott*, 113.

92. Wolcott to Stryker, August 1941.

93. Raedeke, "Marion Post Wolcott," 6.

94. Wolcott to Stryker, August 1941.

95. Ibid.

96. William Buchanan, Jr., "America Eats, Barbecue," 1941, folder 5, box 2, WPA Records, MSU.

97. On the Crow Fair, see Charles Crane Bradley, Jr., *The Handsome People: A History of the Crow Indians and the Whites* (Billings, Mont., 1991), 17, 146; and Sarah Boehme, "The North and Snow: Joseph Henry Sharp in Montana," *Montana The Magazine of Western History* 40 (autumn 1990): 39–42.

98. Wolcott to Stryker, September 1941.

99. Ibid.

100. Russell Lee to Roy Stryker, September 1937, Stryker Papers, ULSC.

101. Russell Lee to Ed Locke, September 5, 1937, Stryker Papers, ULSC; Lee to Stryker, September 1937.

102. Roy Stryker to Russell Lee, October 5, 1937, Stryker Papers, ULSC.

103. Russell Lee to Ed Locke, September 1937, Stryker Papers, ULSC.

104. Creekmore Fath, "Russell Lee: Photographer," *Texas Observer* 70 (December 29, 1978): 2; Richardson, interview; *Today, Tomorrow's History: Photographer Russell Lee*, prod. and dir. Ann Mundy, 1986, videocassette.

105. Amy Conger, "The Amarillo FSA Symposium: A Report," *Exposure* 17 (summer 1979): 53–54; Miles Orvell, "Portrait of the Photographer as a Young Man: John Vachon and the FSA Project," in *A Modern Mosaic: Art and Modernism in the United States*, ed. Townsend Luddington (Chapel Hill, N.C., 2000), 313. For comments on artist training also see John Collier, Jr., interview by Richard K. Doud, Sausalito, Calif., January 18, 1965, AAA.

106. *Austin (Tex.) American-Statesman*, February 22, 1970.

107. F. Jack Hurley, *Russell Lee, Photographer* (Dobbs Ferry, N.Y., 1978), 13. Doris Lee's work was in the American Scene school of Thomas Hart Benton, Grant Wood, and John Steuart Curry. On Doris Lee, see Mary Francey, *American Women at Work: Prints by Women Artists of the Nineteen Thirties* (Salt Lake City, 1991); *Doris Lee: Images of Delight, 1930–1950* (New York, 1996); and "Biographical Sketch of Doris Lee," "Doris Lee" vertical file, National Museum of Women in the Arts, Washington, D.C.

108. Lee's non-FSA photographs are in the Russell Lee Collection at the Center for American History, University of Texas, Austin.

109. Russell and Jean Lee, interview by Richard K. Doud, Austin, Tex., June 2, 1964, AAA.

110. *Today, Tomorrow's History*. On Lee's use of flash, see O'Neal, *A Vision Shared*, 138; and F. Jack Hurley, "Russell Lee," *Image* 16 (September 1973): 4.

111. *Today, Tomorrow's History*.

112. Janet L. Rollins, "Russell Lee: Teacher of Photography," *Southwestern Art* 2 (March 1968): 34.

113. Mary Pat O'Malley, "Russell Lee," *Pearl*, March 1973, 2.

114. Lee to Locke, September 5, 1937.

115. Joan Myers, *Pie Town Woman: The Hard Life and Good Times of a New Mexico Homesteader* (Albuquerque, N.Mex., 2001), 115.

116. Ibid., 114.

117. Russell and Jean Lee, interview.

118. Jean Lee to Roy Stryker, October 26, 1942, Stryker Papers, ULSC.

119. Russell Lee, "Pie Town, New Mexico: Life on the American Frontier, 1941 Version," *US Camera*, October 1941, 39–54, and photographic portfolio. For an analysis of Lee's work in Pie Town, see James C. Curtis, *Mind's Eye, Mind's Truth: FSA Photography Reconsidered* (Philadelphia, 1989), 110–22; and Myers, *Pie Town Woman*.

120. Russell Lee to Roy Stryker, September 6, 1942, Stryker Papers, ULSC.

121. Ibid.

122. Russell Lee to Roy Stryker, September 7, 1942, Stryker Papers, ULSC.

123. Ibid.

124. Russell Lee to Roy Stryker, September 13, 1942, Stryker Papers, ULSC.

125. Russell Lee to Roy Stryker, October 8, 1942, Stryker Papers, ULSC.

126. Lee to Stryker, September 6, 1942.

127. Vachon, "Commentary," 98.

128. O'Neal, *A Vision Shared*, 268.

129. On Vachon's biography, see Ann Vachon, ed., *Poland, 1946: The Photographs and Letters of John Vachon* (Washington, D.C., 1995); and Orvell, "Portrait of the Photographer."

130. Stryker to Vachon, March 18, 1942.

131. Vachon to Stryker, April 1942. There is no way of identifying this photo or of knowing if Stryker conceded to Vachon.

132. John Vachon to Roy Stryker, Wednesday, 1942, Stryker Papers, ULSC.

133. John Vachon to Penny Vachon, March 9, 1942, Vachon Collection.

134. John Vachon to Penny Vachon, [March 10, 1942?], Vachon Collection.

135. Ibid.

136. Vachon to Collier, [March] 1942.

137. Vachon to Vachon, March 14, 1942.

138. John Vachon to Penny Vachon, March 18, 1942, Vachon Collection.

139. John Vachon to Penny Vachon, March 20, 1942, Vachon Collection.

140. John Vachon to Penny Vachon, April 14, 1942, Vachon Collection.

141. John Vachon to Penny Vachon, April 17, 1942, Vachon Collection.

142. John Vachon to Penny Vachon, March 24, 1942, Vachon Collection.

143. John Vachon to Penny Vachon, March 29, 1942, Vachon Collection.
144. John Vachon to Penny Vachon, March 31, April 1, 1942, Vachon Collection.
145. John Vachon to Penny Vachon, April 4, 1942, Vachon Collection.
146. Ibid.
147. Ibid.
148. John Vachon to Penny Vachon, April 7, 1942.
149. Vachon to Stryker, April 1942.
150. On the history of the Hamilton Lab and campaign against spotted fever, see Esther Gaskins Price, *Fighting Spotted Fever in the Rockies* (Helena, Mont., 1948); Pierce C. Mullen, "Bitterroot Enigma: Howard Taylor Ricketts and the Early Struggle against Spotted Fever," *Montana The Magazine of Western History* 32 (winter 1982): 2–13; and Victoria A. Harden, *Rocky Mountain Spotted Fever: History of a Twentieth-Century Disease* (Baltimore, 1990).
151. Harden, *Rocky Mountain Spotted Fever*, 182
152. Vachon to Stryker, April 1942.
153. Vachon to Vachon, April 14, 1942.
154. John Vachon to Penny Vachon, April 15, 1942, Vachon Collection.
155. Vachon to Stryker, March 1942.
156. Ibid.
157. John Vachon to Penny Vachon, April 20, 1942, Vachon Collection.
158. John Vachon to Penny Vachon, April 21, 1942, Vachon Collection; Vachon to Stryker, April 1942.
159. Vachon to Stryker, April 1942.
160. Ibid.
161. Ibid.
162. Ibid.
163. John Vachon to Penny Vachon, April 24, 1942, Vachon Collection.
164. Vachon, "Commentary," 99.

Afterword

1. Marion Post Wolcott, interview by Richard K. Doud, Mill Valley, Calif., January 18, 1965, AAA.
2. Rothstein, interview.
3. Lockie, interview.

Bibliography

Archival Material

Albert B. Alkek Library Special Collections, Southwest Texas State
University, San Marcos
 Lee, Russell. Papers.

Archives of American Art, Washington, D.C.
 Oral History Interviews.
 Rothstein, Arthur. Papers.

Great Falls Public Library, Great Falls, Montana
 "Great Falls–history–oral" vertical file.

K. Ross Toole Archives, University of Montana, Missoula
 Linebarger, David. Papers. Small Collection 104.
 Murray, James E. Papers. Manuscript Collection 91.
 Oral History Collection.

Library of Congress
 Delano, Jack. Papers.
 Farm Security Administration-Office of War Information
 Photograph Collection.

Montana Historical Society Archives, Helena
 Anderson, Bertha Josephson. Reminiscence. Small Collection 360.
 Bennett, James V. Diaries, 1929–1951. Manuscript Collection 236.
 General Montana Oral History Collection.
 MacLean, Eva. Papers. Small Collection 1238.
 Montana Governors' Papers. Manuscript Collection 35.
 Montana Relief Commission Records, 1934–36. Record Series 236.

New Deal in Montana/Fort Peck Dam Oral History Project.
Twentieth-Century Military Veterans Oral History Project.

Merrill G. Burlingame Special Collections, Montana State University
Libraries, Bozeman
 Brewster Family. Papers, 1907–1964. Collection 331.
 Works Progress Administration Records. Collection 2336.

National Archives, Washington, D.C.
 Records of the Farmers Home Administration, 1918–80.
 Record Group 96.
 Records of the United States House of Representatives,
 1789–1990. Record Group 233.

University of Louisville Special Collections, Louisville, Kentucky
 Stryker, Roy E. Papers, 1912–1972. Microfilm edition.

Western Heritage Center, Billings, Montana
 Real West Project. Oral History Collections.

Government Documents

Montana State Appraisal Committee. *An Evaluation of the Federal Works Program in Montana, Report of the Montana State Appraisal Committee.* 1938.

Cronin, Francis D., and Howard W. Beers. *Areas of Intense Drought Distress, 1930–1936.* WPA research bulletin. Washington, D.C., 1937.

Final Report on the WPA Program, 1935–1943. Washington, D.C., 1946.

Great Plains Committee. *The Future of the Great Plains.* Washington, D.C., 1936.

Kraenzel, Carl F., with Ruth B. McIntosh. *The Relief Problem in Montana: A Study of the Change in the Character of the Relief Population.* Montana State College Agricultural Experiment Station bulletin no. 343. Bozeman, Mont., 1937.

Link, Irene. *Relief and Rehabilitation in the Drought Area.* WPA research bulletin. Washington, D.C., 1937.

Peters, Carl B., and H. E. Furgeson, eds. *New Life in the Sun River Valley and in the Greenlands Cooperative Sire and Marketing Association.* Great Falls, Mont., n.d.

Renne, R. R. *Montana Farm Bankruptcies.* Montana State College Agricultural Experiment Station bulletin no. 360. Bozeman, Mont., 1938.

Renne, R. R., and O. H. Brownlee. *Uncollected Property Taxes in Montana.* Montana State College Agricultural Experiment Station bulletin no. 382. Bozeman, Mont., 1940.

Starch, E. A. *Economic Changes in Montana's Wheat Area.* Montana State College Agricultural Experiment Station bulletin no. 295. Bozeman, Mont., 1935.

Taeuber, Conrad, and Carl C. Taylor. *The People of the Drought States.* WPA research bulletin. Washington, D.C., 1937.

Voelker, Stanley W. *Preliminary Report on Local Public Finance Situation in Sheridan County, Montana.* Montana Agricultural Experiment Station report. Bozeman, Mont., 1940.

Wilson, M. L. *Dry Farming in the North Central Montana "Triangle."* Montana State College Extension Service bulletin no. 66. Bozeman, Mont., 1923.

Dissertations and Theses

Bell, Edward. "Helena and the Great Depression, 1929–1935." Honors thesis, Carroll College, 1975.

Boddy, Julie M. "The Farm Security Administration Photographs of Marion Post Wolcott: A Cultural History." Ph.D. diss., State University of New York, 1982.

Edwards, Susan Harris. "Ben Shahn: A New Deal Photographer in the Old South." Ph.D. diss., City University of New York, 1996.

Grey, Michael Ross. "Dustbowls, Disease, and the New Deal: The Farm Security Administration Migrant Health Program, 1935–1945." Master's thesis, University of Washington, 1989.

Homstad, Carla. "Small Town Eden: The Montana Study." Master's thesis, University of Montana, 1987.

Katzman, Laura R. "The Politics of Media: Ben Shahn and Photography." Ph.D. diss., Yale University, 1997.

Kuschke, Blanche Metheney. "A Study of the Factors That May Affect the Leisure Time of Rural Homemakers in Montana." Master's thesis, Montana State College, 1930.

Loken, Scott C. "Montana during World War Two." Master's thesis, University of Montana, 1993.

McIntosh, Ruth B. "Social Problems of the Rural Relief Population Prairie County, Montana." Master's thesis, Montana State College, 1937.

McKinney, Amy Lynn. "From the 'Lost' to the 'Greatest' Generation: Eastern Montana Youth in the 1930s." Master's thesis, Montana State University, 2000.

Plattner, Steven W. "How the Other Half Lived: The Standard Oil Company (New Jersey) Photographic Project, 1943–1950." Master's thesis, George Washington University, 1976.

Preston, Catherine L. "In Retrospect: The Construction and Communication of a National Visual Memory." Ph.D. diss., University of Pennsylvania, 1995.

Sullivan, Joseph Parker. "A Description and Analysis of the Dude Ranching Industry in Montana." Master's thesis, University of Montana, 1971.

Vergeront, Glen V. "Rural Youth Adjustment in Selected Areas of Teton County, 1925–1940." Master's thesis, Montana State College, 1940.

Watkins, Charles Alan. "The Blurred Image: Documentary Photography and the Depression South." Ph.D. diss., University of Delaware, 1982.

Video

Today Tomorrow's History: Photographer Russell Lee. Prod. and dir. Ann Mundy. 1986. Videocassette.

Books

Alexander, Charles C. *Here the Country Lies: Nationalism and the Arts in Twentieth-Century America.* Bloomington, Ind., 1980.

Anderson, James C., ed. *Roy Stryker: The Humane Propagandist.* Louisville, Ky., 1977.

Atkins, Annette. *Harvest of Grief: Grasshopper Plagues and Public Assistance in Minnesota, 1873–78.* St. Paul, Minn., 1984.

Bakken, Gordon Morris. *Surviving the North Dakota Depression*. Pasadena, Calif.,
1992.

Baldwin, Stanley. *Poverty and Politics: The Rise and Decline of the Farm Security
Administration*. Chapel Hill, N.C., 1968.

Baxandall, Michael. *Patterns of Intention: On the Historical Explanation of
Pictures*. New Haven, Conn., 1985.

Bendavid-Val, Leah. *Propaganda and Dreams: Photographing the 1930s in the
USSR and the US*. Zurich, 1999.

Bezner, Lili Corbus. *Photography and Politics in America: From the New Deal into
the Cold War*. Baltimore, 1999.

Borne, Lawrence R. *Dude Ranching: A Complete History*. Albuquerque, N.Mex.,
1983.

Bradley, Charles Crane, Jr. *The Handsome People: A History of the Crow Indians
and the Whites*. Billings, Mont., 1991.

Brannan, Beverly W., and Daniel Horvath, eds. *A Kentucky Album: Farm Security
Administration Photographs, 1935–1943*. Lexington, Ky., 1986.

Brennen, Bonnie, and Hanno Hardt, eds. *Picturing the Past: Media, History and
Photography*. Urbana, Ill., 1999.

Bustard, Bruce I. *A New Deal for the Arts*. Washington, D.C., 1997.

Call, Hughie. *Golden Fleece*. 1942. Reprint, Lincoln, Nebr., 1981.

Cannon, Brian Q. *Life and Land: The Farm Security Administration Photogra-
phers in Utah, 1936–1941*. Logan, Utah, 1988.

————. *Remaking the Agrarian Dream: New Deal Resettlement in the Mountain
West*. Albuquerque, N.Mex., 1996.

Carlebach, Michael L. *American Photojournalism Comes of Age*. Washington,
D.C., 1997.

Carlebach, Michael L., and Eugene F. Provenzo, Jr. *Farm Security Administration
Photographs of Florida*. Gainesville, Fla., 1993.

Carr, Carolyn Kinder. *Ohio, a Photographic Portrait, 1935–1941: Farm Security
Administration Photographs*. Akron, Ohio, 1980.

Coles, Robert. *Doing Documentary Work*. New York, 1997.

Curtis, James C. *Mind's Eye, Mind's Truth: FSA Photography Reconsidered*.
Philadelphia, 1989.

Daniel, Pete, Merry A. Foresta, Maren Stange, and Sally Stein. *Official Images:
New Deal Photography*. Washington, D.C., 1987.

Delano, Jack. *Photographic Memories: The Autobiography of Jack Delano*.
Washington, D.C., 1997.

Dixon, Penelope. *Photographers of the Farm Security Administration:
An Annotated Bibliography, 1930–1980*. New York, 1983.

Doherty, Robert J. *Social-Documentary Photography in the USA*. Garden City,
N.Y., 1976.

Doty, C. Stewart. *Acadian Hard Times: The Farm Security Administration in
Maine's St. John Valley*. Orono, Maine, 1991.

Evans, Walker, et al. *Years of Bitterness and Pride: FSA Photographs, 1935–1943*.
New York, 1975.

Fairfield Heritage Committee, *Boots and Shovels: A History of the Greenfield
Irrigation District, Division of the Sun River Project, Fairfield, Montana*.
Fairfield, Mont., 1978.

Fisher, Andrea. *Let Us Now Praise Famous Women: Women Photographers for the US Government, 1935 to 1944*. London, 1987.

Fleischhauer, Carl, and Beverly W. Brannan, eds. *Documenting America, 1935–1943*. Berkeley, Calif., 1988.

Foster-Harris, William. *The Look of the Old West*. New York, 1955.

Ganzel, Bill. *Dust Bowl Descent*. Lincoln, Nebr., 1984.

Guimond, James. *American Photography and the American Dream*. Chapel Hill, N.C., 1991.

Hales, Peter B. *Silver Cities: The Photography of American Urbanization, 1839–1915*. Philadelphia, 1984.

Harden, Victoria A. *Rocky Mountain Spotted Fever: History of a Twentieth-Century Disease*. Baltimore, 1990.

Hargreaves, Mary Wilma M. *Dry Farming in the Northern Great Plains, 1900–1925*. Cambridge, Mass., 1957.

Hendrickson, Paul. *Looking for the Light: The Hidden Life and Art of Marion Post Wolcott*. New York, 1992.

Heron, Liz, and Val Williams, eds. *Illuminations: Women Writing on Photography from the 1850s to the Present*. Durham, N.C., 1996.

Heyman, Therese Thau, comp. *Celebrating a Collection: The Work of Dorothea Lange, Documentary Photographer*. Oakland, Calif., 1978.

Heyman, Therese Thau, et al. *Dorothea Lange: American Photographs*. San Francisco, 1994.

Hurley, F. Jack, ed. *Industry and the Photographic Image: 153 Great Prints from 1850 to the Present*. New York, 1980.

———. *Marion Post Wolcott: A Photographic Journey*. Albuquerque, N.Mex., 1989.

———. *Portrait of a Decade: Roy Stryker and the Development of Documentary Photography in the Thirties*. Baton Rouge, La., 1972.

———. *Russell Lee, Photographer*. Dobbs Ferry, N.Y., 1978.

Just Before the War: Urban America from 1935 to 1941 As Seen by Photographers of the Farm Security Administration. Balboa, Calif., 1968.

Keller, Ulrich. *The Highway As Habitat: A Roy Stryker Documentation, 1943–1955*. Santa Barbara, Calif., 1986.

Kennedy, David M. *Freedom from Fear: The American People in Depression and War, 1929–1945*. New York, 1999.

Klinkenborg, Verlyn. *Making Hay*. New York, 1986.

Kluger, James R. *Turning on Water with a Shovel: The Career of Elwood Mead*. Albuquerque, N.Mex., 1992.

Kosinski, Dorothy, ed. *The Artist and the Camera: Degas to Picasso*. Dallas, 1999.

Lange, Dorothea. *Dorothea Lange Looks at the American Country Woman*. Fort Worth, Tex., 1967.

Lange, Dorothea, and Paul Schuster Taylor. *An American Exodus: A Record of Human Erosion*. 1939. Rev. ed. 1969. Reprint, New York, 1975.

Lee, Russell, John Collier, Jr., and Jack Delano. *Far from Main Street: Three Photographers in Depression-Era New Mexico*. Santa Fe, 1994.

Leonard, Stephen J. *Trials and Triumphs: A Colorado Portrait of the Great Depression with FSA Photographs*. Niwot, Colo., 1993.

Levine, Lawrence W., and Cornelia R. Levine. *The People and the President: America's Conversation with FDR*. Boston, 2002.

Martin-Perdue, Nancy J., and Charles L. Perdue, Jr., eds. *Talk about Trouble: A New Deal Portrait of Virginians in the Great Depression*. Chapel Hill, N.C., 1996.

McCamy, James L. *Government Publicity*. Chicago, 1939.

McDannell, Colleen. *Material Christianity: Religion and Popular Culture in America*. New Haven, Conn., 1995.

McEuen, Melissa A. *Seeing America: Women Photographers between the Wars*. Lexington, Ky., 2000.

Meltzer, Milton. *Dorothea Lange: A Photographer's Life*. New York, 1978.

Myers, Joan. *Pie Town Woman: The Hard Life and Good Times of a New Mexico Homesteader*. Albuquerque, N.Mex., 2001.

Natanson, Nicholas. *The Black Image in the New Deal: The Politics of FSA Photography*. Knoxville, Tenn., 1992.

Nelson, Paula M. *The Prairie Winnows out Its Own: The West River Country of South Dakota in the Years of Depression and Dust*. Iowa City, Iowa, 1996.

Ohrn, Karen Becker. *Dorothea Lange and the Documentary Tradition*. Baton Rouge, La., 1980.

O'Neal, Hank. *A Vision Shared: A Classic Portrait of America and Its People, 1935–1943*. New York, 1976.

Parks, Gordon. *A Choice of Weapons*. New York, 1965.

Partridge, Elizabeth, ed. *Dorothea Lange: A Visual Life*. Washington, D.C., 1994.

Patterson, James T. *The New Deal and the States: Federalism in Transition*. Princeton, N.J., 1969.

Plattner, Steven W. *Roy Stryker, U.S.A., 1943–1950: The Standard Oil (New Jersey) Photography Project*. Austin, Tex., 1983.

Prescott, Jerome, ed. *America at the Crossroads: Great Photographs from the Thirties*. New York, 1995.

Price, Esther Gaskins. *Fighting Spotted Fever in the Rockies*. Helena, Mont., 1948.

Pyle, Ernie. *Home Country*. New York, 1947.

Quick, Orville M., comp. *The Depression Years, 1930–1939: As Reported in "The Circle Banner."* Circle, Mont., 1987.

Rabinowitz, Paula. *They Must Be Represented: The Politics of Documentary*. London, 1994.

Reid, Robert L. *Back Home Again: Indiana in the Farm Security Administration Photographs, 1935–1943*. Bloomington, Ind., 1987.

———. *Picturing Minnesota, 1936–1943: Photographs from the Farm Security Administration*. St. Paul, Minn., 1989.

———. *Picturing Texas: The FSA-OWI Photographers in the Lone Star State, 1935–1943*. Austin, Tex., 1994.

Rothstein, Arthur. *America in Photographs, 1930–1980*. New York, 1984.

———. *The American West in the Thirties*. New York, 1981.

———. *Arthur Rothstein: Words and Pictures*. New York, 1979.

———. *The Depression Years*. New York, 1978.

———. *Documentary Photography*. Boston, 1986.

Rowley, William D. *M. L. Wilson and the Campaign for the Domestic Allotment*. Lincoln, Nebr., 1970.

Russell, Herbert K. *A Southern Illinois Album: Farm Security Administration Photographs, 1936–1943*. Carbondale, Ill., 1990.

Schindo, Charles J. *Dust Bowl Migrants in the American Imagination*. Lawrence, Kans., 1997.

Schloss, Carol. *In Visible Light: Photography and the American Writer, 1840–1940*. New York, 1987.

Schulz, Constance B., ed. *A South Carolina Album, 1936–1948: Documentary Photography in the Palmetto State from the Farm Security Administration, Office of War Information, and Standard Oil of New Jersey*. Columbia, S.C., 1992.

———. *Bust to Boom: Documentary Photographs of Kansas, 1936–1949*. Lawrence, Kans., 1996.

Smith, Shawn Michelle. *American Archives: Gender, Race, and Class in Visual Culture*. Princeton, N.J., 1999.

Snyder, Robert L. *Pare Lorentz and the Documentary Film*. Norman, Okla., 1968.

Solomon-Godeau, Abigail. *Photography at the Dock: Essays on Photographic History, Institutions, and Practices*. Minneapolis, 1991.

Stange, Maren. *Symbols of Ideal Life: Social Documentary Photography in America, 1890–1950*. New York, 1989.

Stock, Catherine McNicol. *Main Street in Crisis: The Great Depression and the Old Middle Class on the Northern Plains*. Chapel Hill, N.C., 1992.

Stoeckle, John D., and George Abbott White. *Plain Pictures of Plain Doctoring: Vernacular Expression in New Deal Medicine and Photography, Eighty Photographs from the Farm Security Administration*. Cambridge, Mass., 1985.

Stomberg, John R. *Power and Paper: Margaret Bourke-White, Modernity, and the Documentary Mode*. Boston, 1998.

Stott, William. *Documentary Expression and Thirties America*. New York, 1973.

Stryker, Roy Emerson, and Nancy Wood, comps. *In This Proud Land: America 1935–1943 As Seen in the FSA Photographs*. Greenwich, Conn., 1973.

Threads of Culture: Photography in New Mexico 1939–1943, Russell Lee, John Collier, Jr., Jack Delano: The Pinewood Collection of FSA Photographs. Santa Fe, 1993.

Trachtenberg, Alan, ed. *Classic Essays on Photography*. New Haven, Conn., 1980.

Vachon, Ann, ed. *Poland, 1946: The Photographs and Letters of John Vachon*. Washington, D.C., 1995.

Vanderbilt, Paul. *Between the Landscape and Its Other*. Baltimore, 1993.

Vichorek, Daniel N. *Montana's Homestead Era*. Helena, Mont., 1987.

Ware, Caroline F. *The Cultural Approach to History*. New York, 1940.

Watkins, T. H. *The Hungry Years: A Narrative History of the Great Depression in America*. New York, 1999.

Weigle, Marta, ed. *New Mexicans in Cameo and Camera: New Deal Documentation of Twentieth-Century Lives*. Albuquerque, N.Mex., 1985.

———. *Women of New Mexico: Depression Era Images*. Santa Fe, 1993.

Weiss, Margaret R., ed. *Ben Shahn, Photographer: An Album from the Thirties*. New York, 1973.

Winkler, Alan M. *The Politics of Propaganda: The Office of War Information, 1942–1945*. New Haven, Conn., 1978.

Wood, Ann C., ed. *Life in Montana: A Montana Centennial Project*. Hamilton, Mont., ca. 1990.

Wood, Nancy. *Heartland New Mexico: Photographs from the Farm Security Administration, 1935–1943*. Albuquerque, N.Mex., 1989.

Worster, Donald. *Dust Bowl: The Southern Plains in the 1930s.* New York, 1979.

Wunder, John R., Frances W. Kaye, and Vernon Carstensen, eds. *Americans View Their Dustbowl Experience.* Niwot, Colo., 1999.

Zielinski, John M. *Unknown Iowa: Farm Security Photos, 1936–1941: A Classic Portrait of Iowa and Its People.* Kalona, Iowa, 1977.

Articles

Arrington, Leonard J., and Don C. Reading. "New Deal Economic Programs in the Northern Tier States, 1933–1939." In *Centennial West: Essays on the Northern Tier States*, ed. William L. Lang. Seattle, 1991.

Asbury, Dana. "Amarillo Symposium Reunites FSA Photographers." *Afterimage*, March 1979, 4.

Baltensperger, Bradley H. "Farm Consolidation in the Northern and Central States of the Great Plains." *Great Plains Quarterly* 7 (fall 1987): 256–65.

Batchen, Geoffrey. "Official Images: New Deal Photography." *Afterimage*, April 1988, 17–18.

Becker, Howard. "Do Photographs Tell the Truth?" *Afterimage*, February 1978, 9–13.

Beech, Gould. "Schools for a Minority." *Survey Graphic*, October 1939, 615–18.

Berger, Maurice. "FSA: The Illiterate Eye." In *How Art Becomes History: Essays on Art Society and Culture in Post–New Deal America*, ed. Maurice Berger. New York, 1992.

Boddy, Julie M. "Photographing Women: The Farm Security Administration Work of Marion Post Wolcott." In *Decades of Discontent: The Women's Movement, 1920–1940*, ed. Lois Scharf and Joan M. Jensen. 1983. Reprint, Boston, 1987.

Boehme, Sarah. "The North and Snow: Joseph Henry Sharp in Montana." *Montana The Magazine of Western History* 40 (autumn 1990): 32–47.

Bremer, William W. "Along the 'American Way': The New Deal's Work Relief Programs for the Unemployed." *Journal of American History* 62 (December 1975): 636–52.

Cala, Michael. "Photographs Don't Lie (but Photographers Sometimes Do)." *Camera 35* 21 (September 1977): 50–51, 60.

Campbell, Edward D. C., Jr. "'Shadows and Reflections': The Farm Security Administration and Documentary Photography in Kentucky." *The Register of the Kentucky Historical Society* 85, no. 4 (1987): 291–307.

Cannon, Brian Q. "Keeping Their Instructions Straight: Implementing the Rural Resettlement Program in the West." *Agricultural History* 70 (spring 1996): 251–67.

Carlebach, Michael. "Documentary and Propaganda: The Photographs of the F.S.A." *Journal of Decorative and Propaganda Art* 8 (spring 1988): 6–25.

Clawson, Marion. "Resettlement Experience on Nine Selected Resettlement Projects." *Agricultural History* 52 (January 1978): 1–92.

Coles, Robert. "*An American Exodus* As a Documentary Milestone." In *Perpetual Mirage: Photographic Narratives of the Desert West*, ed. May Castleberry. New York, 1996.

Conger, Amy. "The Amarillo FSA Symposium: A Report." *Exposure* 17 (summer 1979): 51–54.

Curtis, James C. "Documentary Photographs As Texts." *American Quarterly* 40 (June 1988): 246–52.

Doherty, Robert J. "USA-FSA: Farm Security Administration Photographs of the Depression Era." *Camera*, October 1962, 9–51, and cover.

Doherty, Robert J., et al. "Roy Stryker on F.S.A., S.O.N.J. and J & L." *Image*, December 1975, 1–18.

"Dressing the Dude." *Vogue* 87 (May 1, 1936): 140–41.

Durniak, John. "Focus on Stryker." *Popular Photography* 51 (September 1962): 60–65.

"Employment and Labor Conditions: Five Years' Operation of the WPA." *Monthly Labor Review* 52 (March 1941): 601–8.

"Farm Security Administration: The Compassionate Camera." *Creative Camera*, March 1973, 84–93.

"Farm Security Administration Photographs: Documents and Oral Histories of the Program." *Archives of American Art Journal* 35, nos. 1–4 (1995): 100–105.

Ganzel, Bill. "Arthur Rothstein: An Interview." *Exposure* 16 (fall 1978): 1–4.

———. "Return to the Dust Bowl." *Historic Preservation* 36 (October 1984): 32–37.

Garrett, Garet. "Plowing up Freedom." *Saturday Evening Post*, November 16, 1935, 16–17, 68–70, 72.

Gelber, Steven M. "In the Eye of the Beholder: Images of California by Dorothea Lange and Russell Lee." *California History* 64, no. 4 (1985): 264–71.

Hale, John P., and Oren Arnold. "America's Hot-Iron Heraldry." *Travel* 74 (April 1940): 11.

Harding, T. Swann. "What the FSA Is and Does—A Justification of a Much Maligned Agency." *Commonweal* 36 (October 2, 1942): 561–62.

Hendrickson, Paul. "Double Exposure." *Washington Post Magazine*, January 31, 1988, 12–25, 36, 38.

Howe, Hartley E. "You Have Seen Their Pictures." *Survey Graphic*, April 1940, 236–38.

Hurley, F. Jack. "The Farm Security Administration File: In and out of Focus." *History of Photography* 17 (autumn 1993): 244–52.

———. "Russell Lee." *Image*, September 1973, 1–32.

"Interview: Arthur Rothstein Talks with Richard Doud." *Archives of American Art Journal* 17, no. 1 (1977): 19–23.

Kernan, Sean. "John Vachon—Profile of a Magazine Photographer." *Camera 35* 15 (December 1971): 31–41, 72.

Kidd, Stuart. "Art, Politics and Erosion: Farm Security Administration Photographs of the Southern Land." *Revue Francaise d'Etudes Americaines* 16, nos. 48–49 (1991): 291–97.

Kozol, Wendy. "Madonnas of the Fields: Photography, Gender, and 1930s Farm Relief." *Genders* 2 (summer 1988): 1–23.

Maverick, Maury Jr. "The History of Today." *Texas Observer*, September 12, 1986, 20–23.

McEuen, Melissa A. "Doris Ulmann and Marion Post Wolcott: The Appalachian South." *History of Photography* 19 (spring 1995): 4–12.

Morgan, Thomas B. "John Vachon: A Certain Look." *American Heritage* 40, no. 1 (1989): 94–109.

Mullen, Pierce C. "Bitterroot Enigma: Howard Taylor Ricketts and the Early Struggle against Spotted Fever." *Montana The Magazine of Western History* 32 (winter 1982): 2–13.

Murray, Joan. "Marion Post Wolcott." *American Photographer*, March 1980, 86–93.

"Notes from the Road: The Way America Was—As Told in the Letters and Photos of Famed Photographer John Vachon." *American Photo* 2 (May/June 1991): 44–5.

O'Connell, Barry. "'In the Coal Mines Far Away': Russell Lee's Photographs of Mining Life." *Prospects* 2 (1976): 309–47.

Orvell, Miles. "Portrait of the Photographer As a Young Man: John Vachon and the FSA Project." In *A Modern Mosaic: Art and Modernism in the United States*, ed. Townsend Luddington. Chapel Hill, N.C., 2000.

"Profile: Arthur Rothstein." *Photographic Journal* 124 (July 1984): 315–21.

Raeburn, John. "Re-Viewing 1930's Photography: A Review Essay." *Annals of Iowa* 51 (fall 1991): 178–87.

Raedeke, Paul. "Interview with Marion Post Wolcott." *Photo Metro*, February 1986, 2–17.

———. "Marion Post Wolcott: Photographs for the Farm Security Administration Documenting Rural American Life in the 1930s and 1940s." *Arrival*, summer 1987, 16–27.

Reilly, Rosa. "Photographing the America of Today." *Popular Photography* 3 (November 1938): 10–11, 76–77.

Robbins, Jhan, and June Robbins. "The Man behind the Man behind the Lens: Roy Stryker." *Minicam Photography* 11 (November 1947): 52–61, 146–47.

Rollins, Janet L. "Russell Lee: Artist with a Camera." *Southwestern Art* 2 (March 1968): 18–28.

———. "Russell Lee: Teacher of Photography." *Southwestern Art* 2 (March 1968): 29–39.

Rosskam, Edwin. "Not Intended for Framing, the FSA Archive." *Afterimage*, March 1981, 9–11.

Roth, Evelyn. "Highway As Habitat: A Roy Stryker Documentation, 1943–1955." *American Photographer*, May 1987, 32.

Rothstein, Arthur. "Setting the Record Straight." *Camera 35* 22 (April 1978): 50–51.

Saindon, Bob, and Bunky Sullivan. "Taming the Missouri and Treating the Depression: Fort Peck Dam." *Montana The Magazine of Western History* 27 (summer 1977): 34–57.

Sammon, Rick. "'The World is My Studio': An Interview with Arthur Rothstein." *Studio Photography*, January 1979, 33–37.

Schreiber, Norman. "Inside Photojournalism." *Camera Arts* 2 (November 1982): 14–24, 76, 90–91.

Severin, Werner J. "Cameras with a Purpose: The Photojournalists of F.S.A." *Journalism Quarterly* 41 (spring 1964): 191–200.

Siegel, Arthur. "Fifty Years of Documentary." *American Photography* 45 (January 1951): 21–26.

Small, Lawrence F. "The Mennonites." In *Religion in Montana: Pathways to the Present*, ed. Lawrence F. Small. Vol. 2. Billings, Mont., 1995.

Snyder, Robert R. "Marion Post and the Farm Security Administration Photographs in Florida." *Florida Historical Quarterly* 65, no. 4 (1987): 457–79.

———. "Marion Post Wolcott: Photographing FSA Cheesecake." In *Developing Dixie: Modernization in a Traditional Society*, ed. Winifred B. Moore, Jr., Joseph F. Tripp and Lyon G. Tyler, Jr. New York, 1988.

Stange, Maren. "Documentary Photography in American Social Reform Movements: The FSA Project and Its Predecessors." *Views* 5 (winter 1983–84): 9–14, 22–23.

———. "The Management of Vision: Rexford G. Tugwell and Roy Emerson Stryker in the 1920s." *Afterimage*, March 1988, 6–10.

———. "'Symbols of Ideal Life': Technology, Mass Media, and the FSA Photography Project." *Prospects* 11 (1986): 81–104.

Stein, Sally. "FSA Color: The Forgotton Document." *Modern Photography* 43 (January 1979): 90–99, 162–64, 166.

Stephens, Oren. "FSA Fights for Its Life." *Harper's Magazine*, April 1943, 479–87.

Swisher, Ely W. "Controlling Mormon Crickets in Montana, 1936–1941." *Montana The Magazine of Western History* 35 (winter 1985): 60–64.

Taylor, Paul. "Migrant Mother: 1936." *American West* 7 (May 1970): 41–47.

Tolan, John H. "Our Migrant Defenders." *Survey Graphic*, November 1941, 615–18.

Tweton, D. Jerome. "'Taking Pictures of the History of Today': The Federal Government Photographs North Dakota." *North Dakota History* 57, no. 3 (1990): 2–13.

Vachon, Brian. "John Vachon: A Remembrance." *American Photographer*, October 1979, 34–45.

Vachon, John. "Commentary: Tribute to a Man, an Era, an Art." *Harper's Magazine*, September 1973, 96–99.

Valdés, Denis Nodín. "Settlers, Sojourners, and Proletarians: Social Formation in the Great Plains Sugar Beet Industry, 1890–1940." *Great Plains Quarterly* 10 (spring 1990): 110–23.

Vindex, Charles. "Survival on the High Plains, 1929–1934." *Montana The Magazine of Western History* 28 (autumn 1978): 2–10.

Walker, Sam. "Documentary Photography in America: The Political Dimensions of an Art Form." *Radical America* 11, no. 1 (1977): 52–66.

White, Robert. "Faces and Places of the South in the 1930s: A Portfolio." *Prospects* 1 (1975): 415–29.

Wilson, M. L. "Food for a Stronger America." *Survey Graphic*, July 1941, 377–78.

Wood, Nancy. "The Man Who Recorded a Nation's Hope." *The Denver Post Sunday Empire Magazine*, January 28, 1973, 10–14.

Zwingle, Erla. "Inspirations: Eight Photographers Talk about What Has Shaped Their Own Art." *Connoisseur* 215 (January 1985): 78–87.

Newspapers

Austin (Tex.) American-Statesman
Choteau (Mont.) Acantha
Circle (Mont.) Banner
Fairfield (Mont.) Times
Sheridan (Wyo.) Press
Sidney (Mont.) Herald
Village Voice
Washington Post

Index

*Photos are indicated with **bold** type. Caption information is indicated with c, e.g. 19c.*

African American troops, **201**
Agricultural Adjustment Act, 9
air raid shelter (Stevensville), **200**
Aitken, Walter, 50
Amalgamated Sugar Company, 83
American Economic Life (Tugwell and Munro), 9
amusement park (Butte), **61**
Anaconda, Montana, 82, **85**, 178
Anaconda company/facilities: community dominance, 125; Lee's photos, 18, **85**, **164**, **178**, **179**
Anderson, Bertha Josephson, 24
Anderson, Peter, 24
Arcade Bar and Cafe (Butte), **104**
Archer, Montana, **165**
Arnold, Jack, 130, 133, **134**
Ashland rodeo, **148**

automobiles (photos): Lee's, **162**, **174**, **176**; Rothstein's, 57; Vachon's, **56**, **92**, **186**; Wolcott's, **79**, **146–47**, **148**
auto repair shop (Glendive), 57

Baecker, Kermit, 25
Bailey, Mr., **100**
Ballinger, Mrs., **180**
bankers, 41
Bannack, Montana, **203**
Bannack road, **92**
barbecues, 151–52
barbershop (Fairfield), **88**
Barkhoefer, Ted (son of), **183**
barns, **16**, **20–21**, **66**
Bartley, William, 78–79
Basin Mercantile Company, **199**
Beaverhead County, **92**
beaverslide, **99**
beer parlor (Birney), **131**
Bell, Edward, 85
Benbow chromite mine, **171**

Bennett, James, 48, 87
Big Hole Valley, **83**, **99**, 162c
Big Horn County, 75
Billings, Montana, 74, 77, 95, **96**
Billings Tribune, 59
Birney, Montana, **131**, **138**
Birney vicinity, **90–91**
Bitterroot Valley, **192**
"black blizzards," 73–74
blacksmith shop (Glendive), 57
blasting powder, **177**
Board of Trade (Butte), **124**
Bonine, Claribel, 62
Bourke-White, Margaret, 9
Bozeman, Montana, 123–24
branding operations/equipment, **39**, **80**, **118**, **192**
Braught, Marie, 123
Brewster, Burton, 130
Brewster, George Warren, 130
Brewster, Grace (born Sanborn), 130

Brewster, Lyman, 130, **133**
Brewster, Warren, 130
Brewster-Arnold Ranch. *See*
 Quarter Circle U Ranch
Broadus, Montana, 80
Broadway Bar (Butte), **60**
Butte, Montana: Lee's photos,
 **61, 73, 86, 116, 166, 174,
 175;** New Deal support,
 50c; opinion of journalists,
 125, 127; relief program
 difficulties, 60; Rothstein's
 photos, **54, 60, 104, 107,
 124, 125, 126;** Stryker's
 priority, 127; unemploy-
 ment, 81–82. *See also*
 copper production
Butte Miners' Union, **86**

calf fries, 58c
Cascade County, 36–37, 48
cattle ranching: described,
 78–81, 82; Rothstein's
 photos, **35, 39, 80, 118,
 136–37;** Vachon's photos,
 192
Cheyenne Indian Reservation,
 53, 79, 115
children (photos): Lange's, **13;**
 Lee's, **2, 4, 5, 6, 43, 116;**
 Rothstein's, **29, 107, 110;**
 Vachon's, **183;** Wolcott's, **22**
Choteau County, 67
chromium production, **170**
churches, 172–73, **198**
circus wagons, **165**
Civilian Conservation Corps,
 50
Civil Works Administration,
 51–52
Collier, John, Jr., **8,** 98, 141, 185
Columbia Gardens (Butte), **61**
Conway, Joseph, 54–55
copper production: Lee's
 photos, **18, 85, 164, 167,
 176, 178, 179;** Rothstein's
 photos, **64–65, 107, 112–13;**
 unemployment, 81–82

correspondence: Lee (Jean)-
 Stryker, 171–72; Lee
 (Russell)-Stryker, 15,
 172–73; Rothstein-Stryker,
 95, 98, 105–6, 123, 124–25,
 127; Vachon-Collier, 111;
 Vachon-Penny Vachon,
 93–94, 94c, 106, 108,
 110–11, 127, 182, 185–86,
 188, 190–91; Vachon-
 Stryker, 92c, 98, 106, 182,
 200; Wolcott-Stryker, 98,
 143–44, 146, 149
Cosgriff, Kaia, 28, 34
cowboy boot/spur, **103**
cowboy portraits: Rothstein's,
 39–40, 58, 97, 132, 134;
 Vachon's, **192.** *See also*
 cattle ranching
Cox, Herald R., 194, 195
crickets, 5–6, 74–75, **75,** 77
Crow Fair: described, 22c, 153,
 156; Wolcott's photos, **140,
 153, 157–58**
Crow Indians, **22,** 52
Custer County, 67

Dagmar, Montana, 26, 64
Daniels County, 38
Delano, Irene, 114
Delano, Jack, 114, 120, 141,
 163, 182
Dillon, Montana, **202**
Domestic Allotment Plan, 9
drought years: *Circle Banner*
 report, 76; Olson's descrip-
 tion, 4–5; summarized, 32–
 34, 38, 78–81. *See also* dust
 storms; homesteading era
dudes: ranch activities, 130–34,
 138–39, 151–53; Rothstein's
 photos, **96, 131, 133;**
 Wolcott's photos, **148, 152,
 153**
dust storms, 5, 73–74

Eaton, Howard, 130
Edwards, Charlotte, 80–81

elections, 48–49
Emrick, Doris (later Lee), 114,
 125, 163–64, 165
Erickson, John E., 41
Evans, Russell, 76
Evans, Vernon, **122,** 123
Evans, Walker, 101–2, 139c

Fairfield, Montana: Rothstein's
 photo, **88;** support for
 resettlement project, 67,
 69–70
Fairfield Bench Farms:
 described, 67, 69–71;
 Rothstein's photos, **30, 33,
 66, 68, 69, 70, 128**
farm equipment: Lee's
 photos, **99;** modernization
 contrasts, 31, 149–51; Roth-
 stein's photos, **33, 70, 76;**
 Wolcott's photos, **144, 150**
Farmers Union, 47
Farm Security Administration,
 9, 64, 67. *See also* FSA
 photography project
Federal Art Project, 55
Federal Emergency Relief
 Administration, 51–52
Federal Writers' Project, 55, 152
Fenske, L. W., 57
Finntown, Montana, **64–65**
Fjell, Anna, **135**
Fjell, Avon, 135c
Flathead Valley, **100, 180**
Flathead Valley Special Area
 Project, **187**
Fly, William, 71
Forsyth, N. A., 156
Fort Harrison (Helena), **201**
Fort Peck Dam, 31, 32c, 50,
 71–73
Frasier, Alice (later Stryker), 8
Fredrickson, Mrs. H., 42
Froid, Montana, **142**
FSA photography project: col-
 laborative character, 101–3,
 117; community contacts,
 115–17; impact/significance,

15, 17, 97, 99, 101, 208–9; locations, xiii; purposes, 12–15, 101c, 127–29; stress/work difficulties, 17, 19, 105–6, 108; Stryker's intent/direction, 114, 117; Tugwell's directions, 9, 12. *See also* Stryker, Roy

Funk, J. Calvin, 42

gambling, 125
Garfield County: relief program difficulties, 60; resettlement proposals, 23, 65–67; Vachon's photos, 20–21, 184–85
George, Ethel, 28, 31, 76
Glacier National Park, 146–47
glass eye story, 41
Glendive, Montana, 57
Going-to-the-Sun-Highway, 146–47
grain elevators, 36–37, 142, 151
grasshoppers: described, 5–6, 74, 76–78; Rothstein's photos, 75, 76
Great Falls: dust storms, 74; Lee's photos, 164, 179; strike, 87; unemployment, 81–82; Wolcott's photos, 151
Great Plains Drought Area Committee, 121, 121–22
Great Western Sugar Company, 28c
Gregg, David, 50–51
Gribble, Doris, 50

Hamilton, Leverne, 86
Hamilton, Montana, 183. *See also* Rocky Mountain Lab
Hanson, Melvin, 71
Harlowtown, Montana, 33
Harrington, F. C., 58
Harrison, John, 49–50
Harrison, John C. (Harlowtown), 33
Harshbarger family: Lee's photos of, 2, 4, 5, 6, 7;

lifestyle described, 2, 3–4, 6; relationship with Lee, 163
Hart, Ray, 56–57
Hauge, John, 48
Havre, Montana, 84
hay stack, 99
Helena, Montana, 84–85, 109, 201
Helsinki Bar (Butte), 60
Hereford bull, 35
Herlihy, John, 166, 167
Highwood Mountains, 145
Hill County family, 129
Hine, Lewis, 9
Historical Section. *See* FSA photography project
Holly Sugar Company, 28c, 82c
homesteading era: beginning years, 24–28, 31–32, 34, 43; drought years, 32–34, 38, 41, 43–44; land ownership changes, 34–35, 38
Hoover, Herbert, 41
houses, exteriors (photos): Lee's, 4, 174; Rothstein's, 64–65, 66, 82, 107, 110, 112–13; Vachon's, 20–21; Wolcott's, 53, 115
houses, interiors (photos): Lee's, 2, 5, 6, 7, 43, 46, 166, 168, 170; Rothstein's, 69, 133; Vachon's, 183
Howard, Joseph Kinsey, 125
Hysham, Montana, 82

insect invasions, 5–6, 74–78, 75, 76

Jackson, Mrs. and Mrs. George, 169–70, 170
Jacobson, Herbert, 50
Javitz, Romana, 17
Jones-Connally Farm Relief Act, 80
Judith Basin County, 60, 150
Judith Gap, Montana, 50–51
Just, Warner, 65

Kalispell, Montana, 56, 189, 204
Kelsey, Jim, 45
Killen, Red, 72
Kindzerski, Mary, 27
kitchens, 43, 46, 135, 183
Kraenzel, Carl, 44, 81
Kuschke, Blanche, 31

labor unrest, 85–87
Lame Deer, Montana, 53, 79, 115
Lang, Mrs. L. R., 47
Lange, Dorothea, 13, 101–2, 106, 114
Laredo, Montana, 129
Last Chance Gulch (Helena), 109
Lee, Doris Emrick, 114, 125, 163–64, 165
Lee, Fred, 160
Lee, Jean (born Smith), 114, 170–72
Lee, Russell: background, 94, 161, 163–68; cartoon of, 163; correspondence with Stryker, 15, 172–73; marriages, 114; photo of, 17; post-FSA period, 179, 207–8; relationship with Stryker, 161–62; travels described, 3, 170–71, 172–76, 179; working style, 162–63, 168–69. *See also* FSA photography project
Lee, Russell (photos): Archer circus wagons, 165; Butte, 61, 73, 86, 116, 166, 174, 175; cattle ranching, 83, 99; copper production, 18, 85, 164, 176, 178, 179; Harshbarger family, 2, 4, 5, 6, 7; miner portraits, 167, 177, 206; Plentywood, 170; sheep ranching, 172–73; Sheridan County, 43, 46, 160, 168; Stillwater County, 171; Wisdom, 162

Lewistown, Montana, **186**
Lewistown Democrat, 59
Linebarger, Elmer, 59
Little Norway Knitting Club, **175**
Locke, Ed, 121–22
Lockie, Wallace, 34–35, 72, 79–80, 209
Lorentz, Pare, 179
lumber production, 81, **189**
Lynd, Robert, 13–14

MacLean, Eva, 52, 62–63
Madison County, **10–11**
Madsen, Emil Ferdinand, 26
main streets (photos): Lee's, **162**; Rothstein's, **ii–iii, 54, 81, 104**; Vachon's, **32, 50–51, 56, 109**
Maltese, Rose, 28, 74
maps, xiii, 45
Marlow Theatre (Helena), **109**
McCone County, 80, **94**
McDorney, Mary Frances Alexander, 38, 83–84
McIntosh, Ruth, 44
McKamey, Edith, 28
McKamey, Leslie, 28
McKenzie, Charles (ranch of), **20–21**
Mead, Elwood, 24
Meaderville, Montana, **112–13**
Medicine Crow, Joe, 52, 77
Migrant Mother, **13**
Miles City, Montana, 80, **81, 121**
military scenes, **200, 201**
miner portraits, **167, 177, 206.** *See also* copper production
miners' meeting, **86**
Miners' Union Hall, **73**
Missoula, Montana, 81
Missoula County, 83
Montana Power Company, 83
Montana State Board of Public Welfare, 55–56
Montgomery County, **16**
Montrose, Colorado, 98

Mormon crickets, 5–6, 74–75, **75, 77**
Morrow, Donald, 26, 60
Morrow family, 50
mothers with children, **4, 5, 13, 43**
Mountain Con mine, 167c
Munro, Thomas, 9
Murray, James E., 57–59

National Youth Administration, 62
Native Americans (Wolcott's photos): Cheyenne, **53, 115;** Crow, **22, 140, 157–58**
Neversweat Mine, **64–65**
New Deal Cash Grocery, **50–51**
New Deal programs: arrival in Montana, 51–52; CCC work, 50; delivery difficulties, 59–60, 72–73; patronage problems, 55–59; predecessors, 41–43, 47–48; statistics about, 44, 45; stigma of, 60–62; vaccine research, 193–94; WPA projects, 50, 52–64, 71–73
Newhall, Beaumont, 17c
Northern Cheyenne Indian Reservation, **53, 79, 115**

Office of War Information, 15, 176
Olson, Erick, 4–5, 31
Olson, Martin, **160**
Oregon or Bust, **122,** 122–23
Original Mine, **107**

Parker, Joseph, 57
Parker, Ralph R., 192
Payson, Lois, 123
Petroleum County, 67, 124
Phelps, Elizabeth, 62
Phelps, Jane, 62
Phillips County, 64
Plentywood, **170**
Pony Mercantile, **ii–iii**
pool parlor (Fairfield), **88**

Post, Nan, 108, 109
Powder River County, **58, 136–37**
Prairie County, 34, 44, 72
prairie oysters, 58c
Prickly Pear Valley, 84–85
Public Health Service, 192–94
Pyle, Ernie, 74

Quarter Circle U Ranch: described, 130–33, 138–39, 151–53; Rothstein's photos, **39–40, 80, 97, 103, 118, 132, 133, 135;** Wolcott's photos, **148, 152**

Railroads: homesteading era, 25–26, 87; wool shipping, 48c; Thomson's dispute, 168c; Wolcott's photos, **84, 142, 145, 151**
Raine, William McLeod, 133, 138–39
ranches. *See* cattle ranching; sheep ranching; wheat farming
"Ranch House Blues" (poem), 62–63
Rauh, Victor, **174**
Ravalli County, **191**
Red Cross, 47, 48
red-light district, **126**
relief programs. *See* New Deal programs
Resettlement Administration, 9
resettlement projects: described, 23–24, 64–67, 69–71; Rothstein's photos, **30, 33, 66, 68, 69, 70, 128**
Resettlers Adjustment Association, 71
Reynolds, Samuel G., 153
Richland County, 64
Ricker, A. W., 47
Ricketts, Howard Taylor, 193
Rivenes, David, 72
Rocky Mountain Lab, 188, 192–94, **194, 195, 196**

Rocky Mountains, **154–55**
Roosevelt, Franklin D., 9, 48–51
Roosevelt and McCone County Farmers Holiday Association, 86
Rosebud County, **25**, **48**, **49**
Rosskam, Edwin, 12–13, 102, 103
Rothstein, Arthur: background, 94–95, 119–20; cartoon of, 120; on colleagues, 102; correspondence with Stryker, 95, 98, 105–6, 123, 124–25; on FSA photography project, 208; photo of, **17**; post-FSA period, 207; response to Montana, 95; on travel life, 111; travels described, 95, 121–23, 125, 127, 130, 132–33; working style, 123–25, 139. *See also* FSA photography project
Rothstein, Arthur (photos): Billings, **96**; Birney, **131**, **138**; Butte, **54**, **60**, **64–65**, **104**, **124**, **125**, **126**; cattle ranching, **35**, **39**, **64–65**, **80**, **118**, **136–37**; copper production, **107**, **112–13**; cowboy boot/spur, **103**; cowboy portraits, **39–40**, **58**, **97**, **132**, **134**; dude activities, **131**, **132**, **133**, **135**; Fairfield area, **30**, **33**, **66**, **68**, **69**, **70**, **88**, **128**; Glendive auto repair shop, **57**; insect controls, **75**, **76**; Miles City, **81**, **121**; Oregon travelers, **122**; Pony Mercantile, **ii–iii**; sheep ranching, **10–11**, **25**, **48**, **49**; skull, **13**, **14**; sugar beet farming, **29**, **82**, **110**; wheat farming, **36–37**; Wolcott, **16**
roundups, **136–37**
Ryan, Jim, **132**

Salida, Colorado, **126c**
Sanborn, Grace (later Brewster), 130
Sanders County, 48
sawmill (Kalispell), **189**
Schnitzler Corporation farm, **144**
Schulz, Anna, 78
Scobey, Montana, 78–79
scrap salvage campaign (Butte), **116**
Shahn, Ben, 101–2
Sharp, Joseph Henry, 156
sheep ranching: Lee's photos, **172–73**; Rothstein's photos, **10–11**, **25**, **48**, **49**; Vachon's descriptions, 190–91; Vachon's photos, **20–21**, **184–85**, **191**; Wolcott's photos, **154–55**
Sheffels's wheat farm, **36–37**
Sheridan, Montana, **172–73**
Sheridan County: drought impact, 38; Lee's photos, **2**, **4**, **5**, **6**, **7**, **43**, **46**, **160**, **168**
Skinner's Saloon, **203**
skull photo (South Dakota), **13**, **14**
smelters, **18**, **85**, **178**
Smith, Jean (later Lee), 114, 170–72
Sobotka, August, **35**
soil conservation, **143c**
South Dakota, **13**, **14**, 130
Spear, Elsa Byron, 156
spotted fever, 192–93
St. Claire, Edna Mae, **59**
Stanley, Jean, **60**
steam bath (Butte), **60**
Steinbeck, John, 150–51
Steiner, Ralph, 142, 143
Stephenson, Lillian, **33**
Stevensville, Montana, **200**
Stillwater County, **171**
Stockman Bar (Miles City), **81**
storage cellar, **128**

stores (photos): Lee's, **162**; Rothstein's, **ii–iii**, **88**, **138**; Vachon's, **50–51**, **199**
Streets, Birdie, **33**
strikes, 86–87
Stryker, Alice (born Frasier), 8
Stryker, Roy: background, 8–9, 97–98; leadership overview, 12–15, 103, 105; on people of FSA photographs, 6, 8; photos of, 8, **17**; post-FSA period, 98–99, 207. *See also* FSA photography project
Stryker, Roy (correspondence/instructions): Lee (Jean), 171–72; Lee (Russell), 15, 172–73; Rothstein, **35c**, **80c**, 95, 98, 105–6, 123, 124–25, 127; Vachon, **92c**, 98, 106, 182, 200; Wolcott, 98, 143–45, 146, 149
sugar beet farming, **29**, **82**, **82–83**, **110**
Sunset Magazine, 133
sweat lodge, **79**
Swisher, Ely, 74–75, 77

Taylor, Paul, 114
telephone sign, **90–91**
Teton County, 67
Thompson, Elmer "Hominy," **168**
Thompson, Mrs. Lawrence, **187**
Three Circle Ranch, **58**, **136–37**
tractors, **31**, **33**, **70**, **99**
trains. *See* railroads.
Treasure County, **29**, **110**
Trees, Julia, 60–62
Tugwell, Rexford Guy, 8–9, 12

unemployment figures, 85
unions, 86, 86–87
University of Louisville, 98

vaccine research, 192–96
Vachon, John: background, 94–95, 181–82; cartoon of,

182; on colleagues, 117; photo of, **17**; post-FSA period, 207; response to Montana, 95; travels described, 93–94, 182–88, 190–92, 197–201; working style, 114, 195–97, 201–3, 205. *See also* FSA photography project

Vachon, John (correspondence): with Collier, 111; with Penny Vachon, 93–94, 94c, 106, 108, 110–11, 127, 182, 185–86, 188, 190–91; with Stryker, 92c, 98, 106, 182, 200

Vachon, John (photos): Bannack, **203**; Bannack road, **92**; cattle ranching, **192**; Dillon, **202**; Flathead Valley, **100**, **180**, **187**; Hamilton, **183**; Helena, **109**, **201**; Judith Gap, **50–51**; Kalispell, **56**, **189**, **204**; Lewistown, **186**; McCone County farm, **94**; Rocky Mountain Lab, **194**, **195**, **196**; sheep ranching, **20–21**, **184–85**, **191**; Stevensville, **200**; Wheeler, **32**; Wisdom, **198**, **199**

Valley County, 63–64

Vanek, Wencil, 47
Venus Alley, **126**
Vindex, Charles, 41, 45
Vindex, Mrs. Charles, 44–45
Vogue, 133–34
Vukonich, John, 79

water pumps, **30**, **88**
Watts, Louise, 42–44
Watts, Steven, 42–44
Webster School, Butte, **116**
wheat farming: described, 4–5, 26–27, 32, 83; Rothstein's photos, **36–37**; Wolcott's photos, **143**, **144**, **150**
Wheeler, Burton K., 50c, 56, 71
Wheeler, Montana, 32, 50c
Whisenhand, Bill, 71–72
Whitmarsh, George, 165c
Williams, Owen, 71
Willow Creek Ranch, **35**
Wilson, Milburn L., 9, 27, 48
Wisdom, Montana, **162**, **198**, **199**
Wiseman, James, 71
Wolcott, Lee, 114
Wolcott, Marion Post: background, 94–95, 141–43; cartoon of, **141**; on colleagues, 102, 117; correspondence with Stryker, 98, 143–44, 146, 149; on FSA photography project, 208; marriage, 114, 146–47; photo of, **16**; post-FSA period, 208; stress/work difficulties, 108, 111; travels described, 143, 145–46, 147, 149, 151, 156, 159; working style, 106, 107, 144–45, 149. *See also* FSA photography project

Wolcott, Marion Post (photos): Cheyenne Indian Reservation, **53**, **79**, **115**; cowboy boot/spur, **103**; Crow Fair, **22**, **140**, **153**, **157–58**; dude activities, **148**, **152**, **153**; Froid, **142**; Glacier National Park, **146–47**; Laredo family, **129**; railroads, **84**, **142**, **145**, **151**; sheep ranching, **154–55**; telephone sign, **90–91**; wheat farming, **143**, **144**, **150**

Womble, James, 23, 78
Wool, Helen, 98
wool production. *See* sheep ranching
Workers Alliance, 87
Work Projects Administration (WPA), 50, 52–64, 72–73